THE BRANCH LINES OF
HAMPSHIRE

THE BRANCH LINES OF
HAMPSHIRE

COLIN G. MAGGS

AMBERLEY

First published 2010

Amberley Publishing Plc
Cirencester Road, Chalford,
Stroud, Gloucestershire, GL6 8PE

www.amberley-books.com

British Library Cataloguing in Publication Data.
A catalogue record for this book is available from the British Library.

ISBN 978-1-84868-343-3

Typesetting and Origination by Amberley Publishing.
Printed in Great Britain.

Contents

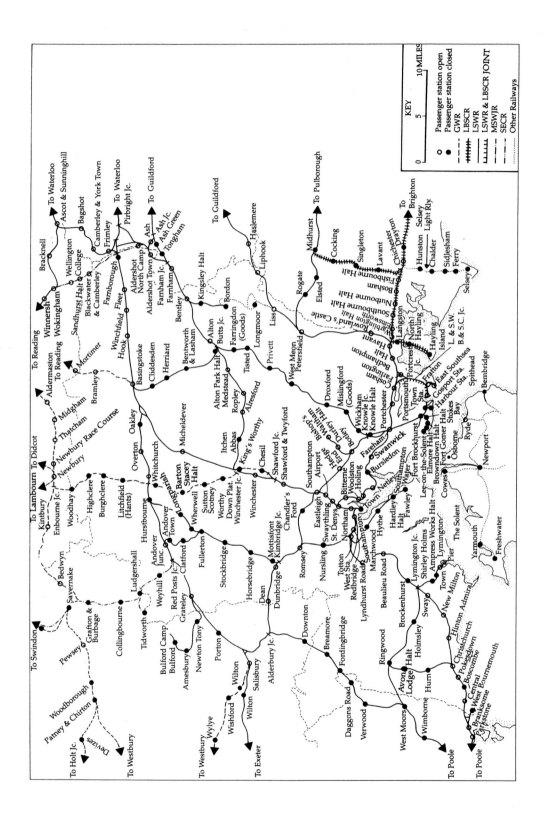

Introduction

Owing to the large number of branches in the county, areas rather than individual branches form a chapter. These areas are described working around the county in a clockwise direction starting with Brockenhurst.

In pre-grouping days the county was served almost exclusively by the London & South Western Railway, the Great Western Railway making inroads only as far as Basingstoke and Winchester, the South Eastern & Chatham Railway to the Farnborough area, while the London, Brighton & South Coast Railway served Hayling Island and shared the East Southsea branch with the LSWR. The southern tip of the Midland & South Western Junction Railway, a line closely allied with the LSWR, just entered the county and part of its station on the Tidworth branch was on Hampshire soil. The only other major branch line owned by other than the LSWR, or its successors, was the Longmoor Military Railway.

Most of the branches are no longer extant. The branch line from Basingstoke to Alton was closed and lifted during the First World War, was reluctantly relaid in 1924 by the Southern Railway and had to close a dozen years later due to the sparsity of traffic. The Meon Valley Line succumbed to closure in 1955 while most of the others shut in the 1960s. The only branches still surviving in Hampshire are the electrified Eastleigh to Fareham line, Alton and Lymington branches, the preserved Mid-Hants Railway from Alton to Alresford and the Totton to Fawley branch.

The Southampton Dock lines have been deliberately omitted from this volume; to have dealt with them here in comparable detail with the other branches would have required a disproportionate number of pages.

Grateful thanks are due to Colin Roberts for checking and improving the text and captions; the late E. J. M. Hayward; Esso Petroleum Company Limited for allowing visiting facilities and to David M. Blay for sharing his knowledge of the Fawley system; and to Ian Crespin for arranging a visit to the Marchwood Military Railways.

It should be noted that the train times in this book follow the form given in the public timetables. Therefore, photographs up to June 1963 are presented using the twelve-hour clock, and photographs after that date use the twenty-four-hour clock.

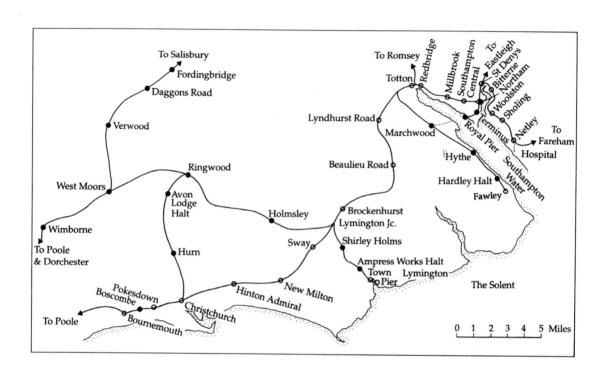

The Brockenhurst Area

BROCKENHURST TO RINGWOOD

The Brockenhurst and Ringwood branch was part of the Southampton & Dorchester Railway authorised by an Act of 21 July 1845 and opened on 1 June 1847. Its rather indirect route gave rise to its nicknames 'Castleman's Corkscrew', (after its proposer), or 'The Water Snake Line'. Although the 'Old Road' ceased to be a main line from the opening of the direct route to Bournemouth on 6 March 1888, it was useful as a diversion and used by some summer Saturday trains. It closed to passengers on 4 May 1964, on which date the Brockenhurst to Ringwood line closed to goods so that freight for Ringwood arrived from the west until 7 August 1967.

Double track left the Bournemouth Direct route at Lymington Junction a mile west of Brockenhurst. The next station, Holmsley, was called Christchurch Road until February 1863. Ringwood, junction with the branch to Christchurch, had three platforms, the outer side of the Down island platform being covered with a train shed. One night during the Second World War the Royal Train with King George VI aboard was stabled under it. During the First World War the Up goods yard was a prisoner-of-war camp. A private siding served Messrs Wellworthy Limited of piston ring fame. For several weeks, commencing 27 May 1940, single line working over the Down line was in force between Holmsley and Ringwood as the Up line was used for stabling wagons. Following the invasion of France in 1944, Ringwood became the railhead for the American military hospital at St Leonard's.

Almost all classes of LSWR engines could be seen at some time on the branch. From about 1930 M7 class 0-4-4Ts worked stopping trains, a two-coach set having a utility van, also fitted for push-pull operation, for carrying prams and other luggage. In the branch's final years, the M7s' duties were taken over by BR Standard engines such as Class 3 2-6-2Ts, passenger and freight trains being hauled by Class 4 2-6-0s. Only the heaviest 4-6-0s and 'Merchant Navy' Pacifics were banned.

Around 1911 a cavalcade of cars carrying the Kaiser was stopped by the closed gates of Christchurch Road level crossing, Ringwood. An irate official leapt from the first car, dashed over to the signal box and shouted imperiously to Signalman Lawford leaning from his window: 'Open these gates at once my man. Don't you know who you are holding up?' With nonchalance the signalman replied: 'Oh yes, I know who he is. But I also know the name of the driver of the train that has just entered my section and he can't be kept waiting either.' With that he withdrew his head and resumed his duties, leaving a red-faced official to apologise for the delay to his distinguished visitor.

The Association of Train Operating Companies report 'Connecting Communities' published in June 2009, proposes a positive business case for re-opening the ten miles from Lymington Junction to Ringwood. An hourly service on a single track electrified line would serve the northern part of the Bournemouth/Poole conurbation as well as the rural area to the north.

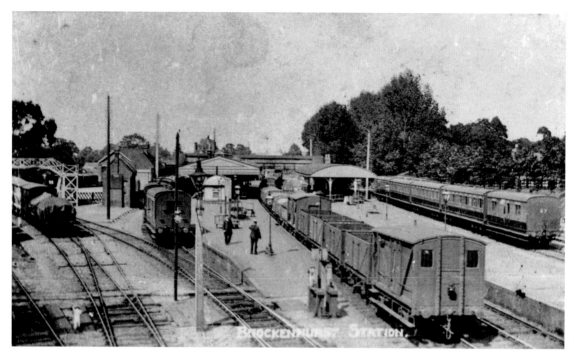

Brockenhurst, view Up *c.* 1910 with coach Set 57 on the right. *Author's collection*

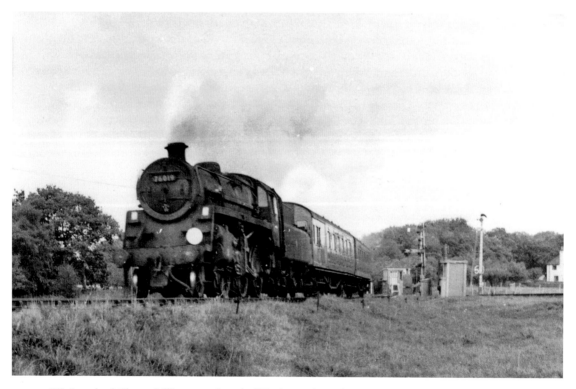

BR Standard Class 4MT 2-6-0 takes the Wimborne branch at Lymington Junction, 5 October 1962. *Revd Alan Newman*

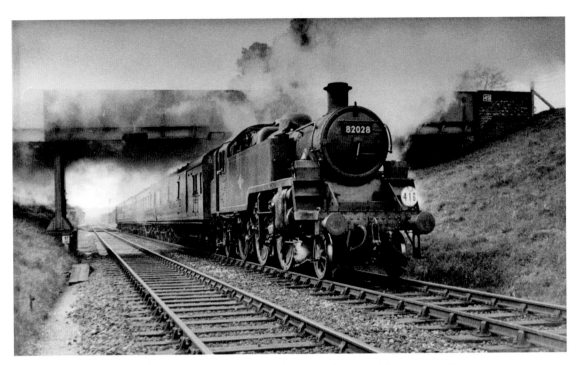

BR Standard Class 3MT 2-6-2T No. 82028 leaves Holmsley with a train to Brockenhurst, 2 May 1964. *Derrick Payne*

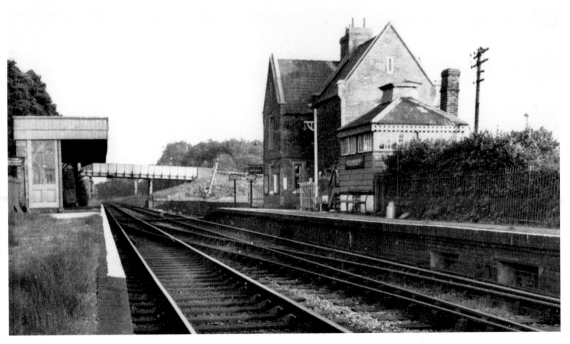

View from Holmsley towards Lymington Junction, *c.* 1967. Notice the hand crane in the goods loading dock. *Lens of Sutton*

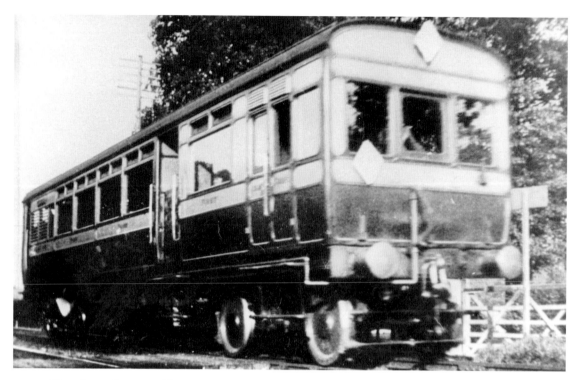

H13 class rail motor, either No. 3 or No. 13, on the Brockenhurst to Ringwood line *c.* 1908. The first-class section is nearest the camera and the third-class saloon beyond. At the far end is the boiler compartment. *Author's collection*

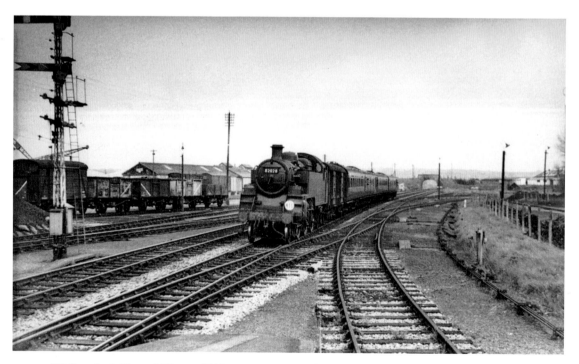

BR Standard Class 3MT 2-6-2T No. 82028 approaches Ringwood from Brockenhurst, 2 May 1964. *Derrick Payne*

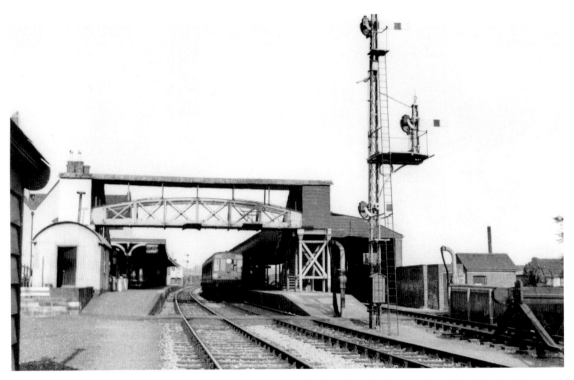

Push-pull Set 352 at Ringwood in the 1930s. The platform for the former Christchurch trains is on the right, here shortened to a siding. The main signal has a repeater at a lower level. Note the footbridge's rather crude corrugated iron roof. *Author's collection*

A Down train headed by an M7 class 0-4-4T at Ringwood *c.* 1955. The goods wagons on the left are under the train shed which covered the Christchurch branch platform. *Lens of Sutton*

The control trailer of Set 383, at the rear of a Down train, leaves Ringwood *c.* 1955. *Lens of Sutton*

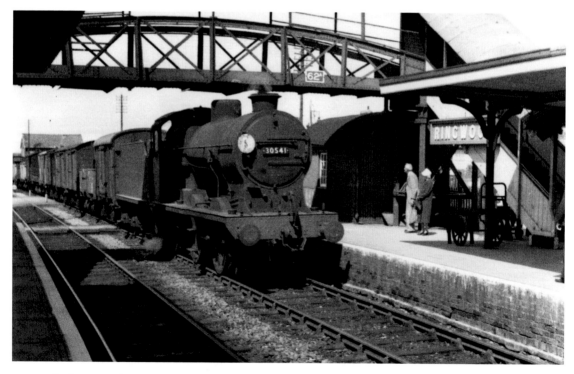

Q class 0-6-0 No. 30541, now preserved, heads an Up goods train through Ringwood *c.* 1955. *Lens of Sutton*

RINGWOOD TO CHRISTCHURCH

The Ringwood, Christchurch & Bournemouth Railway Act, passed on 8 August 1859, authorised an eight-mile- long line from Ringwood to Christchurch, but no further as the residents of Bournemouth declined to have a railway. This Act required the company to provide a private station at the level crossing by the entrance to Avon Castle, about 1¾ miles from Ringwood station. The owner, or occupier, of the castle had the perpetual right to stop an 'ordinary train' by using a red flag by day, or red light at night, in order to take up, or set down, passengers. An express was not classified as an 'ordinary train' because when a through express between Bournemouth and Waterloo was introduced in 1872, the grandson of the owner unsuccessfully tried to stop it at his private platform. He took this case to court but lost.

The railway, with one public intermediate station at Hurn, opened on 13 November 1862, the inaugural train hauled by 'Tartar' class 2-2-2WT No. 18 *Albert*. All trains had to be hauled by tank engines as tender-first working was prohibited. It is recorded that *Queen* of the same class, seemingly accident-prone, broke its leading axle near Hurn on 13 January 1865 and killed a stray bullock soon after leaving Ringwood on 23 November 1866. Severe curves and gradients between Ringwood and Christchurch caused a general speed restriction of 25 mph to be imposed and a lower limit of 15 mph round curves. The line's terminus at Christchurch became the railhead for Bournemouth, through coaches being detached, or attached, at Ringwood from, or to, Weymouth trains. In due course the Ringwood, Christchurch & Bournemouth Railway was able to extend its line to Bournemouth on 14 March 1870.

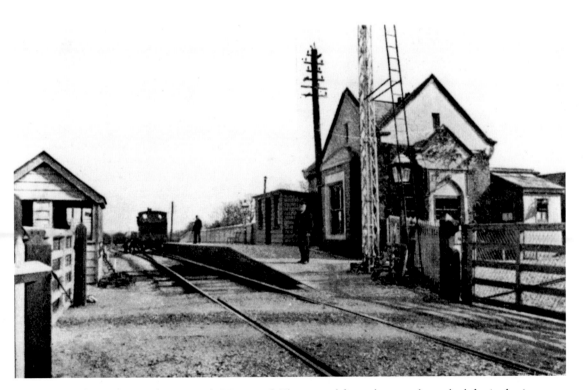

View from Avon Lodge, towards Ringwood. The ground frame hut stands on the left. *Author's collection*

Hurn, view Down *c.* 1932. The loop was taken out of use on 9 August 1927 and subsequently lifted, leaving the Down home signal on the disused platform some distance from the remaining track. *Author's collection*

When the Bournemouth Direct line between Lymington Junction and Christchurch was opened on 6 March 1888 the Ringwood to Christchurch line became a backwater. From 1 March 1906 steam railcars Nos 3 and 4 worked the Ringwood to Poole service via Hurn, while a little later these duties were taken over by a coach set hauled by C14 class 0-2-2Ts Nos 737 and 744. These looked very strange with their 3-ft diameter trailing wheels as large as the driving wheels. One of the last innovations on the branch was a camping coach stabled at Hurn in the 1930s. The branch was closed to all traffic from 30 September 1935.

The Engineer on 26 February 1886 reported: 'The LSWR has been adjudicated by a jury at the Hampshire Assizes as liable to pay damages for a prairie fire on a small scale, caused by one of their engines in running between Ringwood and Bournemouth. The large tract of heath outside Bournemouth, and the peaty ground on which it grew, were so dried up by the hot, sunny weather last summer, as to be in a highly combustible condition. The South-Western Company is said by a local paper to have 'put on an engine built nearly 30 years ago in which the natural tendency of steam engines to emit sparks was not under adequate control.' On Lord Malmesbury's estate alone 650 acres were set ablaze.

BROCKENHURST TO LYMINGTON

The Lymington Railway Act, passed on 7 July 1856, allowed a 5¾ mile long branch to be built from Brockenhurst to Lymington Town Quay, which, together with Lymington Bridge, the company had powers to purchase. The line was ceremonially opened on 8 May 1858 when a train ran to Lymington, crowds swarming into the coaches leaving the directors, engineers and contractors to ride on the engine and tender.

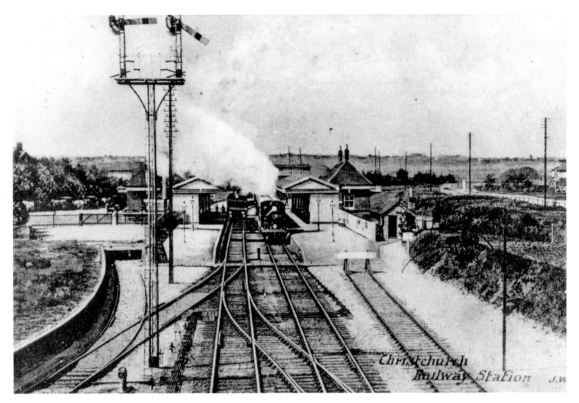

The new Christchurch station opened on 30 May 1886. The branch to Ringwood curved away to the right behind the photographer. At the platform is a Down railcar, while an Up train, probably headed by a C14 class 2-2-0T, is leaving for Ringwood, the branch signal having been cleared, *c.* 1910. *Author's collection*

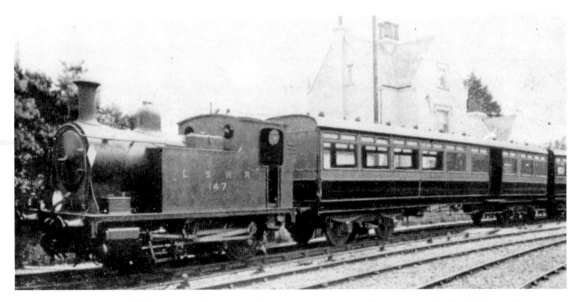

S14 class 0-4-0T No. 147, with an auto branch train *c.* 1912. No. 147 was built in September 1910 and sold March 1917. *Author's collection*

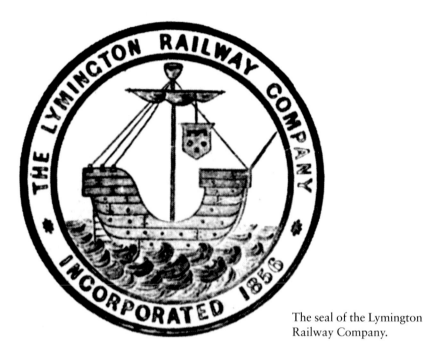

The seal of the Lymington
Railway Company.

M7 class 0-4-4T No. 30052 at Brockenhurst with a train for Lymington, April 1964. The
platform on the right can be swung at right angles so that luggage may be taken on the level
from the approach road to the left-hand platform. *R. A. Lumber*

Several more trips were made that day, while navvies celebrated by drinking a barrel of ale supplied by Alfred Mew, a brewer and also the company's chairman. The sleepers were frugally placed at 3 foot 9 inch intervals instead of the more usual 3 foot and the working company, the LSWR, insisted on additional sleepers being laid. This delayed the public opening until 12 July, with goods traffic commencing eleven days later. There were six trains daily and three on Sundays. The Solent Steam Packet Company's paddle steamers *Solent* and *Red Lion* made four connecting return sailings each weekday.

A permanent station at Lymington Town, vaguely Italianate in design and boasting a train shed, was opened on 19 September 1860. The delay was caused by having to fill in the mill pond on which the station was built. The temporary station then became a dwelling house until demolished in 1954. Shirley Holms station, a single wooden platform opened on 10 October 1860 to serve residents of Sway and Boldre, was probably the first British halt. A request stop, it was only used during daylight hours. The fare table completely ignored it: Down passengers booked to Lymington and Up passengers paid at Brockenhurst as from Lymington. The station fell into disuse following the opening of Sway on the Bournemouth Direct line in 1888, and closed soon after the turn of the century. Another unusual station was Ampress Works Halt, which opened on 1 October 1956, but trains ceased to call there after May 1977. In 1859 the LBSCR cut Cowes to London return fares so low that passengers from Lymington caught the boat to Cowes and thus saved some 10s on a third-class ticket.

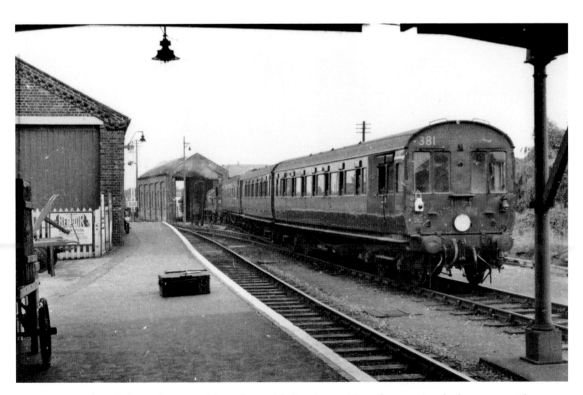

An unidentified M7 class 0-4-4T stands outside Lymington Town locomotive shed, *c.* 1955, with push-pull Set 381. *Lens of Sutton*

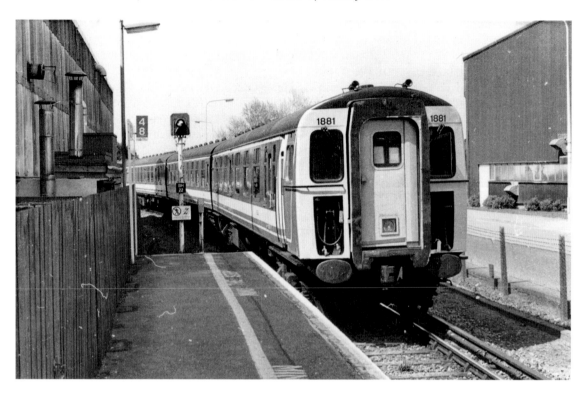

Above: Rear view of Class 421/4 EMU Set No. 1881 departing from Lymington Town with the 14.43 Lymington Pier to Brockenhurst, 14 May 1996. *Author*

Left: The unusual architecture of Lymington Town station, 14 May 1996. *Author*

The private Wellworthy Ampress Works Halt, view Down. The concrete components were cast at Exmouth Junction. *Lens of Sutton*

Due to difficulties in reaching the Isle of Wight ferry steamers at low water, on 22 August 1881 a 900-yard-long extension was authorized to be built from Lymington Town station to a new deep water pier where ships could berth at any state of the tide. This new length of line crossed the Lymington River over a 70-yard-long viaduct of ten spans supported on nine screw piles. This extension opened on 1 May 1884 and two months later the LSWR purchased the steam ferry.

Until 1 May 1938 two paddle steamers carried passengers while a tug towed up to four barges laden with vehicles and cattle. On that date a new passenger and vehicle ferry, *Lymington,* was brought into use. It was fitted with Voith-Schneider propellers which overcame the difficulties of navigating the Lymington River. These propellers were arranged diagonally opposite, each diesel engine driving a separate propeller, the design of which allowed the ship to move sideways, or turn about its centre without going backwards or forwards. The vessel was double-ended so that vehicles could drive forwards both on and off. A tractor and trailers were maintained at Lymington to transfer containers by ferry. A slipway to suit this new ferry was brought into use on 24 May 1938.

Boat trains up to ten coaches in length were run from Waterloo to Lymington Pier. Up boat trains, even if delayed by the late arrival of the ferry, were required to reach Waterloo on time because their coach sets were diagrammed for smart turnrounds as departures to various destinations. In the event of a through train being too long for an engine to run round its train on arrival at the Pier station, from 1953 it was authorized to 'top and tail' an Up train from the Pier to Brockenhurst. Usually an M7 class 0-4-4T was on the front and a Q or Q1 class 0-6-0 at the rear.

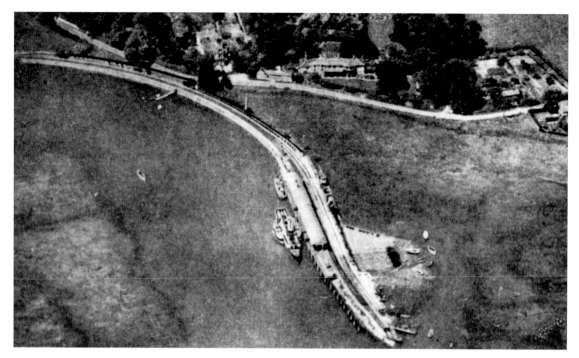

Lymington Pier from the air *c.* 1930. This photograph was taken before the pier was adapted to take vehicular traffic. Notice the paddle steamer moored alongside. *Author's collection*

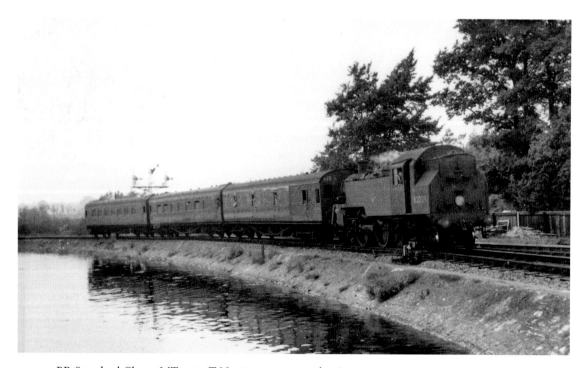

BR Standard Class 3MT 2-6-2T No. 82029 approaches Lymington Pier, 12 August 1964, with the 17.00 from Brockenhurst. *Author*

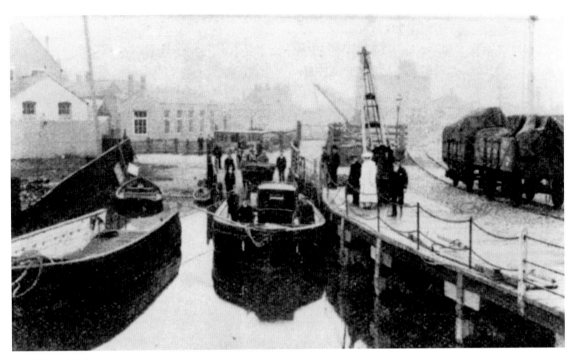

Loading cargo boats at Lymington, bound for the Isle of Wight, *c.* 1910. A car can be seen in the right-hand barge. This landing stage was sited immediately south of Lymington Town station. *Author's collection*

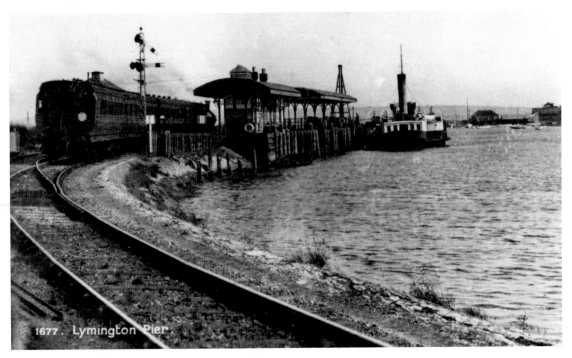

A three-coach push-pull motor set leaves Lymington Pier *c.* 1914. The paddle steamer to Yarmouth is moored at the pier. *Author's collection*

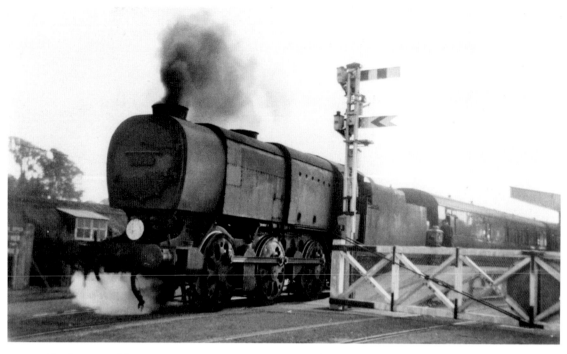

Q1 class 0-6-0 No. 33023 at Lymington Pier, 17 September 1955, with a train of through coaches to Waterloo. The level crossing permits vehicles to access the ferry. *R. A. Lumber*

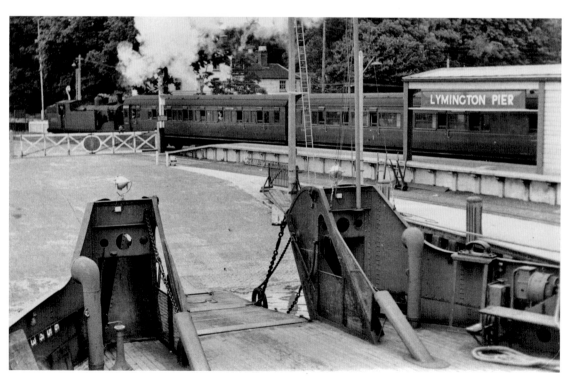

M7 class 0-4-4T No. 30052 at Lymington Pier, 12 July 1950, with a train to Brockenhurst, viewed from the Isle of Wight ferry *Farringford*. Vehicle access to the ferry is in the lower centre. *Frank F Moss/Colin Roberts collection*

A variety of locomotives have worked branch trains, the majority being tank engines. The first were 2-4-0WT No. 143 *Nelson* and No. 176 *Southampton,* while in the 1870s 'Hercules' class 2-4-0 *Taurus* appeared. As a shed was yet to be built at Lymington, it was stabled in the open and Boiler Register records that by May 1878 its steam pressure had been reduced from 110 lb per square inch to 85 lb and a notice on the footplate warned the crew not to exceed 20 mph.

C14 class 2-2-0T No. 744 and trailer worked the branch in 1907, bucking and corkscrewing along the track if speed exceeded 20 mph. S14 class 0-4-0Ts worked push and pull trains in 1910 and were capable of hauling 2 fully laden trailers. They were restricted to 25 mph. In 1911 O2 class 0-4-4Ts returned. By about 1918 0-4-4Ts were converted for push-pull working; the driver, when in the control compartment of what had been the last coach, worked the locomotive by a system of wires and pulleys. By about 1930 this rather primitive control system was changed to the far more practical compressed air system.

The Lymington branch could boast that it was the last to be worked by BR steam, this form of propulsion ending on 2 April 1967. 'Hampshire' DEMUs took over for a few weeks to enable the redundant run-round loops and engine shed line to be safely lifted. Some electric trains began on 2 June 1967 and from 26 June all services were EMU worked. On 22 May 2010, the last two 'slam door' 3CIG class EMUs were withdrawn and replaced with Class 158 DMUs (Mon-Fri) and Class 450 EMUs (at weekends). The CIGs were periodically reversed to even out tyre wear.

Branch trains start from Brockenhurst, the two island platforms providing a total of four faces. Today Lymington branch trains usually begin and terminate at the outer Down platform. The station is interesting in that it has a covered way from the car park to the platforms and that a rare, if not unique, swing bridge leads from the north-side station approach to the Up platform for wheeled items such as platform trolleys which cannot negotiate the footbridge. This movable bridge, level with the platform, swings across the Up loop and for safety is interlocked with the signals.

In 1908 Brockenhurst station lighting was changed to acetylene gas produced by the reaction of water on calcium carbide; this illumination was also used for signal lamps. During the First World War there were difficulties in obtaining carbide and lighting reverted to oil lamps. Soon after the armistice the station was lit electrically.

The Lymington Railway Company provided a small, single-road, brick-built engine shed at Lymington Town, just beyond the Up end of the platform. No turntable was provided as tank engines were normally used on the branch, but if an engine required turning, the table at Brockenhurst could be used. Lymington shed closed on the withdrawal of steam.

Lymington was the base of early railway-owned motor buses. On 19 July 1905 the LSWR inaugurated a service from Lymington to New Milton, operated by Clarkson steam buses. A paraffin fuelled boiler was used to produce steam at 300 lbs per square inch to drive a 32 hp engine. In 1906 Clarkson's fitted them with the latest type of water tube boiler. A luxurious touch was that the eighteen and twenty-seater saloons were heated in winter. A mishap occurred at Brockenhurst station after one overhaul. The goods yard crane was used to lift the cab from above the boiler and, following the completion of the task, the cab was lowered and bolted on. When the bus moved off there was a loud rending noise — the crane hook had not been detached!

In September 1932 the Hants & Dorset company, operator of the Lymington Town station to Milford-on-Sea route, provided an interesting facility permitting prospective passengers to telegraph the Lymington depot and ask to be picked up at their door or to be taken home following a railway journey.

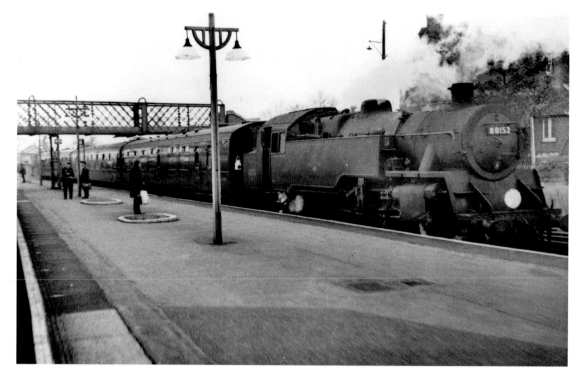

BR Standard Class 4MT 2-6-4T No. 80152 arrives at Brockenhurst, from Lymington Pier, on 1 April 1967, the last day of steam working. *R. A. Lumber*

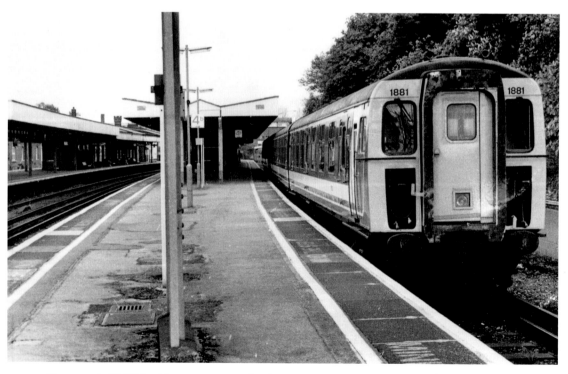

Class 421/4 EMU Set No. 1881 at Brockenhurst with the 15.28 to Lymington Pier, 14 May 1996. *Author*

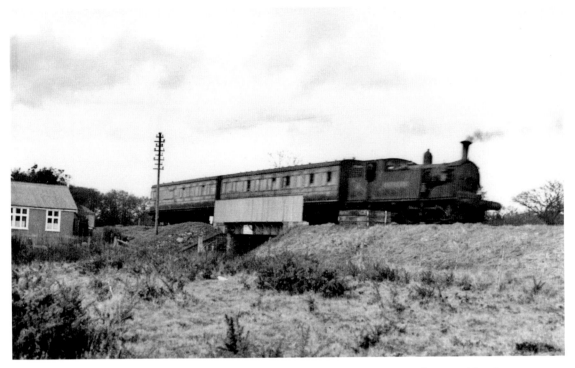

An M7 class 0-4-4T propels a Lymington Pier to Brockenhurst train, south-west of Lymington Junction, 1947. *C. T. Standfast*

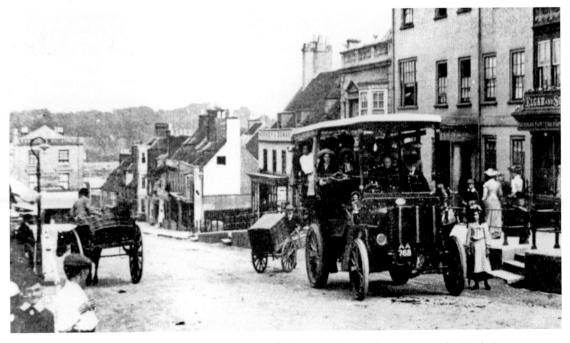

LSWR bus, registration number AA 768, climbs a gradient of 1 in 10 up the High Street, Lymington *c*. 1906. *Author's collection*

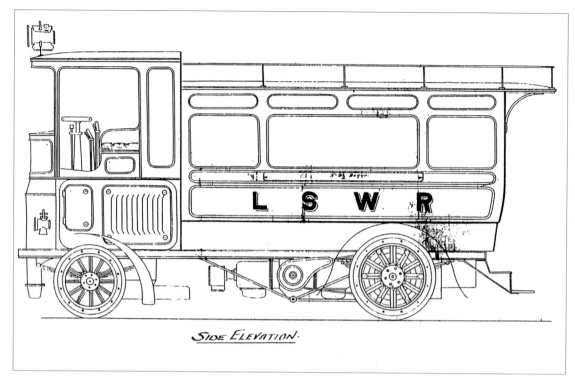

Clarkson steam bus.

O. S. Nock in his book the *London & South Western Railway* records a fascinating story concerning the line during the Second World War. Preparing for the 1944 Normandy invasion, an American officer was appalled at the single track, meandering branch with its sparse siding accommodation at the ferry and wanted it improved. A railwayman in the Royal Engineers attached to the US unit for liaison purposes, observed that it was unreasonable to spend money on a line which could not recoup its investment in peacetime. The senior American officer listened and said 'We're *nart* interested in the *carst;* we're *nart* interested in post-war development; we're *gonna* win this goddam war.' So saying, he took a ruler and drew a straight line from Brockenhurst to Lymington. 'Gentlemen,' he said, 'we build a *nu* railroad. That's the route. We start Monday.' Despite this, the branch remained unaltered.

BREAMORE TO FORDINGBRIDGE

Breamore and Fordingbridge stations are in the Hampshire portion of the Salisbury & Dorset Junction Railway which ran from Alderbury Junction on the Romsey line, four miles south of Salisbury to West Moors. It received its Act on 22 July 1861. Financial difficulties, coupled with the unusually wet winter of 1865-6, delayed the line's completion. When Captain Tyler made the Board of Trade inspection he found that works were below the recently raised standard required, but Henry Jackson, the line's contractor, carried out improvements at cost price. Eventually Tyler passed the line for carrying passenger traffic.

A Down train enters Breamore station *c.* 1910. *Author's collection*

L11 class 4-4-0 No. 437 heads an Up parcels train through Fordingbridge *c.* 1938. *Author's collection*

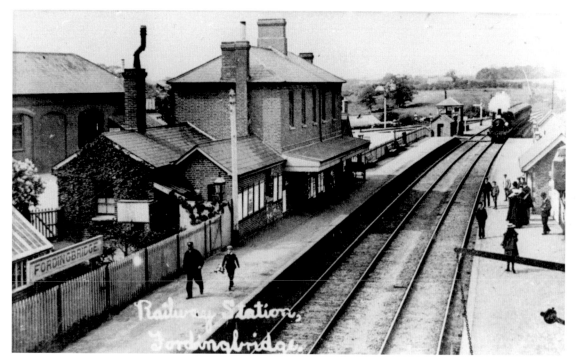

A Dorchester to Salisbury train enters Fordingbridge *c.* 1910. The crooked chimney is worth a glance. *Author's collection*

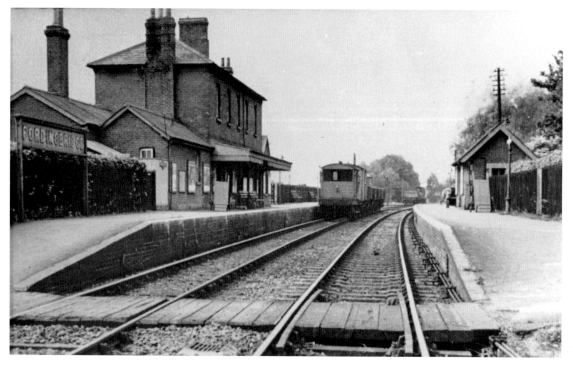

View south from Fordingbridge – A Down goods is shunting. *Lens of Sutton*

The opening day was 20 December 1866 but the new line hardly proved to be a roaring success. The LSWR, which worked the line, was only able to hand over £14 to the Salisbury company in the first six months as its share of the income. However, receipts rose from £4,981 in 1868 to £8,893 in 1875. Unfortunately, the LSWR proved most obstructive and did its best to dissuade passengers travelling over the Salisbury & Dorset Junction Railway. It was certainly in its interest to do so, as it received more income if passengers travelled further via the LSWR's own metals. One ploy was to use uncomfortable 'very old and very small carriages' on branch trains, while another was by the Waterloo booking clerks refusing to issue tickets via that line. As the Salisbury & Dorset failed to show the handsome returns its shareholders were anticipating, they sold it to the LSWR on 31 October 1882. The branch, identified by the 1963 Beeching Report as uneconomic, closed to passengers and goods on 4 May 1964.

Breamore station despatched milk, market garden produce and bricks. In about 1913 Fordingbridge was a busy station with sidings to factories manufacturing such goods as bricks, farinaceous foods, canvas, sailcloth and gunpowder. Grapes, tomatoes and flowers were grown and very large consignments sent off during the season. Burgate Siding, between Fordingbridge and Breamore, was a Second World War development, opened in June 1942; it served the Ministry of Works and Planning Stores. In addition to normal traffic, in the 1950s the branch was used on summer Saturdays by through Bournemouth to Cardiff trains.

TOTTON TO FAWLEY

The nine-mile-long Fawley branch had the rather cumbersome official title of the Totton, Hythe (Hants) & Fawley (Hants) Light Railway. Its original powers were obtained under a Light Railway Order of 10 November 1903, but no start was made before they expired. On 13 August 1906 the LSWR inaugurated a bus service between Totton and Fawley worked by a Thornycroft 24 hp bus, joined the following year by a Thornycroft charabanc with tiered seats. A sad accident occurred to the bus conductor on his first day out, 12 May 1908 — he fell off the rear platform at Dibden and was killed instantly. To raise money for his widow and four children, a penny pamphlet was sold. Due to poor receipts the bus service was withdrawn on 14 November 1908.

In 1920 the AGWI Petroleum Company (Atlantic Gulf West Indies Corporation) planned to open a refinery at Fawley and use rail to despatch 150,000 tons of petroleum products annually. With the support of the LSWR, local landowners, the Admiralty and the Air Ministry, a new Light Railway Order was confirmed on 21 December 1921, the original having long expired. Following the 1923 Amalgamation of Railways, on 27 February 1923 the Southern Railway obtained an Light Railway Order for transfer of powers and also to make route deviations.

The line opened on 20 July 1925. Passenger traffic was sparse — about three trains each way daily — so the light railway restrictions of 10 mph at ungated level crossings caused little hardship. Freight traffic, particularly oil, was the chief reason for the creation of the branch. The siding to Marchwood Military Port opened on 28 November 1943 and required a signal box, so an office at the branch station was converted to this new use. It is now one of the few Network Rail mechanical boxes in the south of England. Between 1949 and 1951 Fawley's new owners, Esso, expanded it to become the largest oil refinery in Europe.

Development of the works of International Synthetic Rubber, Monsanto and Union Carbide in the 1950s saw the opening of the adjacent Hardley Halt on 3 March 1958.

FAWLEY.

Agwi Petroleum Corporation sidings.—Except when specially authorised by the Divisional Superintendent, the Company's engine must not proceed beyond the boundary gate, immediately inside which, wagons to and from the private siding must be exchanged.

There are extensions of the private siding on the Agwi Petroleum Corporation's premises, and in the event of the Company agreeing at any time to allow their engines to work over the extended sidings (in respect of which an instruction will be issued), this working must be confined to the Company's " F " and " J " class engines (Western section).

Ample notice must be given to the Agwi Petroleum Corporation's local Manager, on each occasion, as to when the Company's engine will work over the extended sidings, to enable the firm to provide such attendance or protection at any crossing of a public road or footpath as the Station Master may deem necessary. Movements with the Company's engine over the extended sidings must be accompanied by a competent man appointed by the Station Master.

The Company's engine, when working over the extended sidings, must be equipped with a spark arrester of standard or other approved type.

Extract from SR Working Timetable Appendices 1934.

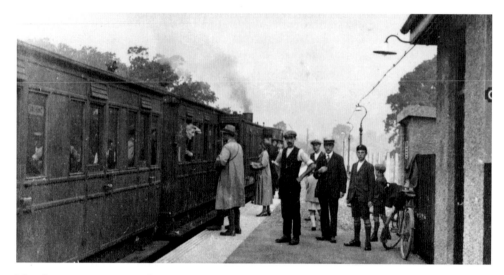

The first passenger train from Fawley arrives at Hythe, 20 July 1926. The buildings are of Exmouth Junction concrete construction. *Lens of Sutton*

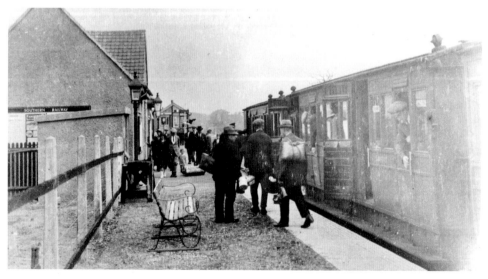

The first passenger train arrives at Fawley, 20 July 1926. All the men have their heads covered. *Author's collection*

Not included in BR timetables, it closed on 5 April 1965, almost a year before the branch passenger service of two trains each way was withdrawn on 14 February 1966. Latterly a total of only twenty-five regular passengers were carried daily. At one time Fawley station handled a considerable quantity of freight for the RAF at Calshot and a large number of parcels.

In the interests of road safety, the open level crossing at Frost Lane south of Hythe, received the then new-fangled lifting barriers on 30 June 1963. From 1962 diesel traction replaced steam and in the late 1960s as many as sixty oil trains left Fawley each week. The daily train to Esso's Birmingham distribution depot at Bromford Bridge was BR's heaviest and longest regular train. It consisted of fifty-four long-wheelbase, 2-axle 35-ton tankers together weighing over 2,000 tons, a pair of class 33 locomotives heading it for the whole trip. In December 1985 the first train of crude oil from Wytch Farm on the Isle of Purbeck was discharged at Fawley. When the Wytch Farm to BP Hamble pipeline opened, this traffic of approximately fifteen trains weekly ceased. In 1986 the Holybourne Terminal of the Humbly Grove oilfield just east of Alton sent three to four trains of crude oil to Fawley for refinery; previously it had come by road.

In the latter days of steam, working on the branch was particularly interesting. In the 1950s an M7 class 0-4-4T arrived at Fawley at 4.40 p.m. with seven coaches; three were detached and drawn to the yard by the afternoon shunting engine. At 5.15 p.m. the remaining four coaches left for Southampton Terminus and after its departure the three coaches were propelled back to the platform to form the 6.43 p.m. Fawley to Eastleigh. On Sundays the 7.30 a.m. arrival left its coaches at Fawley and returned light engine to Eastleigh. A light engine arrived at Fawley at 4.35 p.m. and departed with the coaches at 4.45 p.m.

In January 1960 the massive H16 class 4-6-2T No. 30516 was sent to the branch as the weight of the oil trains was excessive for BR Standard Class 3 2-6-2Ts. For a period of four months until No. 30517 became available, No. 30516 alone had the Monday to Friday duty of piloting a Class 3 2-6-2T on the 6.22 a.m. Eastleigh to Fawley passenger train; working the 8.07 a.m. Fawley to Southampton Terminus passenger; running light engine to Eastleigh for shunting before working the 12.50 p.m. empty tankers to Fawley; shunting at Fawley and returning loaded tankers to Eastleigh. BR Standard Class 4 2-6-4Ts and Z Class 0-8-0Ts also appeared on the branch in the latter years of steam.

In about 1960, an annual schools special started from Fawley, picking up more children at Hythe and Marchwood, for an educational trip to the London area for such delights as Windsor Castle, London Airport and a trip on the Thames. At about the same time, the Esso Social Club ran New Year trips to London for pantomimes and the circus. The number of passengers was so great that two specials, each of about seven coaches, was required, double-headed on the Fawley branch. One assisting engine was a WR 0-6-0PT believed to be running in after an overhaul at Eastleigh. It had appeared on several goods trains on the branch.

In June 2009 the Association of Train Operating Companies' Report 'Connecting Communities' recommended that Totton to Hythe be reopened to passenger traffic and certainly road congestion in the Hythe and Totton areas requires that something should be done. The opportunity to restore services was strongest when the Romsey to Totton diesel service was introduced via Chandler's Ford as this ran on to the Hythe branch connection at Totton to reverse direction. However, when this was altered more recently to run from Salisbury to Romsey via Redbridge and Chandler's Ford and the Totton shuttle ended, the immediate chance for restoration was lost.

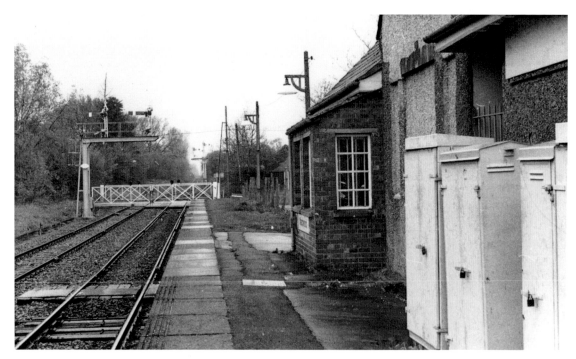

View Up from Marchwood, 2 May 1996. The signal box is in the bay window. Today the signal box remains open working the track circuit block to Eastleigh Panel Box in the Totton direction, while towards Fawley, the branch is worked on a 'No Signalman Token' system with a ground frame at Fawley. *Author*

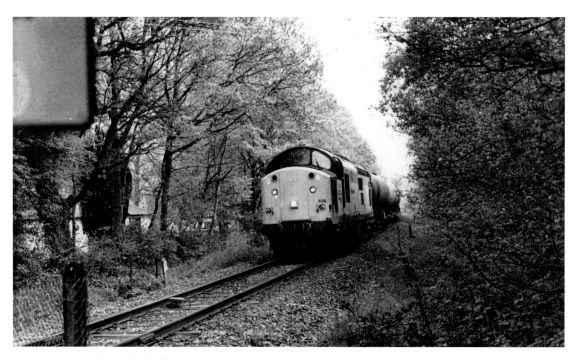

An Up oil train, headed by No. 37709, approaches Veals Lane level crossing south of Marchwood, 24 May 1996. *Author*

An M7 class 0-4-4T and Set No. 812 at Hardley Halt with an Up train, 17 May 1958. *Hugh Davies*

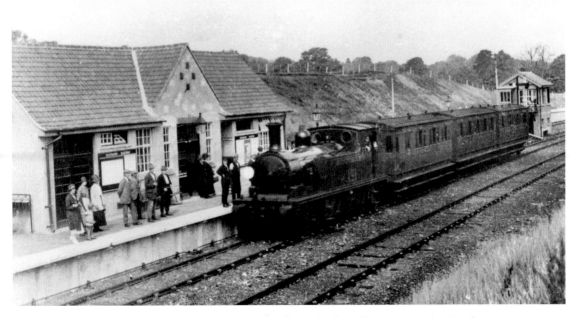

O2 class 0-4-4T No. 191, with a train of three four-wheel coaches, on arrival at Fawley *c.* 1932. *Author's collection*

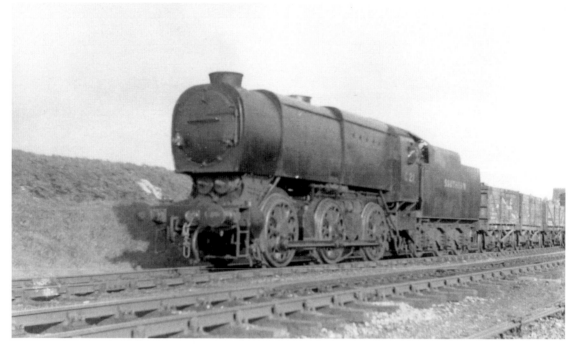

Q1 class 0-6-0 No. C21 at Fawley, May 1948. The prefix led to the class being nicknamed 'Charlies'. *Wessex collection*

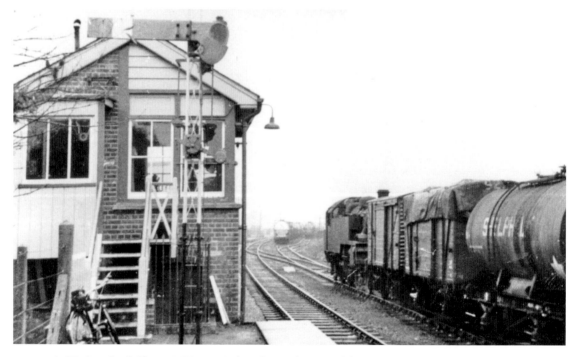

A BR Standard Class 3MT 2-6-2T beside Fawley signal box with Cadlands Sidings in the background. Notice the tarpaulin covering the van in order to keep it watertight. The bicycle probably belongs to the signalman. When the signal is in the 'Off' position, the shield prevents a driver from mistakenly seeing a 'Green for Go' light. *M. E. J. Deane*

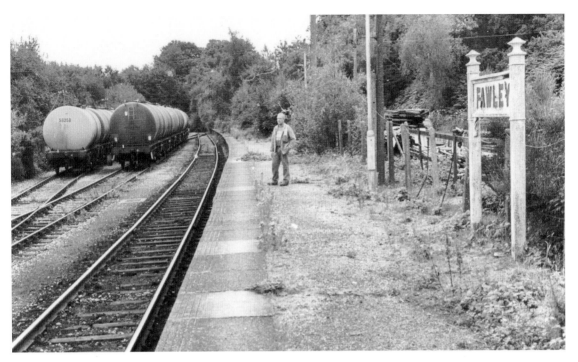

The former passenger platform and cast-concrete name board at Fawley, 16 July 1996. *Author*

A scheme which has been postponed is the Dibden Bay container terminal development. This would have brought heavy container traffic to the Totton end of the Fawley branch. Plans foundered on ecological grounds due to the threat of disruption to birdlife on Southampton Water. The scheme may well be resurrected when there is an upturn in the economy and port capacity again becomes an issue.

THE MARCHWOOD MILITARY RAILWAYS

During the Second World War the War Office needed to find a suitable base for fabricating part of the Mulberry Harbour, which in Churchill's phrase 'Must rise and fall with the tide'. A patch of reclaimed ground at Marchwood directly opposite the port of Southampton and adjacent to the Fawley branch was selected. The facilities included a four-berth jetty, storage sheds, workshops and camps, all built in a very short period by Royal Engineers construction units in June 1943. The associated Marchwood Military Railways became operational on 28 November 1943 and its 22 miles of 75 lb/yd flatbottom track served the Mulberry operation, stores depot and main jetty. A particularly interesting feature was the production line for the Whale units associated with the Mulberry Harbour. These were fabricated on rail and taken to the final assembly track by a traverser which fed ten tracks to the warping jetty where the units were floated to the final assembly point, there to be drawn by tugs. The traverser pit still exists.

From about 1948 Marchwood became the No. 1 Port & Inland Water Transport & Repair Depot run by another branch of the Royal Engineers. Since 1977 the Marchwood Military Railways has been run by civilians. The locomotives utilised

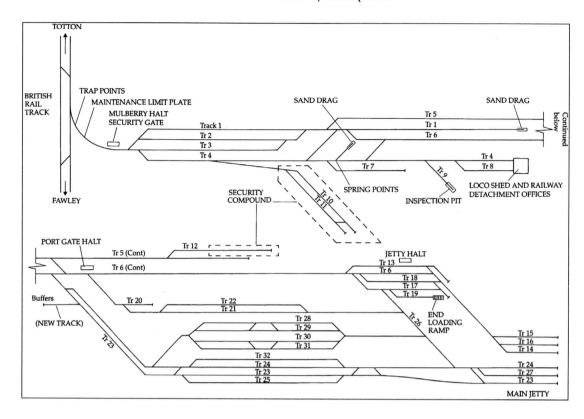

were standard War Department steam or diesel types supplied by the Longmoor Military Railway until that line's closure in 1969. At present the stock consists of five spark-arrested Thomas Hill Vanguards:

Ministry of Defence No.
01522
01527
01541
01544
01549

At one time the locomotives carried names, but these were removed when the system required locomotives to be fully interchangeable between depots.

Today the railway is open twenty-four hours a day and literally every day of the year. Most Army equipment just passes through *en route* to or from shipping as today there are minimal storage facilities at Marchwood. The original 30 miles of track have now diminished to about seven miles. There is now approximately one train daily from the main line. Inside the gate there are four exchange sidings, each holding a normal length train. A passenger train consisting of an ex-Gatwick Express 2-coach set runs morning, noon and evening between the married quarters and the jetty area.

The Marchwood Military Railways notice and badge of the Royal Logistical Corps, 2 May 1996. *Author*

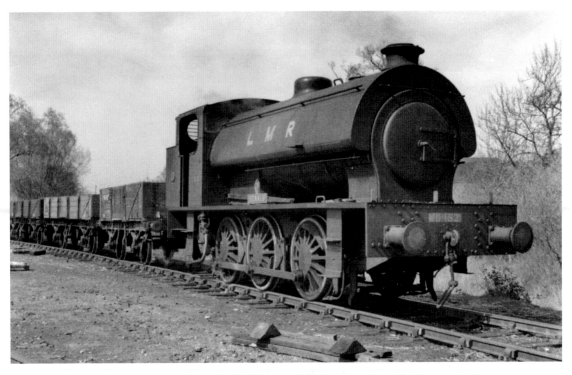

Robert Stephenson & Hawthorn-built WD 0-6-0ST No. 152, originally No. 75189 *Rennes*, on the Marchwood Military Railways, 25 April 1955. *M. H. Walshaw*

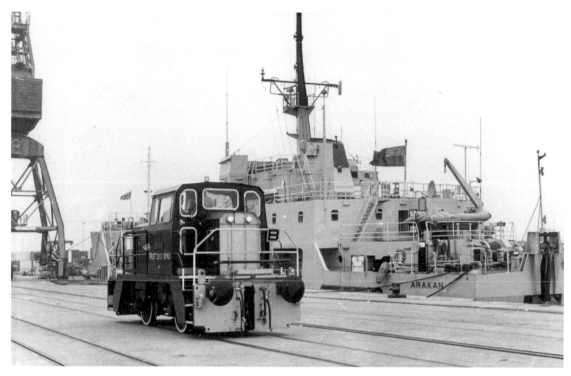

MOD No. 263 *McMullen* and HMS *Arakan* beside Marchwood jetty, 2 May 1996. *Author*

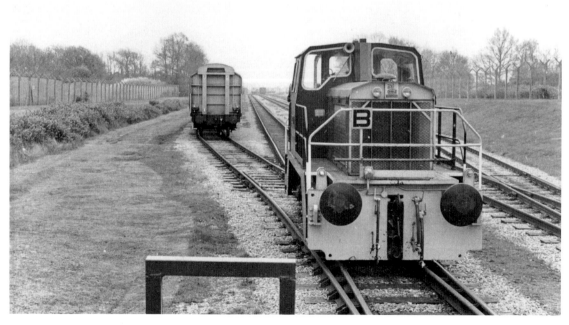

MOD No. 213 *McMullen* near Mulberry Halt, 2 May 1996. The exchange sidings can be seen. *Author*

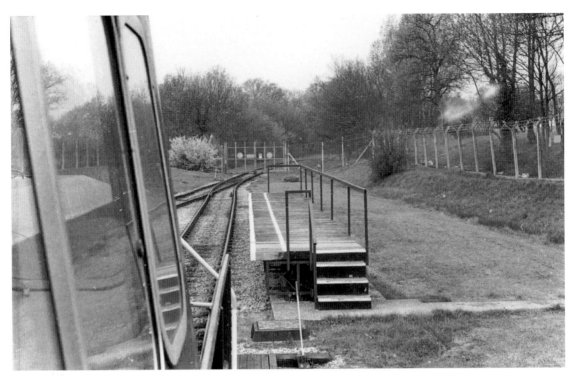

View of the gate at Mulberry Halt, 2 May 1996. *Author*

MMR passenger coach, an ex-EMU motor brake second. The beam to which the electric pick-up shoe was attached has not been removed. *Author*

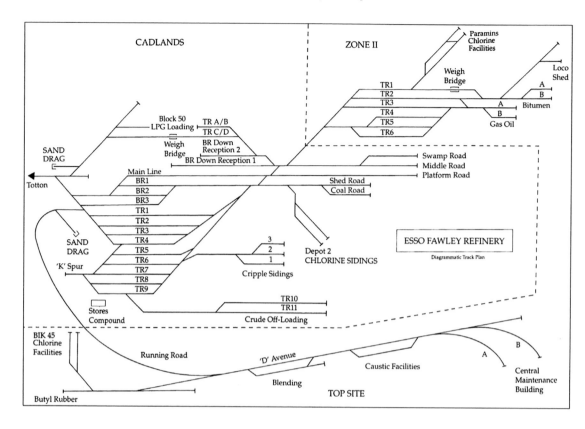

THE RAILWAY AT THE ESSO FAWLEY REFINERY

In 1920 the AGWI Petroleum Company laid a 2 foot gauge line from Ashlett Creek on Southampton Water to the refinery site, initially for conveying construction material and later for internal transport. This narrow gauge line, at first steam-worked but petrol-mechanical from 1927, had ceased operation by November 1961. The refinery came into production on 18 June 1921 and from the opening of the Fawley branch on 20 July 1925 rail transport was used. This refinery was south-east of Fawley station and between 1949 and 1951 a new refinery was built west of the BR station and this was only served by the standard gauge. Fawley now has the second largest refinery in Europe.

Construction workers were taken up to its site on a hill by a General Electric 0-4-4-0 diesel-electric which hauled two coaches to a special platform. The locomotive was first owned by Foster Wheeler, the site's main contractor. When this refinery was completed, caustic, lubricating oil and chlorine were taken down the gradient of approximately 1 in 40 and returning empties always had an ex-LMS brake van (built Derby 1945, lot No. 1387) on the rear to guard against breakaways.

The line has always used internal-combustion engined locomotives and never operated steam. Today there are two Hunslet 0-6-0 diesel-hydraulic locomotives with brass nameplates carrying a reproduction of the appropriate bird, the whole engine being painted in the appropriate colour.

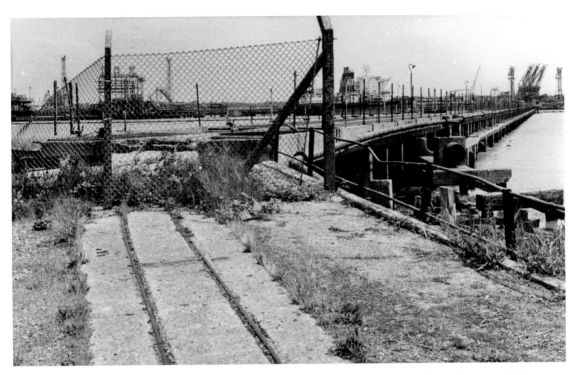

The remains of the former 1 ft 11½ in gauge AGWI railway at Esso's Fawley Refinery, 16 July 1996, looking towards the jetty. *Author*

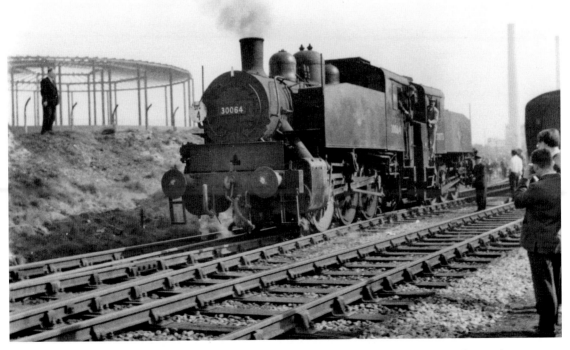

USA 0-6-0Ts No. 30073 and 30064 running round at Fawley, having arrived with a Railway Correspondence & Travel Society special, 20 March 1966. *John Bamsey*

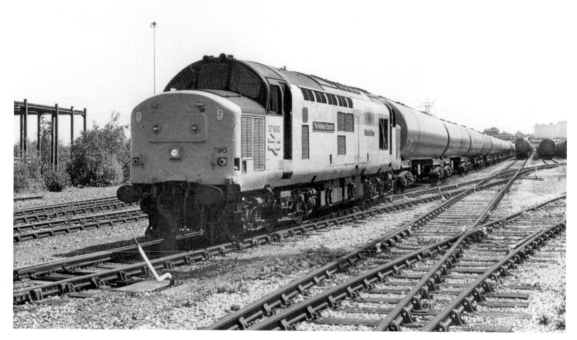

No. 37890 *The Railway Observer* leaves Fawley with the 13.34 to Eastleigh and Tavistock Junction, 16 July 1996. *Author*

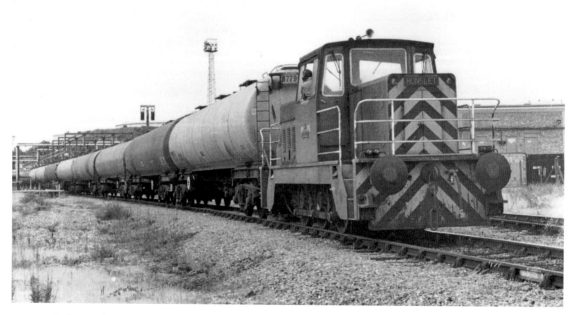

Redwing shunting on-shore crude tankers, 16 July 1996. *Author*

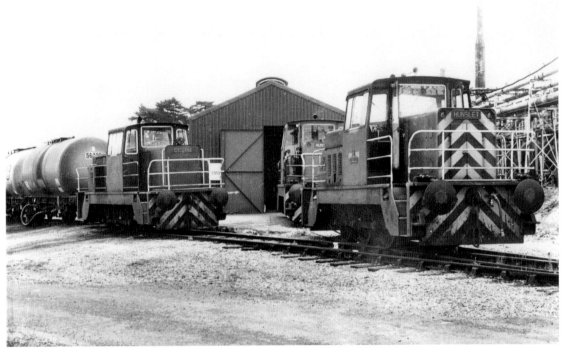

Greenfinch, *Bluebird* and *Redwing* outside the engine shed, Fawley, 16 July 1996. *Author*

David Blay, 16 July 1996, holding a pinch bar used to move a wagon by hand. *Author*

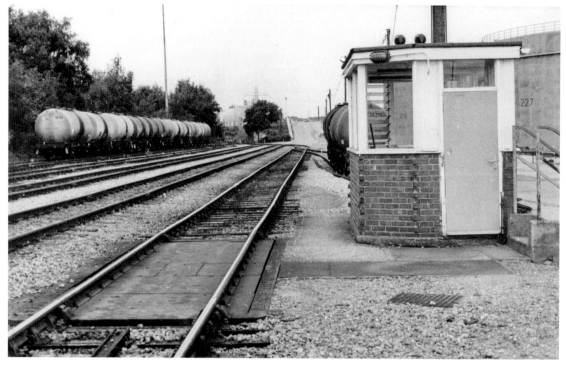

The weighbridge and weigh house, view Up, 16 July 1996. *Author*

The 'Beetle' wagon mover in its ambush pit, 16 July 1996. Its track gauge is 3 ft 3½ in. *Author*

Name	Works No.	Building Date
Bluebird	8998	1981
Redwing	8999	1981

Both locomotives were sold back to Hunslet Holdings in March 2006 and have been re-fitted, the work on *Redwing* being carried out in 2006-7 and *Bluebird* 2007-8. *Greenfinch*, works No. 7542 and built in 1978, last ran on 28 February 1997 and is now cannibalized for spares.

Engines are maintained in a single road shed just long enough to hold one locomotive. On at least one occasion BR Eastleigh works has carried out heavy maintenance, the engine travelling by road. An Esso engine driver has ear defenders, microphone and speaker. At its maximum Cadlands Yard had three reception sidings and sixteen other sidings. The latter have now been reduced to nine.

A 'Beetle' puller, introduced in about 1967 could lock onto wagon wheels and draw a maximum of eight 90-tonne bogie cars, or sixteen 4-wheel cars, through the LPG (liquid petroleum gas) loading bay. The 'Beetle' puller was drawn by an electric winch along a 3 foot 3½ inch gauge track set between standard gauge rails.

Today the derelict passenger platform is still extant together with nameboards. In the early 1970s rail use by Esso slumped, but revived in 1978-9 when twelve trains departed on Mondays. Between 1975 and 1982 there was a revival in rail traffic with trains to such destinations as: Acton, Bedworth, Cardiff, Clydach, Drakelow, Gatwick, Langley, Longport, Nottingham, Plymouth, Polmadie, Purfleet, Scunthorpe, Spondon, Tiverton Junction and Waddon Marsh. Today crude oil arrives from Holybourne approximately twice-weekly. The last LPG train left in October 1997 and the last bitumen train in June 2009. Today approximately 110 class A wagons are used to convey traction fuel to First Great Western depots at Bristol St Philip's; Plymouth Laira and Penzance and to Arriva Trains at Cardiff Canton and Freightliner Ipswich. Movements total about eight weekly – a far cry from the late 1970s which saw 36 daily movements. The railway facilities at Fawley are not visible from a public road.

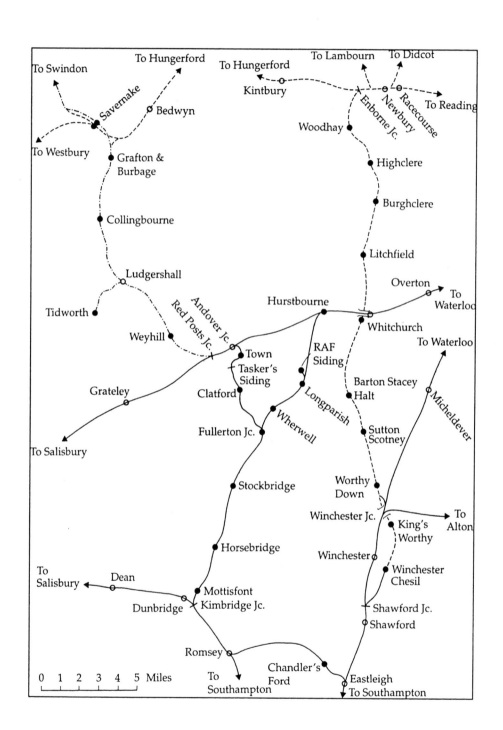

The Andover Area

ANDOVER TO LUDGERSHALL

The line from Red Posts Junction just west of Andover to Ludgershall ran through Hampshire until a mile south of Ludgershall. It was built by the Swindon, Marlborough and Andover Railway which received its Act on 21 July 1873. Although the northern half of the line opened on 27 July 1881, a serious shortage of capital meant that the Grafton to Andover section was not ready until 1 May 1882, when its opening shortened the rail distance from Andover to Swindon by 40 miles. The line eventually became part of the Midland & South Western Junction Railway and reached Cheltenham on 1 August 1891, from which date through trains were run from Southampton to the Midlands.

The MSWJR proved invaluable in the First World War carrying war supplies from the North and Midlands to the Channel ports; transporting troops from the various camps in the area; and, sadly, carrying wounded soldiers from Southampton in hospital trains. Old people recalling the war still say, 'Them trains never stopped' and certainly throughout the hostilities an average of four troop trains and one ambulance train ran daily. Drivers were sometimes so busy that they did not see their families for a fortnight, occasionally having to work twenty-four hours without rest. Traffic was so heavy that additional locomotives had to be borrowed from the Great Western, London & South Western and Midland Railways. Coaches, too, came from far afield; on one occasion the sidings at Ludgershall held carriages from the Great Central, Great Western, Highland, London & North Western, London & South Western, Midland, North Eastern and North British Railways.

Milk traffic was very important and each evening between 9 and 10 p.m. an MSWJR train arrived at Andover with seventeen loaded vans. From there an LSWR engine and guard were ready to take them onwards to Clapham Junction and Waterloo, the MSWJR crew returning from Andover with the empties. During the First World War American soldiers occasionally rode in the milk vans, some of which were old six-wheel passenger coaches still with their original passenger doors. For many years after, MSWJR men remembered their terror at seeing moving bodies in the darkness where no one was expected.

During the Second World War the line developed as a vital artery again, but with the development of road transport in the 1950s it became very uneconomic. Passenger services over the whole line ceased on 11 September 1961, when much of the line closed, including Savernake to Ludgershall, but Ludgershall to Red Posts Junction remains open on an 'as required' basis to serve the Army depot at Ludgershall.

Swindon, Marlborough & Andover Railway locomotives were of the 0-6-0T, 2-4-0T and 0-4-4T wheel arrangement, the latter being a Fairlie design. Although at a cursory glance it appeared a normal engine, closer inspection revealed that the driving wheels were not fixed to the frames but were on a bogie, thus allowing it to negotiate curves more easily. Built in 1878, it was one of the first in the country to be fitted with Walschaert's valve gear and one of the earliest tank engines to have a water tank under the coal bunker in addition to side tanks. It had a coal consumption of 45-50 lb a mile

— twice that of many engines — and was only used if no other was available. One of the 2-4-0Ts, No. 6, was sold to the Isle of Wight Central Railway in 1906, becoming that company's No. 7 and in due course, SR No. W7.

The Midland & South Western Junction Railway added tender engines to its stock — 2-4-0s, 4-4-0s, 0-6-0s and 2-6-0s — and when the first of the latter was purchased, it was the only engine of that wheel arrangement in the country. They also purchased two 4-4-4Ts and an 0-4-4T.

SMAR and MSWJR engines were painted red, but MSWJR goods engines wore green livery. During the First World War many of the engines were painted black.

When the GWR absorbed the company in 1923 it Great Westernised some of the MSWJR engines and gradually GWR engines such as 'Duke' class 4-4-0s and 45XX class 2-6-2Ts appeared, followed by 43XX 2-6-0s and 'Manor' class 4-6-0s. In the last few years before the line closed, SR 'N' and 'U' class 2-6-0s worked through from Southampton Terminus to Cheltenham.

LUDGERSHALL TO TIDWORTH

When James Purkess, the MSWJR's general manager, learned about a new military camp being erected at Tidworth, he arranged with the War Department for a railway to be built to it from his company's line at Ludgershall. Constructed on War Department land and therefore not requiring an Act of Parliament, most of the branch was situated in Wiltshire. The line opened for military manoeuvre traffic on 8 July 1901. At first for War Department use only, public goods began to be carried from 1 July 1902 and public passengers from 1 October in the same year.

The branch certainly justified its existence. In 1922 the garrison accommodated about 8,000 troops, while up to 100,000 were quartered in summer camps in the surrounding district. The seven sidings in the yard held 290 wagons, or 10 trains of 12 coaches each. On days when the Tidworth Tattoo was held it was particularly hectic, trains arriving from the GWR, SR and LMS systems and having to be stabled most carefully to enable them to leave in the correct order. Receipts at Tidworth, the only MSWJR station lit by electricity, were the greatest on the system and the station was in charge of the railway's highest-ranking station-master. A curiosity was that when buying a ticket at Tidworth, the passenger stood in Hampshire and the booking clerk in Wiltshire! Much of the camp was in Hampshire and had its own standard gauge railway system worked by a variety of tank engines including *Molly*, a vertical-boilered four-wheeled Sentinel. The camp line closed in 1953.

The only Sunday train on the Tidworth branch ran from Ludgershall to Tidworth for the benefit of servicemen returning from leave. The front portion of the Andover to Swindon train worked this, the remainder being left standing at Ludgershall until the engine returned from Tidworth to take it forward. In winter, vociferous complaints were often made that the Swindon portion grew very cold while waiting engineless, and therefore heatless, for thirty minutes. Public services were withdrawn from the branch on 19 September 1955.

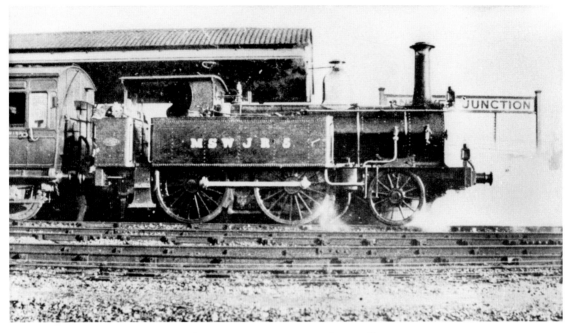

MSWJR 2-4-0T No. 5 at Andover Junction *c.* 1905. *Author's collection*

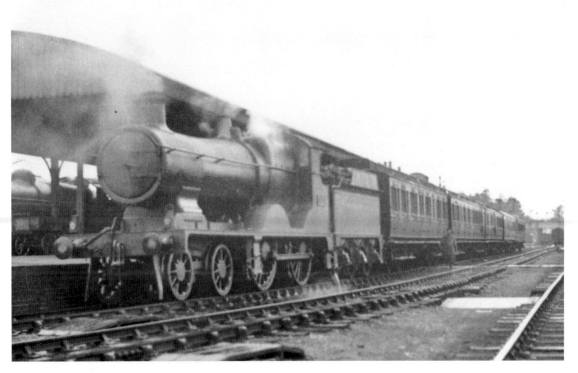

GWR 4-4-0 No. 1120 (ex-MSWJR No. 20) seen here at Andover Junction on 4 July 1931 heading an express to Cheltenham, having been 'Great Westernised'. *Author's collection*

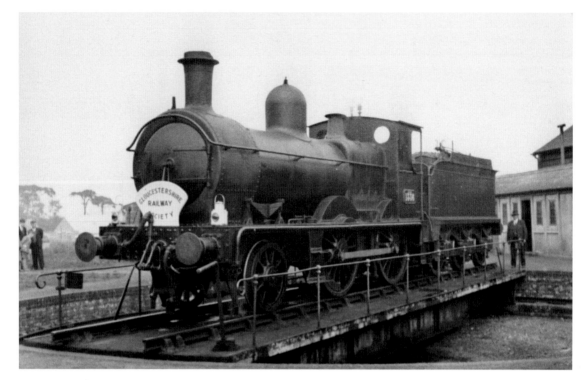

GWR 2-4-0 No. 1336 (ex-MSWJR No. 12) at Andover Junction, being turned, after arriving with a Gloucestershire Railway Society special, 9 May 1953. *Author's collection*

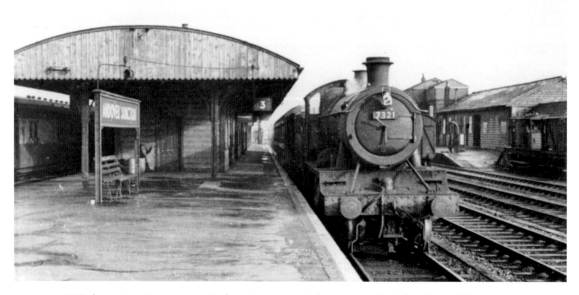

43XX class 2-6-0 No. 7321, at Andover Junction, with a train to Swindon. *Lens of Sutton*

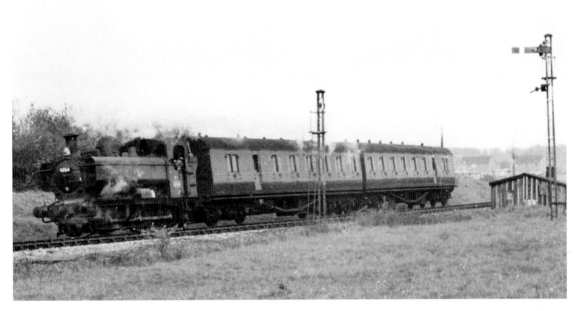

8750 class 0-6-0PT No. 9754 at Red Posts Junction, with the 2.50 pm Andover Junction to Swindon Junction, 17 April 1961. From 1919 the junction at Red Posts was not physical, but the MSWJR ran parallel beside the LSWR's Up line to Andover Junction station. *Author*

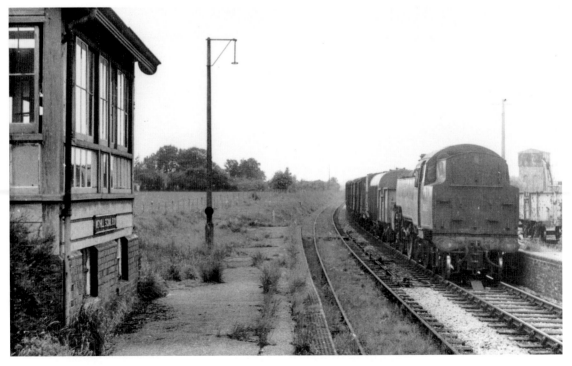

BR Standard Class 4MT 2-6-4T No. 80065 at Weyhill, 1965. *Paul Strong*

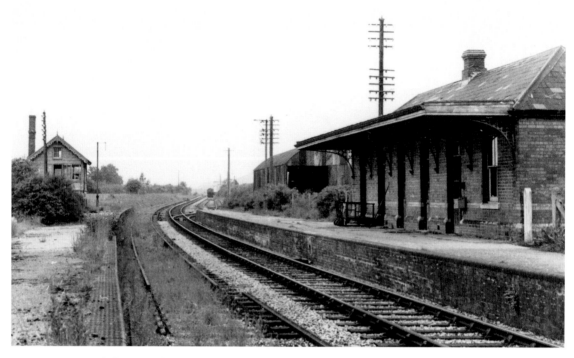

View North from Weyhill, 1965, after track singling. *Paul Strong*

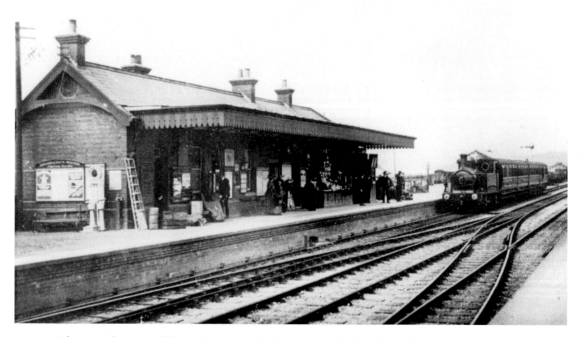

A four-coach train at Tidworth *c.* 1913. Notice the burnished buffers of the 0-6-0T. The engine shed, whose roof can be seen to the right of the last coach, was removed to another position in 1915 to make room for increased siding accommodation. *Author's collection*

WOODHAY TO WINCHESTER

The Didcot, Newbury & Southampton Railway paralleled, and was similar to, the MSWJR, inasmuch that its object was to provide a link between Southampton and the Midlands. Its Act was passed on 5 August 1873 and the Didcot to Newbury section opened to the public on 13 April 1882. The Newbury to Winchester portion was completed three years later and the opening set for 24 March 1885, but owing to the GWR being unable to find sufficient staff of the right calibre it was postponed, the formal opening not taking place until 1 May, public services starting three days later. The line was single track, though bridges and earthworks were built wide enough for double line. Unlike other DNSR stations, which were in cottage style with a small gable over each upstairs window, the station at Winchester was of typical GWR design and for various reasons was not fully completed until 1892. Named Winchester (Cheesehill), the LSWR spelt it 'Cheesill', and BR finally conformed with local pronunciation and called it 'Chesil' in 1950.

LSWR engines drew trains from Southampton to Winchester (Cheesehill) where GWR locomotives took over for the journey over the DNSR. On a long goods train, engine changing had to carried out in the semi-darkness of the tunnel.

In 1922, immediately before the absorption of the DNSR by the GWR, a new signal-box was built at Winchester with an electric power lever frame — a startling innovation at a time when most British signal boxes had a manual frame. Moisture penetrated the circuits and mechanical working had to be restored in 1933.

The DNSR proved a vital lifeline in both world wars — in fact the fate of the country may have depended on it. During the First World War it was especially important. The public passenger service was entirely suspended from 6-22 August 1914, while a shuttle service of troop trains ran continuously day and night to Southampton Docks. North of Winchester three large camps were built at Avington Park, Winnall Down and Morn Hill, with access provided by a special three-mile-long branch built by the War Department and opened on 20 October 1918. It remained in use until the camps closed in November 1920.

During the Second World War, on 4 August 1942 all passenger and day-goods trains were suspended for eight months while the DNSR was doubled, but not in Hampshire where all the crossing loops were extended to 700 yards. This meant that the distance of one set of points was too far from the signal box for mechanical operation so a hand generator was installed to power the electrically worked points at the far end. Passenger services were restored on 8 March 1943. It is said that 16,000 military trains ran over the DNSR to Southampton in the twelve months before the Normandy landings in June 1944. Without the DNSR D-Day might have been impossible.

After the war one interesting engine which worked over the line was No. 3717 *City of Truro* (which also ran as No. 3440, seen on page 59) of 102 mph fame and brought out of York Railway Museum in 1957. Shedded at Didcot, she worked trains to Southampton Terminus when not pulling special trains for railway enthusiasts.

Passenger services over the line were withdrawn on 10 September 1962. Freight from Southampton Docks to the Midlands, and heavy oil trains from Fawley Refinery, the latter often hauled by a BR Class 9 2-10-0, continued to run until 10 August 1964. Ex-LMS 'Jubilee' and 'Black Five' class 4-6-0s were reported to have hauled this train on occasions. The goods yard at Winchester stayed open until 4 April 1966 and the track was lifted in 1967.

A unique girder bridge carried the A34 over the line just north of Highclere station and is believed to have been bought second-hand from Belgium. It replaced a 130 foot long tunnel which collapsed before the line opened. The 7-ton weight limit over

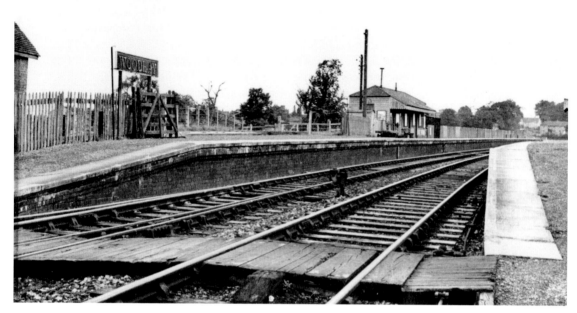

View Up from Woodhay, *c.* 1960. *Lens of Sutton*

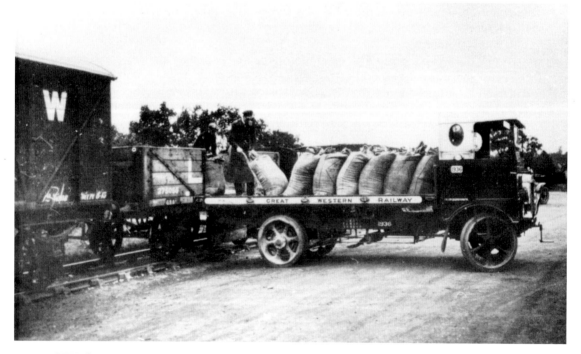

GWR lorry No. 1936, an Associated Daimler, at Woodhay 24 September 1929. *Author's collection*

the bridge was frequently ignored and to strengthen the structure, in order to allow Army tanks to use it, sturdy timber supports were added. The cost of £2,240 was paid by the Ministry of War Transport.

Highclere Station was blessed with particularly pleasant spring water and on hot summer days locomotive crews, while waiting in the loop to cross another train, used it for a cool drink. This was in contrast to Burghclere station's water supply which had to be brought from Winchester in water tank wagons and then emptied into a sump. From here it was hand-pumped into a storage tank on the main station building.

It was not unknown for parcels destined for Lichfield, Staffordshire, to arrive at Litchfield, but it is unlikely that passengers would be so deceived, and the porter's cry of 'Litchfield Aunts' seemed superfluous. Cattle traffic at Whitchurch could be so considerable that twenty-five wagons were despatched at a time. A platform and siding opened at Worthy Down in October 1917 to serve a nearby Royal Flying Corps depot. This platform came into public use on 1 April 1918. During the Second World War a special late evening train carried sailors, (they had taken over the camp), from Winchester to Worthy Down

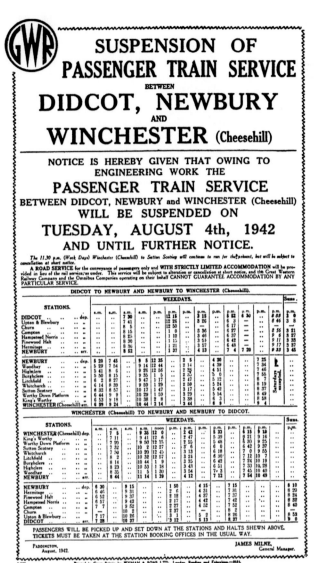

Notice of suspension of the passenger service between Didcot, Newbury and Winchester.

and Naval officers were on board to quell boisterous revellers. They also ensured that any vomit was cleaned up and, if there was insufficient time at Worthy Down, sailors completed the task as the train returned empty coaching stock to Winchester leaving them a walk of four miles back to camp.

Winchester had a single road brick and stone engine shed long enough to stable two tank engines. The 42-foot diameter turntable had its capacity increased in 1934 by the provision of detachable extension bars, heavy to move into place. When the extension was in use engines had to be balanced on the turntable most carefully. A new vacuum-operated 65-foot turntable was brought into use on 29 September 1947 at a cost of about £15,000, but unfortunately the shed closed on 8 June 1953!

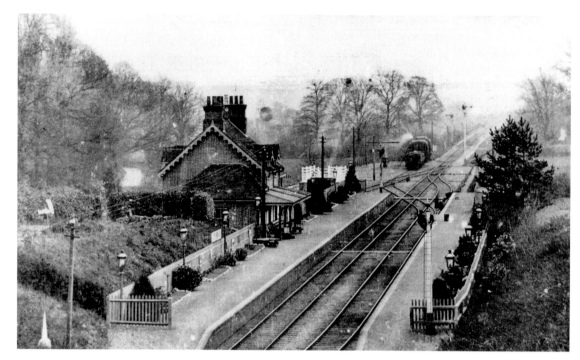

View Down Highclere station *c.* 1901. The crossing loop was extended in 1910. *Author's collection*

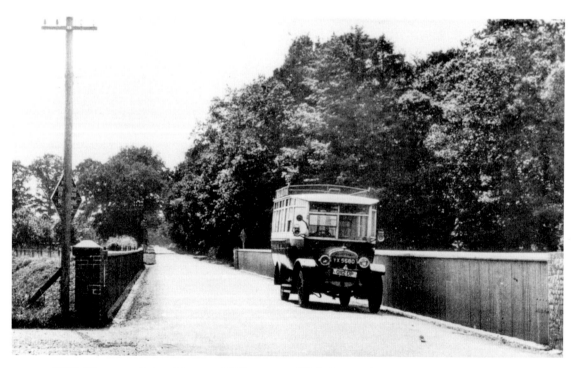

GWR Thornycroft bus No. 1468 YX 6580 at Highclere, 5 August 1932. It carries 0112 DP trade plates. It is believed that the bus had ceased to be used by the GWR at this date. *Author's collection*

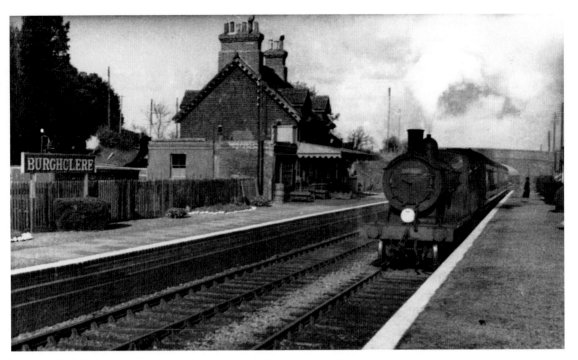

SR T9 class 4-4-0 No. 30300 at Burghclere, 4 February 1953, with a Down train. SR engines did not work regularly over this line until 8 June 1953. The station's water tank can be seen above and to the left of the platform canopy. *Lens of Sutton*

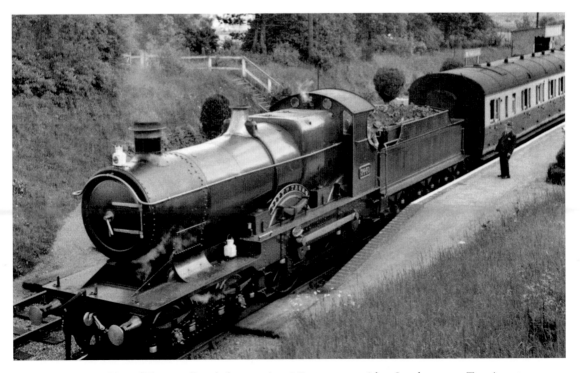

No. 3440 *City of Truro* at Burghclere station 8 June 1957, with a Southampton Terminus to Didcot train. *Hugh Davies*

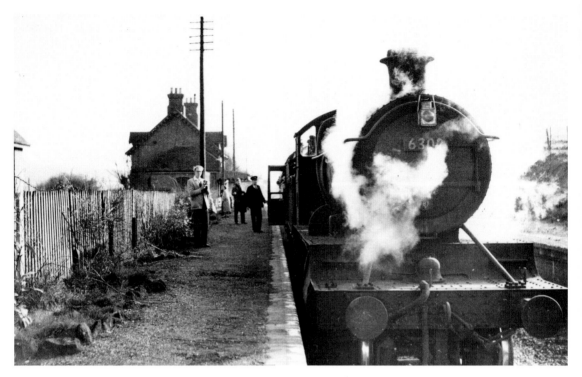

43XX class 2-6-0 No. 6302 at Litchfield with a Southampton Terminus to Newbury train on 5 March 1960, the last day of passenger trains on the line. The engine is still in original condition with inside steam pipes. *Author's collection*

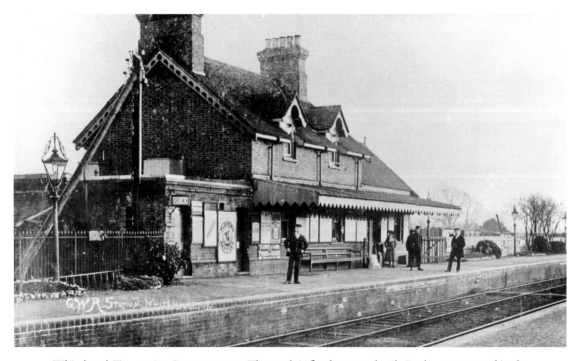

Whitchurch Town, view Down *c.* 1905. The track is flat-bottomed rail. Coal wagons stand in the sidings to the right. *Author's collection*

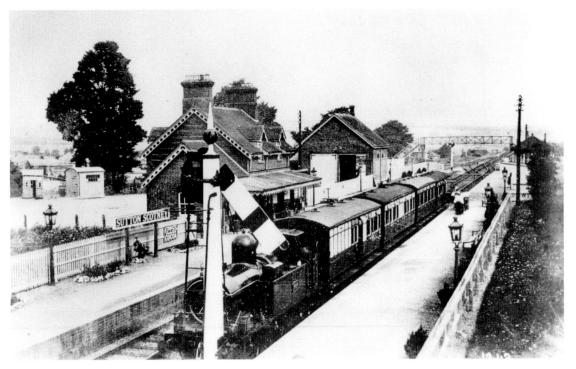

517 class 0-4-2T No. 1484 heading an Up train at Sutton Scotney, *c.* 1910. *Author's collection*

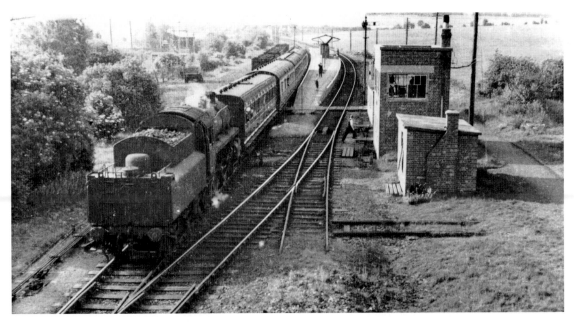

A BR Standard engine at Worthy Down. Perhaps the engine is propelling the coaches into the platform. There are no head or tail lamps on the tender. Notice the length of line on the photographer's side of the permanent way hut, used for storing the permanent way trolley. *Author's collection*

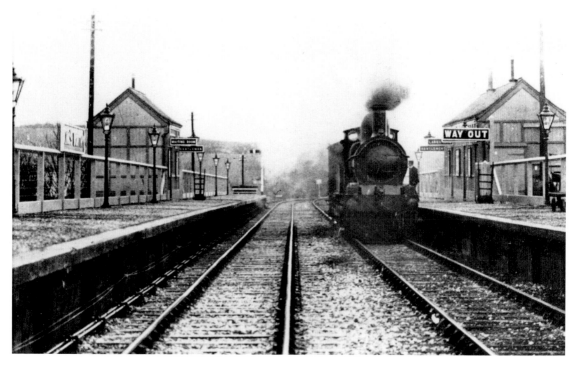

King's Worthy, probably on the opening day, 1 February 1909. *Author's collection*

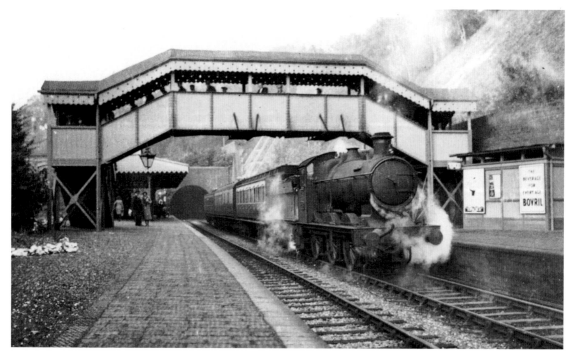

A 2251 class 0-6-0 enters Winchester Chesil *c.* 1938, with a Didcot to Southampton Terminus train. The Bovril advertisement reads 'The beverage for every age'. *Lens of Sutton*

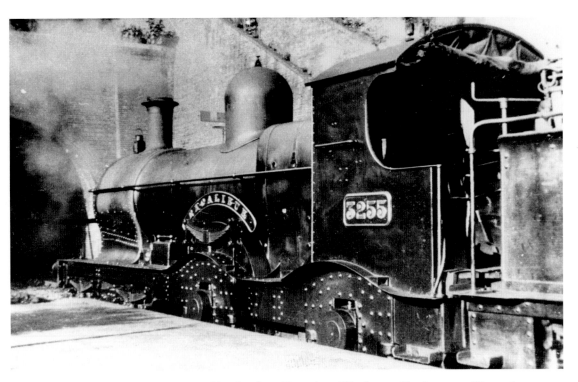

Duke class 4-4-0 No. 3255 *Excalibur* heads an Up train at Winchester Chesil *c.* 1930. The engine was withdrawn in June 1936. *Author's collection*

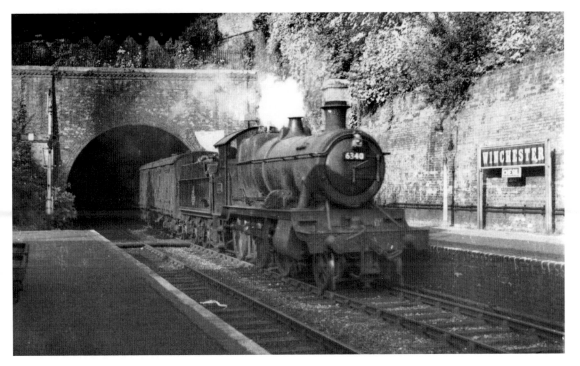

43XX class 2-6-0 No. 6340 emerges into Winchester Chesil station with a Down stopping passenger train. *Author's collection*

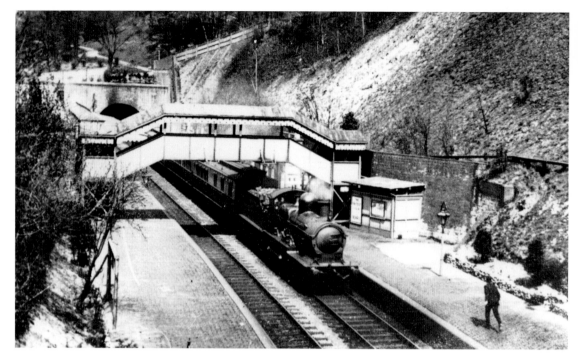

A Didcot to Southampton Terminus train enters Winchester Chesil *c.* 1930, headed by a Duke class 4-4-0. *Author's collection*

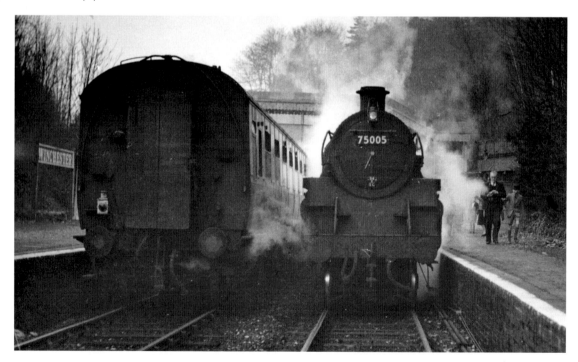

BR Standard class 4MT 4-6-0 No. 75005 (84E, Tyseley) enters Winchester Chesil, 5 March 1960, with the penultimate Down train, while the last train to Newbury stands on the left. The nameboard, left, simply reads 'Winchester'. Despite impending closure, the platform edges are neatly whitened. *Author's collection*

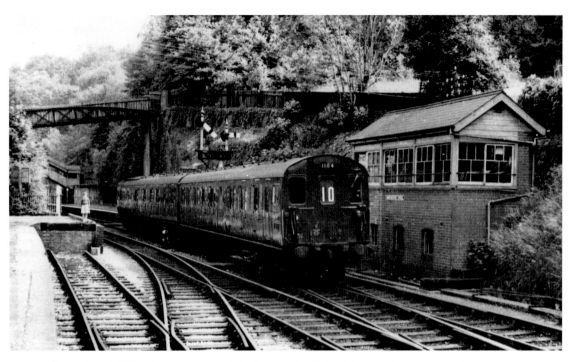

Hampshire DEMU No. 1104 passes Winchester Chesil signal box with a Down working *c.* 1962. *Author's collection*

ANDOVER TO KIMBRIDGE JUNCTION — THE 'SPRAT & WINKLE' LINE

On 12 July 1858 the Andover & Redbridge Railway was granted an Act for building a line between these two towns. Lord Palmerston turned the first sod at Ashfield Bridge near his home, Broadlands, Romsey, on 20 September 1859. As the railway would take its trade, the Andover Canal was purchased for £25,000, half this sum being in railway shares. Richard Hattersley, the contractor appointed by the railway, proved rather a rogue and instead of immediately draining the canal so that the mud would harden, waited until he was nearly ready to build the railway on its site and then charged the cost of removing the sticky mud. Eventually Hattersley was dismissed in May 1861 for poor work. He had been aided and abetted by John S. Burke, the company's engineer, who resigned a couple of months later. Henry Jackson & Co. replaced Hattersley, but eventually all work on the line ceased. Rowland Brotherhood enthusiastically started work on the line nine months later, but suddenly stopped in July. In December the financial situation was eased when the LSWR took over the company.

Hopes of opening in 1864 were dashed when the Board of Trade insisted that the rails should be of a heavier section than it had originally agreed to. Eventually the line was completed to the required standard and the directors made a trip on 4 March 1865, the single track 'Sprat and Winkle' being opened to the public two days later.

The first train was hardly a sell-out, in fact it arrived at Andover at 8.30 a.m. with only five passengers aboard. One of these was Mr Footner who had been sufficiently enthusiastic to walk to Clatford in order to ride back on the first train. There were

The Andover & Redbridge Railway
Company's seal.

four trains daily to and from Southampton. The solitary Sunday train started from
and returned to Southampton, which meant that Andover residents could not use the
line out and back that day. Because the line followed the course of the former canal,
its curves were tortuous but necessary in order to avoid the expense of crossing the
River Test too frequently. Gradients were easy except between Andover Junction and
Andover Town where the steepest incline was 1 in 62.

Branch finances were given a boost by the opening of the Swindon, Marlborough &
Andover Railway on 1 May 1882, this company running through trains from Swindon
to Southampton. In fact traffic grew to such an extent that between January 1883 and
November 1885 the Andover to Kimbridge Junction line was doubled.

It was not unknown for country boys to approach a goods train halted at a signal,
quietly uncouple the brake van and then enjoy the guard's fury when the rest of the
train departed without it.

During both world wars the line, coupled with the MSWJR, became a vital artery
with troops and supplies moving southwards and wounded soldiers northwards.

In March 1928 the branch was used by one of the first internal-combustion engined
railcars in the country. Built by Drewry in 1928, it had a 50 hp engine and seated
twenty-six passengers. It was later sold by the SR to the Weston, Clevedon & Portishead
Light Railway where it finished its days.

Passenger services on the Andover to Kimbridge Junction line improved in 1957
with the introduction of an hourly service of DEMUs. However, operation became
uneconomic and passenger trains were withdrawn on 7 September 1964 and the line
closed completely on this date between Andover Town and Kimbridge Junction. Andover
Town itself remained open for goods traffic, but closed on 18 September 1967.

South of Andover Town, Tasker's Siding at Clatford served the firm of agricultural
engineers and implement makers and in August 1933 became Upper Clatford Public
Siding. At Leckford, which had no station and is situated north of Stockbridge, in 1886
every weekday a small black dog collected a newspaper in a wrapper thrown out by
the guard of the 12.56 p.m. from Andover and carried it to his master in the village.

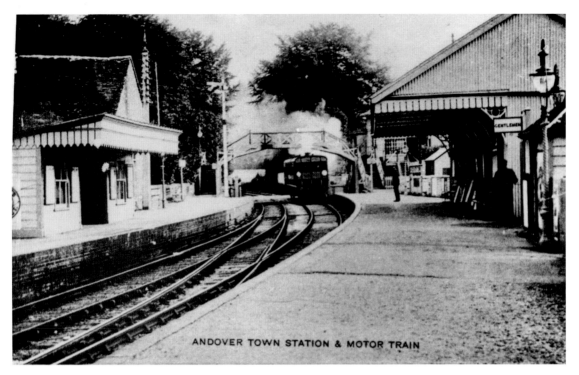

H13 class railcar No. 12 enters Andover Town *c.* 1908, with a working to Southampton Terminus. *Author's collection*

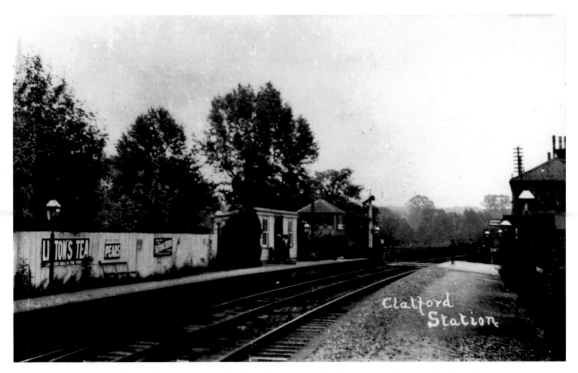

View Down Clatford, *c.* 1910. Notice the absence of platform canopies. *Author's collection*

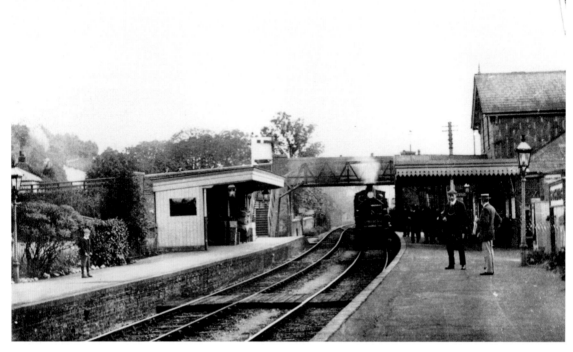

An Up train enters Stockbridge *c.* 1910. Notice the white sighting board behind the home signal. The footbridge is constructed of timber. *Author's collection*

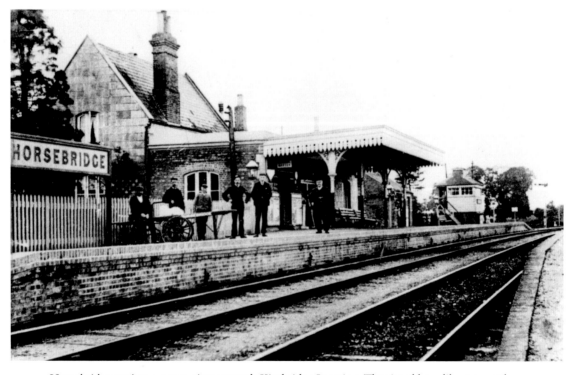

Horsebridge station *c.* 1910, view towards Kimbridge Junction. The signal box, like many others on the LSWR, has relatively small windows. *Author's collection*

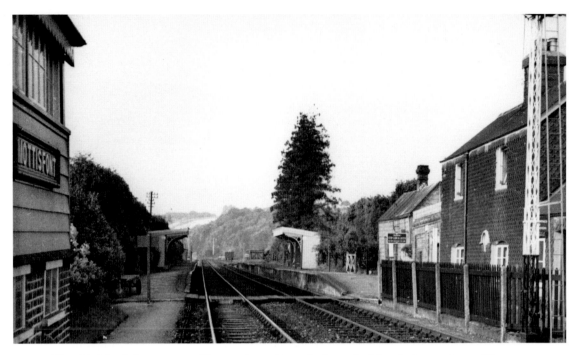

View Up Mottisfont, *c.* 1960. The goods yard is at the far end of the platforms. *Lens of Sutton*

HURSTBOURNE TO FULLERTON JUNCTION — THE LONGPARISH LOOP

To counter the threat of the Didcot, Newbury & Southampton Railway line reaching Southampton, the LSWR submitted a bill for a cut off between Hurstbourne, on the main Basingstoke to Andover line, and Fullerton on the 'Sprat & Winkle'. The LSWR hoped that the DNSR would use this line between Whitchurch and Southampton rather than extending its own line southwards. The LSWR-supported Northern & Southern Junction Railway, as this line was called, obtained its Act on 10 August 1882.

The contractor, Joseph Firbank, encountered difficulties with seams of flint between Hurstbourne and Longparish, but when broken up they proved useful as base ballast. Gravel deposits were excavated near Longparish and this material was utilized as top ballast. The double track line was inspected by Colonel Yolland on 8 December 1882. He questioned the lack of a toilet on the Down platform at Fullerton Junction, feeling that passengers would have insufficient time to cross over the line to use the facilities provided on the Up platform. He withdrew this objection when railway officials observed that trains would not be stopping sufficiently long for anyone to use the toilet, even if one were on the Down platform.

The new line opened to the public without ceremony on 1 June 1885. At that period new appendages to the LSWR were named after topical parts of the British Empire and the Longparish Loop became known as 'The Nile'.

The junction station on the main line at Hurstbourne opened on 1 December 1882 and, just over quarter-of-a-mile west and at the far end of the Hurstbourne Viaduct, the Longparish Loop curved away. Branch trains started or ended their journey on the north side of the Up island platform at Whitchurch.

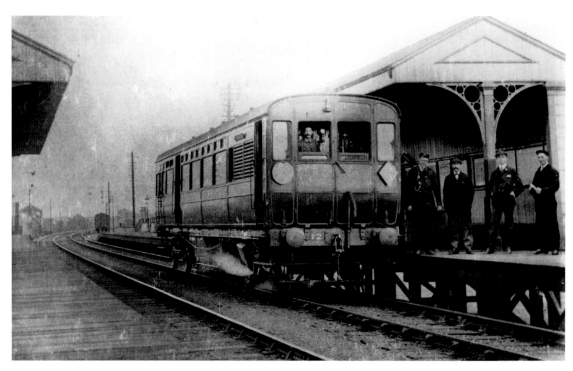

An H12 class railcar at Hurstbourne, working the Whitchurch to Fullerton service *c.* 1910. Notice that this view is unusual in that it shows the cab's interior. *Author's collection*

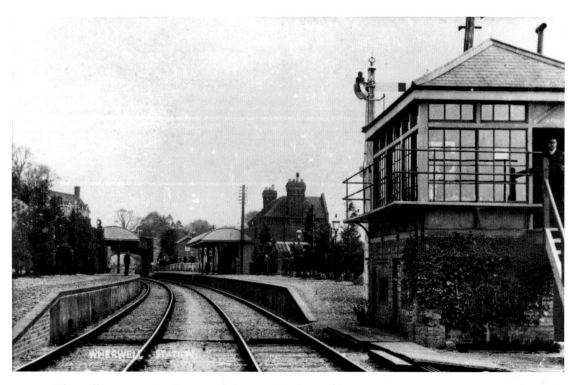

Wherwell, *c.* 1910, view Up towards Longparish. *Lens of Sutton*

At the other end of the Longparish Loop was Fullerton Junction, a timber-built station in the 'V' about 100 yards south of the 1865 platforms. Provision of double track for the branch was found to be too lavish and the line singled on 13 February 1913. Ironically, the following year the First World War caused the development of through traffic to serve new military camps at Barton Stacey, Mottisfont and Stockbridge. Later in the war some special trains to and from Southampton Docks were routed via Longparish to avoid the congested main line at Winchester. The Longparish Loop proved useful on 13 October 1914, following the blockage of the main line at Andover Junction due to a cattle train accident, several main line goods trains were diverted over the loop before the wreckage was cleared.

In 1915 Messrs Kynoch Limited opened the largest wood distillation works in England at Longparish and used ex-LSWR Southampton Docks 0-4-0T No. 109 *Southampton* for shunting its sidings which had a total length of about three-and-a-half miles. The works produced acetate of lime used for manufacturing high explosives; naphtha; methyl; alcohol; acetone; tar; pitch; wood oils and charcoal. Over 900 tons of wood, coal and lime arrived weekly, while outwards traffic comprised 175 tons of charcoal, 35 tons of acetate, 20 tons of tar and 20 tons of alcohol etc. Messrs James Taylor Limited, timber merchants, Longparish, specialised in wood for railway work — manufacturing carriage and wagon, keys and trenails, and during the First World War produced material for aircraft and naval use.

By 1920 the four daily passenger trains had been reduced to three, while the hitherto daily goods train only ran on Mondays, Wednesdays and Fridays.

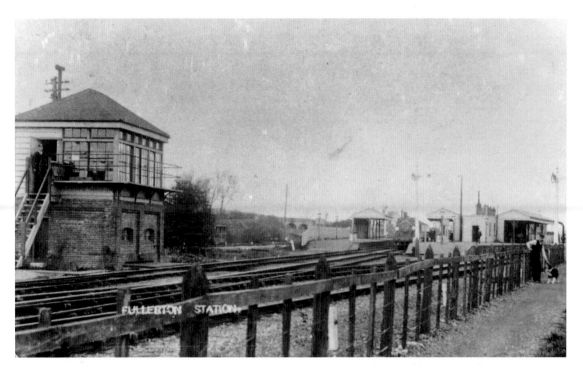

View Up Fullerton Junction, pre-1934. The Longparish branch platforms are on the right. *Author's collection*

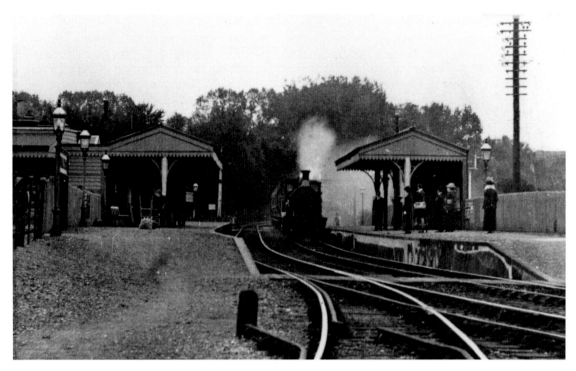

A passenger train for Andover Junction enters Fullerton Junction *c.* 1910. The track in the centre leads to the cattle pens behind the photographer. *Author's collection*

Working of goods trains.—In order to provide the requisite brake power for safely controlling a down goods train, the load of which is in excess of equal to 25 wagons, on the falling gradients between Longparish and Wherwell, and between Wherwell and Fullerton stations, the Guard of such train must ascertain from the Driver before leaving Longparish or Wherwell, as the case may be, what number of wagon brakes are required to be pinned down and arrange for the train to be brought to a stand before descending the gradient to Wherwell or Fullerton respectively, so that wagon brakes may be applied accordingly.

The undermentioned table may be regarded as indicating the minimum number of brakes that should be pinned down over the sections of the line indicated, but, in the discretion of the Driver, more brakes may be applied according to necessity arising from abnormal weather conditions, or other unfavourable circumstances.

Load equalling (exclusive of brake van.	No. of wagon brakes to be pinned down with 20-ton brake van behind. See Note A.	No. of wagon brakes to be pinned down with 10-ton brake van behind. See Note B.
50	10	13
45	8	11
40	6	9
35	4	7
30	2	5
25	Nil	3
20	Nil	1

Note A.—A 20-ton brake van to be provided, whenever possible, at the rear of all up and down goods trains between Longparish and Fullerton.

Note B.—To apply in the event of a 20-ton brake van not being available at any time.

The Driver must be informed by the Guard the number and class of vehicles forming the train, and the Guard will be responsible for releasing the brakes on arrival at Longparish, Wherwell or Fullerton.

Engines.—For general purposes the axle load of engines working between Longparish and Fullerton in each direction must not exceed 16 tons 7 cwt. on the driving axle.

Extract from SR Working Timetable Appendices, 1934.

In about 1928 the Longparish Loop proved useful as a large engine-turning triangle. Andover Junction turntable had failed and GWR enginemen refused to work back over the ex-MSWJR tender-first so local initiative suggested sending them round the triangle with an SR driver as pilotman. This led to repercussions later in the day when Eastleigh had urgent need of an Andover engine and was horrified to learn that the spare driver was not on shed to leave immediately, but was trundling round Hampshire on the footplate of a 'foreign' locomotive.

Passenger services over the line were withdrawn on 6 July 1931, Longparish to Hurstbourne closed completely on 29 May 1934 and the track lifted in October.

During the Second World War the RAF opened a maintenance unit in Harewood Forest and used the surrounding woodland for bomb and bullet storage. Up to four ammunition trains arrived at Longparish daily. Probably the last passenger trains to use the line ran in late 1945, when fourteen specials carried National Servicemen to Longparish to detrain for the Royal Engineers' Depot at Barton Stacey. The RAF siding at Longparish closed in 1953 and from then on the only traffic to Longparish was for the coal merchant and steel for the engineering works. The last train ran on 25 May 1956 and the line closed from 28 May 1956. Until 20 April 1960 about a mile of track was retained for wagon storage.

H13 class steam railcar No. 12 worked the line from June 1906 until February 1910 and proved so popular that one train each way was extended to Basingstoke and later to Andover Town. At night the spare railcar carried signalmen, permanent way men, coal and churns of drinking water to outlying signal boxes and level crossing keepers' cottages.

The railcars were replaced by C14 class 2-2-0Ts No. 738 and No. 742 hauling a trailer coach. In due course these were replaced by conventional locomotives. Another interesting vehicle was a four-wheeled Drewry petrol railcar, also used on the 'Sprat & Winkle' line.

In 1940 the branch was strengthened and, until 1945, K10 and L11 class 4 4 0s and 0-4-2 A12 'Jubilee' class locomotives worked most of the trains. Until 1951 0395 class 0-6-0s appeared periodically, T9 4-4-0s handling trains for that year until closure, with No. 30288 heading the very last train.

The Alton Area

BENTLEY TO ALTON

An Act obtained on 16 July 1846 authorised a line from Guildford to Alton which entered Hampshire approximately midway between Farnham and Bentley stations. Work proceeded well until a recession delayed completion. The line to Farnham opened on 8 October 1849, but the inauguration of the single-line section of Farnham to Alton was delayed until 28 July 1852. The line was doubled on 2 June 1901 and electrified on 4 July 1937, with the introduction of a service of two trains each hour, including Sundays. Bentley lost its goods traffic on 1 June 1964 and Alton on 6 January 1969, but passenger traffic still flourishes.

Oil was discovered below the chalk downland around Herriard, a village at one time served by the Basingstoke & Alton Light Railway, and this led to the development of the Humbly Grove Oilfield, which officially opened on 4 June 1986. Crude oil is piped to Holybourne, 2 miles east of Alton, where it is loaded into rail tankers to be taken to the refinery at Fawley. On the Alton line a daily path is provided in the late morning There are aspirations to increase production at the oilfield which would see an increase in the number of trains required to serve it. This has led to thoughts of re-doubling the line from Farnham to Alton to create greater capacity and ease the performance problems of passenger trains over the current single line. Network Rail in its Rail Utilisation Strategy puts forward plans to extend the platforms at Alton to accommodate twelve car trains and to improve the freight run-round facility there.

In May 1932 the SR tested an interesting Michelin pneumatic-tyred railcar between Ascot, Aldershot and Alton. An articulated unit, the engine was under the tractor's bonnet, while the low-slung passenger saloon behind held twenty-four passengers. The SR did not order any because, although the railcar could accelerate to 50 mph in a minute, stop from 55 mph in 45 yards and was economical to run, it had drawbacks. Passenger accommodation was very limited and it could not pull a trailer or tail traffic; it lacked standard drawgear so in the event of failure could not be hauled; and its rubber tyres could not operate track circuits.

BLACKWATER TO FARNBOROUGH NORTH

The Ash Junction to Reading line was promoted by the Reading, Guildford and Reigate Railway, incorporated on 16 July 1846 to build a 45¾-mile-long line joining Reading with Redhill on the London, Brighton & South Coast Railway. One of the line's purposes was to act as a link between Dover and the Midlands. This Act empowered the South Eastern Railway to lease the Reading, Guildford and Reigate Railway at 4½ per cent and receive half of any profits, although in the event the latter never materialized. Opened on 4 July 1849, the company was absorbed by the SER in 1852. Branch stations in Hampshire are Blackwater and Farnborough North.

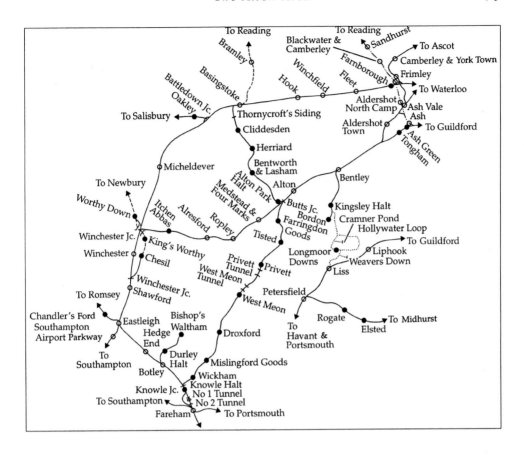

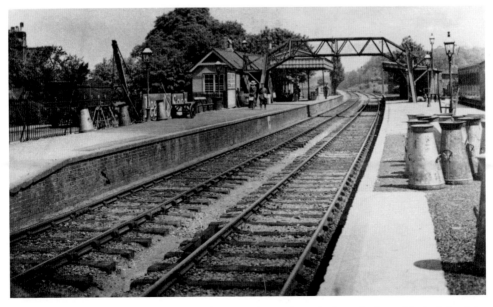

Bentley, view Up, *c.* 1910. On the far right a coach stands in the bay platform. To the left of the crane, a locomotive tender is lettered 'LSWR'. Notice the slender footbridge, 'barley sugar' lamp post and abundance of milk churns. *Author's collection*

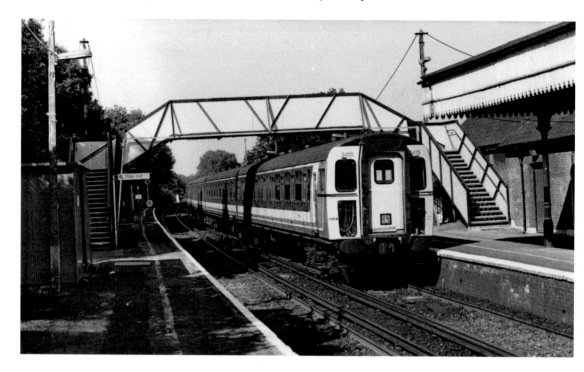

Above: Rear view of Class 423/0 EMU Set No. 3415 leaving Bentley 15 June 1996, with the 08.12 Waterloo to Alton. The platform edge has recently been whitened. *Author*

Left: Class 423/0 EMU Set No. 3415 working the 09.26 Alton to Waterloo just east of Holybourne Oil Terminal, 15 June 1996. *Author*

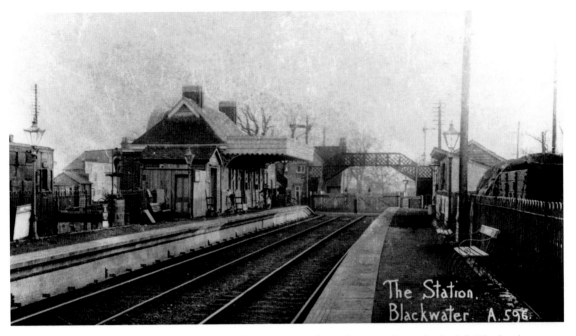

Blackwater station, view towards Reading *c.* 1905. A horse box stands on the far left. The level crossing gates are closed to rail traffic. *Author's collection*

At first the line was not favoured as a through route due to the break of gauge at Reading, but through services from the Midlands to Kent and Sussex resorts began in 1897. In order to carry passengers over its lines for the maximum mileage, the South Eastern and Chatham Railway, as the SER had become, promoted Reading as a useful exchange point for passengers from Dover to the Midlands and the North. Today most of the stopping trains run between Reading and Gatwick Airport.

THE ALDERSHOT TOWN LOOP

On 19 June 1865 the LSWR obtained powers for a branch from Pirbright Junction, on its Waterloo to Salisbury line, to Aldershot Town and Farnham, on its Guildford to Alton line. The SER was granted running powers between Ash and Aldershot Town, while in return the LSWR was granted running powers over the SER between Ash Junction and Aldershot North Camp. Pirbright Junction to Farnham opened on 2 May 1870 and curiously, although the Aldershot Town line was LSWR property, the bulk of the service was provided by the SER. The line was electrified on 4 July 1937 as part of the Alton programme.

ALTON TO WINCHESTER — THE MID-HANTS RAILWAY

The railway having reached Alton, residents of the area between there and Winchester pressed for an extension of the line with the result that the Alton, Alresford & Winchester Railway Act was passed on 28 June 1861. Cash was in short supply, but

fortunately many landowners took payment in shares, though a contrary was that the LSWR, which was to work the line, insisted on works being prepared for the double track. As the existing terminal station at Alton was unsuited to be on a through line, a new station was built just to the south and the old building converted into a stationmaster's house. In more recent years the latter building has been demolished to make room for a car park. At one time a siding on the Up side, a quarter-of-a-mile west of the station, led to two breweries, which received coal, barley, and hops, beer being the outgoing traffic.

The single line between Alton and Winchester Junction two miles north of the city, opened on 2 October 1865, with some of the four daily passenger trains from Guildford to Alton being extended through to Southampton. Medstead station at the line's summit, 650 feet above sea level, opened on, or just before, 1 August 1868. Meanwhile from 1 January 1865 the company changed its name to the Mid-Hants Railway as it planned a branch from Ropley to Fareham to make the shortest main line from London to the Isle of Wight via Stokes Bay. In the event this plan was aborted.

The MHR was displeased with the way the LSWR worked the line because it failed to offer more than one reasonable train over the MHR between Waterloo and Southampton and did not develop through traffic, wishing to protect its own line via Basingstoke. The MHR's share of income for the first three years after opening averaged about £3,600 — an inadequate return on an expenditure of some £200,000. On 30 June 1884 the LSWR purchased the MHR for £237,500.

The line was very busy during the First World War when hundreds of troop trains used it *en route* from Aldershot to Southampton. Economies in the 1930s involved the removal of the Up loops at Ropley and Itchen Abbas, thus saving the signalmen's wages.

The 1937 electrification to Alton required modification of train services on the MHR and M7-worked push and pull trains were introduced between Eastleigh and Alton. This really marked its change from a through route to a branch line, though special through trains continued to be run. Normally the M7 pushed the two-coach set to Alton. and pulled it on the return journey. Regular steam passenger working ended on 16 September 1957 when the 'Hampshire' DEMUs began working, offering an hourly service and reduced the Alton to Southampton Terminus time by twenty minutes, the new trains taking only fifty-five minutes. An immediate success, the number of passenger journeys increased by about 50 per cent and the units were changed from two to three-car. From 6 September 1965 conductor-guards were introduced and passengers issued with tickets on trains because intermediate stations, except Alresford, had become unstaffed by January 1967. Although closure notices were issued in 1967, objectors succeeded in keeping the line open until 5 February 1973.

As a significant proportion of the line was on a gradient of 1 in 60, it was not surprising that several accidents occurred as a result of runaways — in fact two happened in 1900. On 1 May, 20 wagons of an Up train ran back from Medstead to Alresford while on 27 December a horse box which had been uncoupled from a train ran down the bank colliding with its train at Ropley.

Major J. W. Pringle stated in his report: 'The 2.45 pm passenger train from Waterloo to Southampton, on arrival at Medstead station, detached a M&SWJR horse box and started towards Ropley, the next station. The horse box followed the train down the incline and collided with it 300 yds beyond Ropley sation. Five passengers complained, but the horse appears not to have been injured.'

The mishap occurred due to the horse box being fitted with a vacuum brake pipe, but no hand brake. It was also fitted with solid wheels, so the lack of spokes made it difficult to fit a sprag, so any slight movement of the vehicle would withdraw any

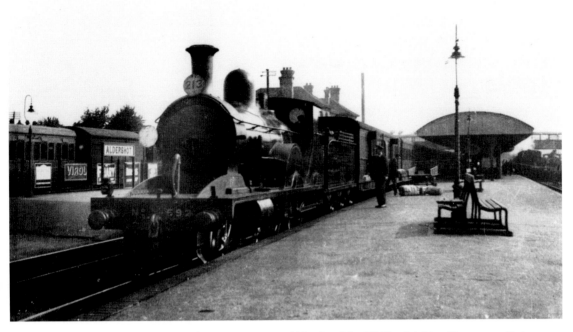

X2 class 4-4-0 No. 592E heads a Down train at Aldershot. The 'E' (Eastleigh) suffix was applied in June 1924 and removed in December 1931. No. 592 was withdrawn in December 1936. *Lens of Sutton*

ON THE OPENING OF THE
Alresford, Alton, and Winchester Railway,
On *MONDAY, OCTOBER 2nd*, 1865,
By Mess. J. & W. Freemantle, Alresford, Hants.

" Labor omnia vincit."

We have our Railway at last. It has been talked about for many years, 20 years or upwards, and we hope and trust that it will be for the benefit of Alresford and surrounding neighbourhood, and for persons in general. Several poor men lost their lives during the cutting, we lament to state. Masses of earth fell upon them and buried them alive! The Lord God save us from such a dreadful end!!! There are three things says Lord Bacon that make a nation great and prosperous—*Busy Workshops; Ready Money; and an easy transit of goods from place to place!*

Notice of the opening of the Alton to Winchester line.

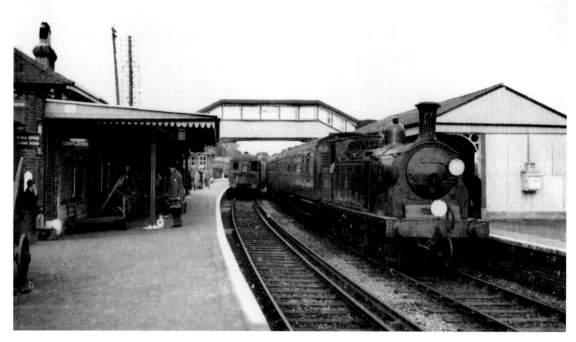

M7 class 0-4-4T No. 30033 at Alton with a train for Winchester. An electric set stands on the other road. *Lens of Sutton*

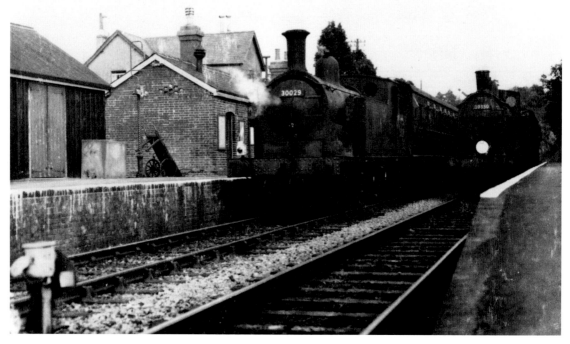

Two trains cross at Medstead & Four Marks: M7 class 0-4-4T No. 30029 (71A, Eastleigh) propels a Winchester to Alton passenger, while 700 class 0-6-0 No. 30350 probably heads a goods train. *Lens of Sutton*

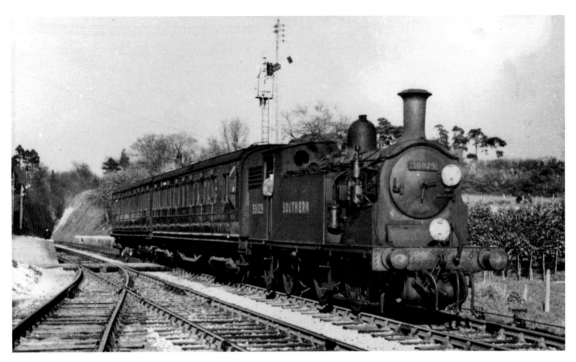

M7 class 0-4-4T No. 30029, with 'Southern' on its side tanks in 'sunshine' lettering and with a BR number, leaves Medstead & Four Marks for Winchester. Notice the pump beside the smokebox to provide compressed air for working the push-pull gear. *Author's collection*

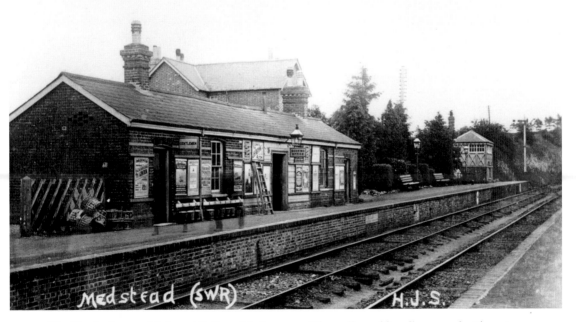

The Up platform at Medstead & Four Marks *c*1910. The walls are liberally covered with posters and advertisements. The steps to the left of the booking office door were probably used to maintain the oil lamp. Notice the row of fire buckets. *Author's collection*

'Merchant Navy' class Pacific No. 35005 *Canadian Pacific* at Medstead & Four Marks with the 11.30 Alresford to Alton, 15 June 1996. Notice the 'barley sugar' lamp post. *Author*

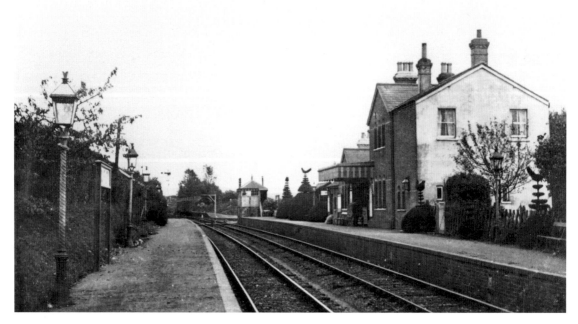

Ropley, view Up, *c.* 1910. Observe the topiary beyond the station building. *Author's collection*

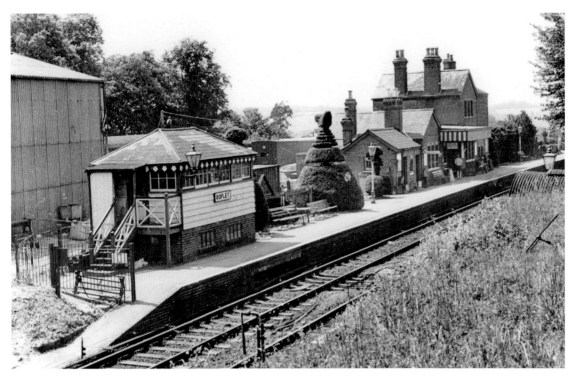

Ropley, view Down, 15 June 1996. The station has been beautifully restored to its former appearance in LSWR days, including the topiary. *Author*

Pacifics flanking BR Standard Class 5MT 4-6-0 No. 73096 in the locomotive yard at Ropley, on 15 June 1996. *Author*

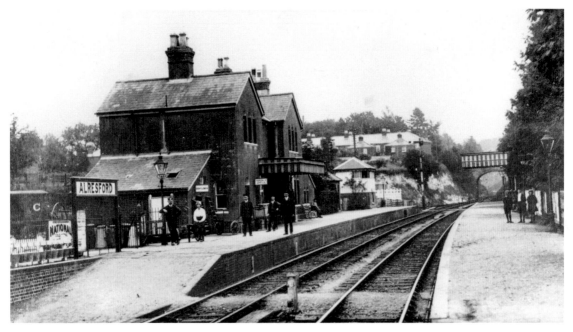

Alresford, view Up *c.* 1910. A Great Central Railway van stands in the goods yard, far left.
Author's collection

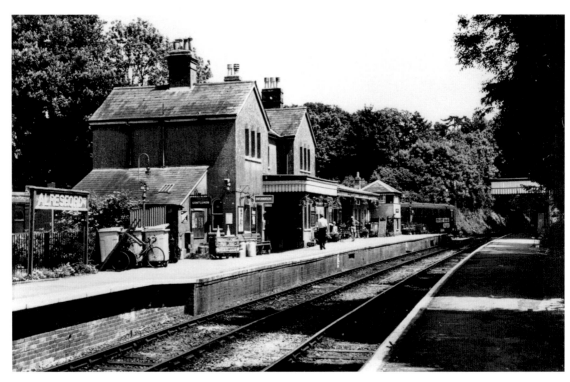

Alresford, view Up, 15 June 1996 – little has changed in the intervening eighty-six years.
Author

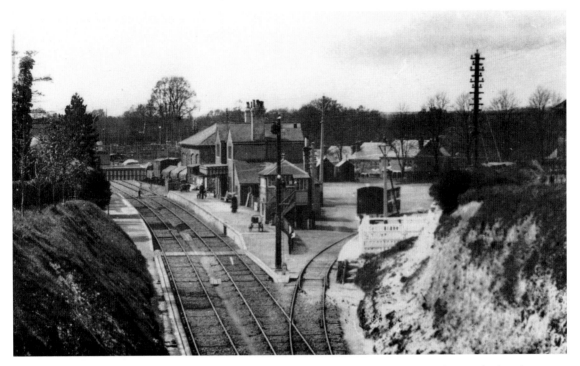

Alresford, view Down, *c.* 1910 with the grain siding curving to the right. The whitewashed cattle dock, which dealt with many sheep, is also on the right. *Author's collection*

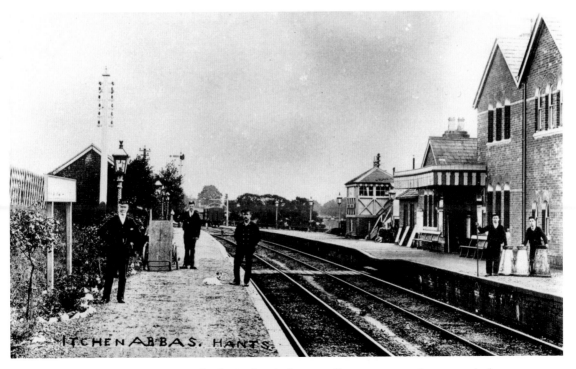

Itchen Abbas, view Up. Note the dip in the platform to allow easy access from one platform to the other. *Author's collection*

pressure on the sprag exerted by the wheel and allow the sprag to fall. The movement in this case was probably communicated to the box by the express starting.

BR closure on 5 February 1973 did not mean the end of the branch as the Mid-Hants Railway Limited had been formed to preserve the Alton to Alresford section. It opened from Alresford to Ropley on 30 April 1977, reached Medstead & Four Marks on 28 May 1983 and finally ran through to Alton on 25 May 1985.

A locomotive shed has been erected in what was Ropley goods yard and the passenger station restored to its LSWR livery. Today, although the MHR has mostly tender engines, the lack of a turntable at each end means that they have to spend half their lives travelling in reverse.

MID-HANTS RAILWAY LOCOMOTIVES, 2010

Number	Wheel Arrangement	Class	Name & Notes
Steam:			
506	4-6-0	S15	
850	4-6-0	Lord Nelson	*Lord Nelson**
2890	0-6-0ST	Austerity	*Thomas*
30075	0-6-0T	USA	
30076	0-6-0T	USA	
30499	4-6-0	S15	
31625	2-6-0	U	
31806	2-6-0	U	Built as a 2-6-4T
31874	2-6-0	N	Often runs as No. 5 *James*
34007	4-6-2	West Country	*Wadebridge*
34016	4-6-2	West Country	*Bodmin*
34105	4-6-2	West Country	*Swanage*
35005	4-6-2	Merchant Navy	*Canadian Pacific*
41312	2-6-2T	2MT	
45379	4-6-0	Black Five	
60019	4-6-2	A4	*Bittern*
73096	4-6-0	5MT	
76017	4-6-0	4MT	
92212	2-10-0	9F	
Diesel:			
D3358	0-6-0	08	
D5353	Bo-Bo	27	
D6593	Bo-Bo	33	
45.132	1CO-Co1	45	
4	0-4-0		Ex-WD No. 242

DEMU

1125 2-car Hampshire unit

* *Lord Nelson* is part of the National Collection owned by the National Railway Museum.

Coaching stock consists of a few ex-Southern Railway coaches, but most are ex-BR Open Seconds. In addition the MHR possesses a variety of non-passenger carrying coaching stock and over forty goods vehicles.

BRAMLEY TO BASINGSTOKE

The Berks & Hants Railway Act was passed on 30 June 1845 authorising fifteen-and-a-half miles of broad gauge line from the GWR at Reading to the LSWR at Basingstoke. As the Berks & Hants was a GWR subsidiary, I. K. Brunel was appointed engineer to the company. Construction was let in one contract which was basically finished in August 1847, but opening was delayed through the awkwardness of negotiations with an obstructive LSWR whose through station the Berks & Hants terminus adjoined.

In the meantime the Berks & Hants line from Reading to Hungerford opened on 21 December 1847. When negotiations with the LSWR were finally settled on 1 November 1848, the Basingstoke branch opened from Southcote Junction, just under two miles from Reading. The Basingstoke line had the advantage of providing communication between south and north without the necessity of travelling via London, though, due to the differences in gauge, through trains could not be run until 22 December 1856, when the branch was converted to mixed gauge. Initially, Mortimer in Berkshire was the only intermediate station, but Bramley, formerly only a goods siding, was opened to passengers in April 1895.

The Berks & Hants station at Basingstoke was of the train shed variety and set immediately to the north of the LSWR's station. It had one through road and two terminal bay platforms. The two platforms were connected by a drawbridge. From 22 December 1856 the through line made a connection with the LSWR at the west end of the station. On 1 January 1932 GWR trains were diverted to the former LSWR station which took over one of the GWR platforms.

The two-road engine shed at Basingstoke was curious in that one wall was of timber and the other of brick. The mixed gauge 32-foot diameter turntable was also used by LSWR engines, with that company paying an acknowledgement for the privilege. The LSWR had its own turntable before 1872 and in the 1880s the GWR placed a 42-foot turntable at the east end of its shed, the original at the opposite end being removed. By 1920 the GWR was using the LSWR's 55-foot turntable installed in 1905, while in 1943 the SR had replaced this with a 70-foot vacuum-operated turntable. With the closure of the ex-GWR shed on 26 November 1950, engines were serviced at the SR Basingstoke depot.

In 1916, just south of Bramley station, an extensive Command Ammunition Depot was built. Initially various steam tank engines were used, but from 1922 English Electric battery-electric locomotives appeared and were safer in the proximity of explosives. Later, Ministry of Defence diesels were used.

In addition to the branch being used by Basingstoke to Reading local traffic, the branch has long been important as a through route. On 1 July 1902 a Newcastle to Bournemouth through service was inaugurated using Great Central Railway stock. In 1939 two of the eighteen trains which ran over the branch daily originated north of Oxford. In 1959 Eastern Region B1 class 4-6-0s from the ex-Great Central line ran through from Oxford *en route* to the SR. In 1962 the local service from Reading to Basingstoke was dieselised using the relatively rare three-car 'Berkshire' DEMUs with above-floor mounted engines and two traction motors on the inner bogies.

Notice on the Down platform at Bramley, 9 August 1995. *Author*

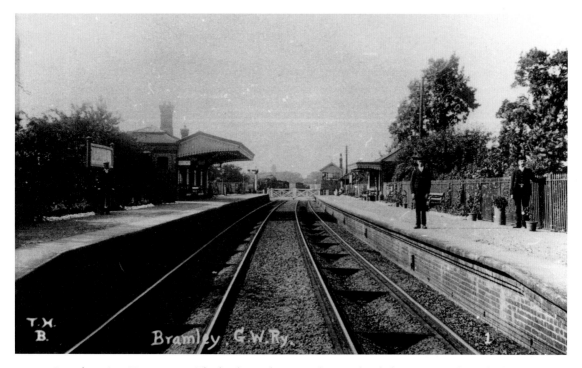

Bramley, view Up, *c.* 1910. The bridge rails are on longitudinal sleepers. On the right hand platform, plants are in pots. *Author's collection*

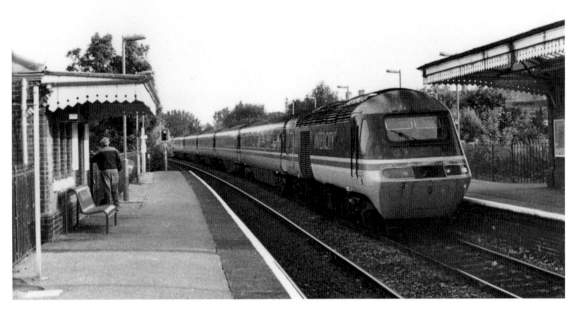

HST No. 43097, working the 17.16 Bournemouth to Birmingham New Street, passes Bramley on 9 August 1995. *Author*

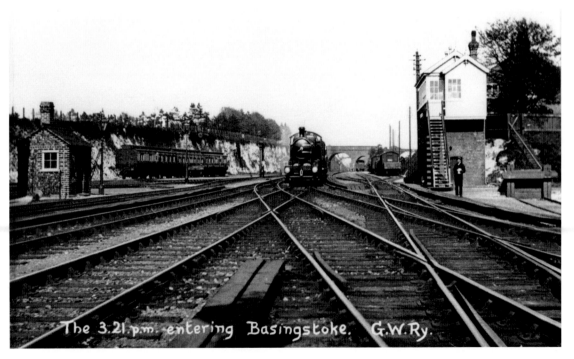

The 3.21 p.m. from Reading enters Basingstoke, *c.* 1905, headed by No. 3556. This engine, built in 1889 as a broad gauge convertible 0-4-2ST, proved an unstable runner and was changed to a 0-4-4T in 1890 and then converted to standard gauge in 1892. Still unsteady and subject to derailment, it was turned back to front, becoming a 4-4-0 tender engine in 1901. *Author's collection*

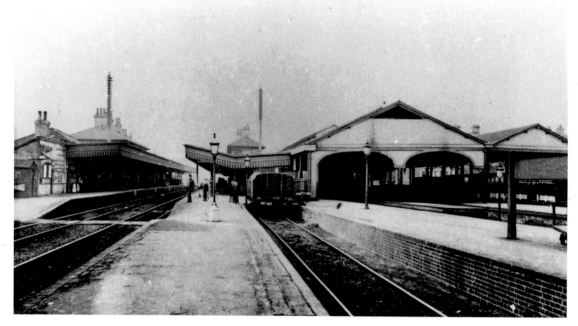

Basingstoke, *c.* 1905, with the GWR terminus on the right. *Author's collection*

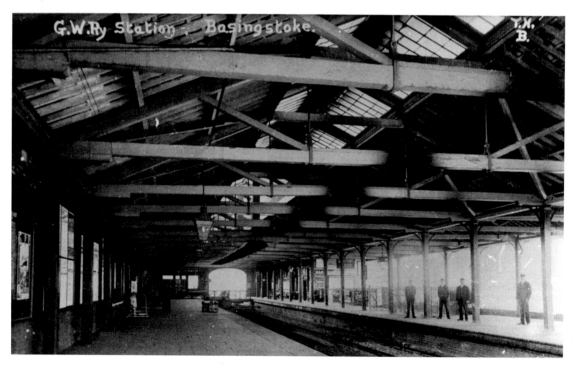

The interior of Basingstoke GWR station, view west. A drawbridge, connecting the platforms, can just be seen at the far end beyond the trunks. Also towards the far end can be seen a smoke chute to carry away fumes from a locomotive chimney. *Author's collection*

Today the line has really lost its branch status and has become an important route for expresses from the south coast to the Midlands, North of England and Scotland.

BASINGSTOKE TO ALTON

When the GWR proposed a line from Basingstoke to Portsmouth, the House of Lords' Committee decided that a light railway, or railways, for Basingstoke-Alton-Fareham would be adequate as Portsmouth was already well-served by main lines. The result was that the LSWR constructed the Basingstoke & Alton Light Railway and the Alton to Fareham line.

The Light Railways Act of 1896 permitted certain sections of railway to be operated under rules offering safety with less expense. For example, level crossings were permitted to have cattle grids instead of gates, each set of grids costing £22 and much cheaper than a crossing cottage, gates and a crossing keeper's wages. This was ideal for the Basingstoke & Alton Light Railway. Instead of an Act, it was built under a Light Railway Order of 9 December 1897. As it was the very first light railway, on 22 July 1898 the Right Honorable Charles Ritchie, President of the Board of Trade, cut the first sod in a field adjoining Messrs Thornycroft's motor lorry works, Basingstoke.

The line opened without ceremony on 1 June 1901. It saw very little traffic that day, only a total of about fifty tickets being sold at intermediate stations. One advantage of the line was that people could travel from Basingstoke to Alton in an hour at a cost of 1s 2d, whereas the previous route via Winchester took two hours and cost 3s 0½d.

The *Hampshire Herald & Alton Gazette* of 8 June 1901 commented, 'The man in the street expects to find the village somewhere near the station. But such little details do not trouble the promoters of railways, who, if the station is somewhere in the parish named — the parish may be a dozen miles in area — are quite content to take the name, which, with common people, is generally associated with the village. And so it has turned out on the Basingstoke & Alton Railway. The three intermediate stations are named Cliddesden, Herriard, and Bentworth & Lasham respectively. But the villages bearing those names are a long way from the stations and not a glimpse of them can be seen from the train'.

The three intermediate stations had their platform buildings constructed from corrugated iron with a matchboarding interior. Each station had four railwaymen's cottages and a station master's house built some distance from the track so that they would not have to be demolished if the line was doubled. Herriard and Bentworth & Lasham had more than four acres of land for stations, which seems excessive. Each station had a well and two of these were worked by a wind pump, while the well at Herriard, over 300 feet deep, was served by an oil-driven pump. It was the scene of a fatal accident when a seat lowering a fitter's mate down the well tipped and he fell. The line's summit at Herriard was nearly 600 feet above sea level. Concrete telegraph poles gave the line a modern touch. Passenger trains were restricted to a maximum of five bogie vehicles and goods trains to fifteen loaded wagons (a load of coal, sand or bricks counted as one-and-a-half wagons), eighteen mixed wagons or 25 empties.

A private siding served Thornycroft's Works and, near Butts Junction, Alton, a siding was laid to a hospital and convalescent camp with accommodation for 500 men built under the auspices of the delightfully named Absent Minded Beggar Fund. This curious title came from the fact that at fund-raising concerts for the construction of the hospital during the South African War Rudyard Kipling's poem 'The Absent Minded Beggar' was recited. This siding was eventually removed, but a similar one provided

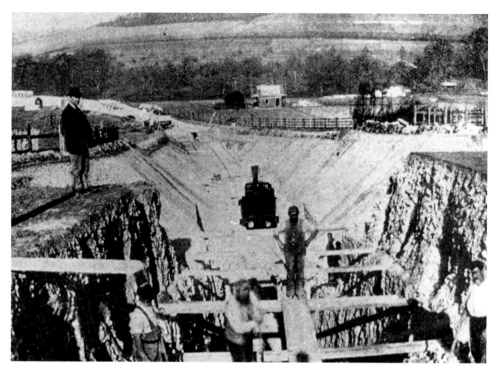

Excavating in 1899, a deep cutting at Whitedown, north of Alton. *Author's collection*

A steam shovel in 1899 removing chalk at Winslade, near Cliddesden. *Author's collection*

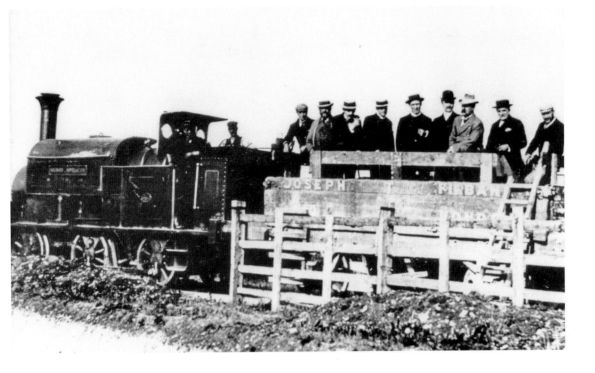

Above: 0-6-0ST *Henry Appleby* with an inspection train on the Basingstoke & Alton Light Railway. Notice the safety planks on the Joseph Firbank's wagon to prevent passengers being thrown over the side. *Author's collection*

Right: Notice of the opening of the Basingstoke & Alton Light Railway.

LONDON AND SOUTH WESTERN RAILWAY. INSTRUCTION No. 30, 1901.

Instructions to District Superintendents, Station Masters, Inspectors, Enginemen, Guards, Signalmen, and all others concerned, as to the

OPENING OF THE
BASINGSTOKE AND ALTON LIGHT RAILWAY
On *SATURDAY, JUNE 1st*, 1901,

FOR

PASSENGERS, PARCELS AND GOODS TRAFFIC.

A New Single Line, 12 miles 72 chains in length, has been constructed between Basingstoke "C" Box and Butt's Junction Signal Box. The gauge of this New Line is 4 feet 8½ inches. No Engine, Carriage, or Truck bringing a greater weight than fourteen tons upon the rails by any one pair of wheels must be run on this Railway.

The speed of Trains must not exceed 20 miles per hour at any time, or 10 miles per hour when passing over any curve the radius of which shall be less than nine chains.

For the present, Trains to and from the Alton Light Railway will travel between Basingstoke Station Down Bay Road and the "C" Signal Box on the Siding, next to the Down Main Line.

There are three intermediate Stations, viz. :—Cliddesden, Herriard and Bentworth and Lasham.

The Line will be worked under Tyer's Train Tablet System (No. 6 Instruments) as described in Instruction No. 17, 1898, which has been supplied to all concerned.

The Tablet Sections are as follows :—

 1. Basingstoke Station Bay Road,
 ("B" Box) to Basingstoke "C" Signal Box.
 2. Basingstoke "C" Signal Box „ Herriard Station.
 3. Herriard Station „ Butt's Junction.

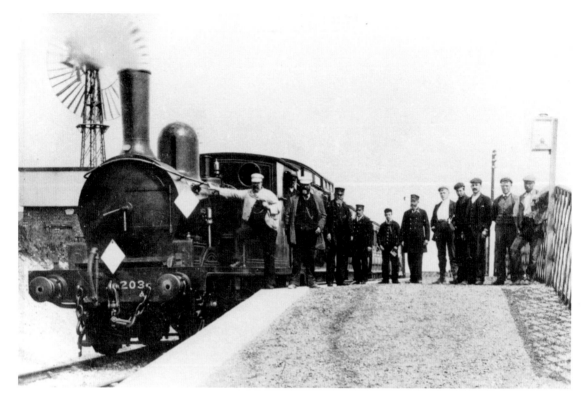

O2 class 0-4-4T No. 203 arrives on 1 June 1901 at Cliddesden with the first train. The engine is still fitted with safety chains. Notice the lamp at the head of the platform ramp and the wind pump for raising the station's water supply. *Author's collection*

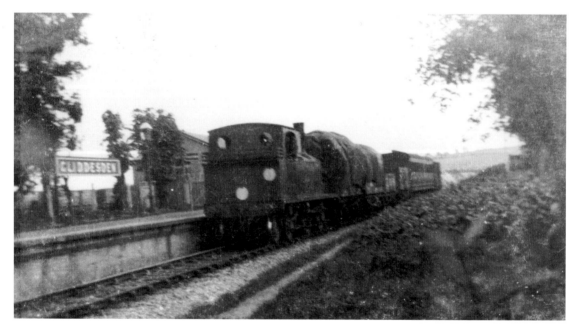

An O2 class 0-4-4T at Cliddesden heading a mixed train. The sheeted wagons next to the engine probably contain hay. *Lens of Sutton*

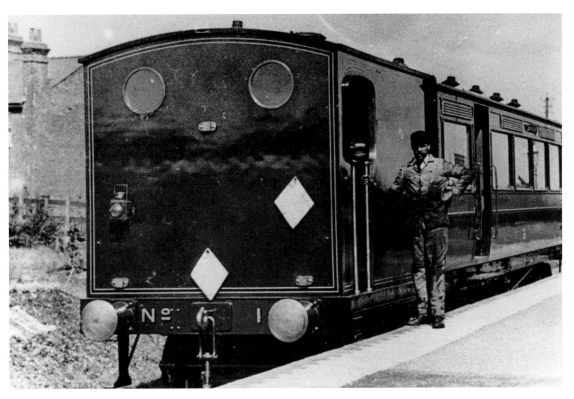

H12 class railcar No. 1, at Cliddesden, 1904. Notice on the far left, the station name in chalk on the embankment. In the background are staff cottages. *Author's collection*

Bentworth & Lasham station *c*. 1920. *Author's collection*

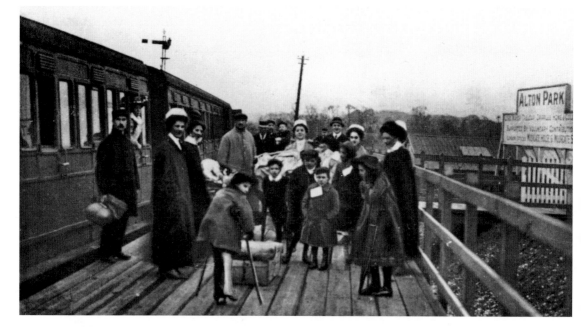

Disabled children arriving at Alton Park, Treloar's Hospital Platform *c.* 1932. *Author's collection*

on 5 April 1910 for the Lord Mayor Treloar's Cripples' Home, which received 1,500 tons of coal annually. In 1908 the home had taken over the convalescent camp huts. A 200-foot passenger platform was on the Basingstoke and Alton branch and used by Founder's Day specials. Then a train with a T9 4-4-0 at each end obviated the danger of reversing round a curve.

The military demand for track caused the Basingstoke & Alton Railway to be closed on 1 January 1917, though sidings to the Thornycroft works and to the Lord Mayor Treloar's Home remained open, as did Herriard and Cliddesden stations for milk and parcel traffic, which was carried to and from Basingstoke station on an LSWR Karrier bus converted into a lorry.

In 1921 the LSWR directors considered potential traffic insufficient to warrant relaying the line. The House of Lords rejected abandonment due to pressure from landowners who had sold their land cheaply on the understanding that a railway service was to be provided. Following the 1923 Amalgamation of Railways the SR reopened the branch on 18 August 1924. Despite record loadings on the first Basingstoke market day following this event, gross receipts for the first two weeks totalled only £94 11s 11d against wage costs alone of £102 17s 0d. As the directors had anticipated, traffic was not viable and the line closed to passengers on 12 September 1932 and to all traffic on 1 June 1936, though Thornycroft's siding and the Lord Mayor Treloar's Home siding remained until 1967.

On 1 July 1904 two steam railcars, Nos 1 & 2, started work on the branch. Unlike the pair on the Fratton to East Southsea joint line (see page 149), the footplate was over the leading axle (also the driving axle) and the smokebox adjoined the car body. Braking was by hand only and lighting by oil. These cars were insufficiently powerful to tackle the curved ruling gradient of 1 in 50 and needed banking assistance from

PUBLIC MEETING

WILL BE HELD IN THE

TOWN HALL,

BASINGSTOKE,

ON

Wednesday, 10th Jan., 1923,

TO PROTEST

Against the proposed abandonment of the

BASINGSTOKE & ALTON LIGHT RAILWAY,

And to decide what action shall be taken.

The Chair will be taken at 3 p.m., by

HIS WORSHIP THE MAYOR OF BASINGSTOKE,

(MR. ALDERMAN J. W. MUSSELLWHITE).

Supported by The COUNTESS OF PORTSMOUTH, Col. Sir ARTHUR HOLBROOK, K.B.E., M.P., Col. W. G. NICHOLSON, M.P., and other Ladies and Gentlemen.

Herriard Park,

Basingstoke,

22nd December, 1922.

Dear Sir,

BASINGSTOKE & ALTON LIGHT RAILWAY.

As you are probably aware the London & South Western Railway Company are bringing an Omnibus Bill before the House of Commons for powers to, among other items, abandon the Basingstoke and Alton Light Railway.

The Mayor of Basingstoke is arranging a Meeting of Protest to be held at the Town Hall, Basingstoke, at 3 p.m., on Wednesday, 10th January, 1923 (should the date be altered I will let you know), at which our Member, Sir Arthur Holbrook, will be present.

May I ask you to make a special effort to be present at this Meeting to support the protest, as it is of vital importance that the abandonment of the line be opposed.

I intend, in conjunction with my neighbouring Landowners and others interested, to do all that is possible to have this line re-opened.

Yours faithfully,

F. H. T. JERVOISE.

Protest against the abandonment of the Basingstoke & Alton Light Railway.

Basingstoke shed, so were withdrawn on 12 August. No. 1 was later used on the Bishop's Waltham branch and the service between Southampton West and the Royal Pier. All the LSWR's steam railcars worked their trial 1,000 miles over the Basingstoke & Alton Light Railway, sometimes coupled in pairs to complete the mileage as quickly as possible.

The branch was first used for filming on 19 August 1928 when *The Wrecker* was shot at Lasham. Ex-SECR F1 class 4-4-0 No. A148 and 6 coaches crashed into a Foden steam lorry. The *Basingstoke Gazette* for 25 August 1928 recorded:

'After rehearsing for several hours up and down the track with the train and across the private crossing with the steam Foden wagon, everything was ready for the final masterpiece. The Foden wagon was placed across the track. The engine of the doomed train was in the charge of Driver J. Brown and Fireman G. Goodright, both of Guildford. The indication of the start was given by one of the many field telegraph operators. At about 1.10 p.m. the Director gave the signal to the linesman – 'Let her come'. An electric camera was placed on the front of the engine, and two dummies placed in their proper positions. The regulator was opened with full steam ahead. The driver shouted to his fireman to jump and then himself left the footplate. In sixty-five seconds it was all over. Rushing down the incline on a gradient of about 1 in 50 the train reached the point of impact at about 45 mph. There was a terrible explosion, which could be heard a mile away. Smoke and sparks shot 15 ft into the air. After ploughing up the track for 120 yards the engine fell on its side — a perfect wreck. The electric camera on the front of the engine was found with the camera glass broken and

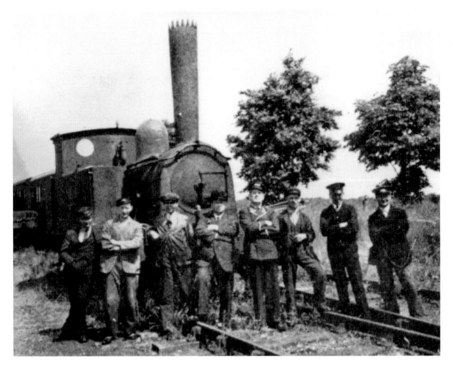

Kent & East Sussex Railway 2-4-0T *Northiam*, renamed *Gladstone* for the film *Oh! Mr Porter*, at Cliddesden June 1937, with some of the cast. *Author's collection*

Buggleskelly signal box, signal and washing hung over the line, all part of the film set at Cliddesden station. *Author's collection*

a 30 ft rail had pierced through the tender into the guard's van. The whole of the train had left the track with the exception of the last pair of wheels.'

In June 1937 scenes from *Oh! Mr Porter* were shot at Cliddesden, renamed 'Buggleskelly' for the occasion, the track from Basingstoke to Herriard still being in situ. The following three locomotives were used: X2 class 4-4-0 No. 657; 0395 class 0-6-0 No. 3509 and Kent & East Sussex Railway 2-4-0T No. 2 *Northiam,* renamed *Gladstone* and given an extra tall chimney to make it look antique.

One morning the film unit arrived at Cliddesden station and found an old woman and her even older companion sitting on a station seat waiting for a train. When told that trains had stopped running five years before and that the station was now part of a film set she poured out abuse. The more they insisted it was not a real station, the more she insisted she would write to *The Times* about it!

ALTON TO FAREHAM — THE MEON VALLEY LINE

The line from Butts Junction, Alton to Knowle Junction, two-and-a-half miles from Fareham, was built under an Act of 3 June 1897. its curves and gradients were suited for express running and station platforms, 600 feet in length, could hold long trains. The topography required considerable engineering works, including the 1058-yard Privett Tunnel, the 539-yard West Meon Tunnel and the concrete and steel West Meon Valley Viaduct with four arches each of 56-foot span. Earth slips delayed the line's construction. During the cutting of Privett Tunnel two men were buried when a ventilation shaft collapsed. One died almost instantly, but the other managed to dig himself to the surface with a knife and on reaching his friends above ate six loaves. Only a single track was laid, though land had been purchased for double and all overbridges and tunnels allowed for it.

R. T. Relf, the railway's contractor, offered higher wages than local farmers and the latter, threatened with also having to pay higher wages in order to retain staff, agreed that if any of their men, or their families, went to work on the line, they would be thrown out of their cottages. One lad employed as a fireman on a contractor's engine had to leave his home on the Basing Park Estate, Privett and lodge with an aunt in West Meon, in order to avoid his father being thrown out on the street. The line eventually opened without ceremony on 1 June 1903, some weekday trains running to and from Waterloo.

Fareham Tunnels, No. 1 at the west end, 147 yards and No. 2 at the east end, 553 yards, had caused problems since their opening on 29 November 1841, the land being unstable. The Meon Valley Railway Act permitted a two-mile-long deviation line to be built between Knowle Junction and Fareham. This new single line for Up trains came into use on 2 October 1904 and in September 1906 the Down line was completed, the original route through the tunnels then being closed for reconstruction. The latter reopened on 2 June 1906 for Meon Valley traffic. However, time proved that a slipping tunnel had been exchanged for a slipping cutting which was to cause trouble until its closure. The problem was that the clay through which it was cut had the unpleasant characteristic that when dry it was so hard that explosives were required to assist excavation, yet became slurry after exposure to heavy rain. In June 1962 an earth slip blocked the Up deviation line and for a time all traffic had to use the old single line through the tunnels. This gave rise to an imbalance of single line tablets which was rectified by the excess number being collected from Knowle Junction signal box by a lineman on a motorcycle. Later the Down deviation track

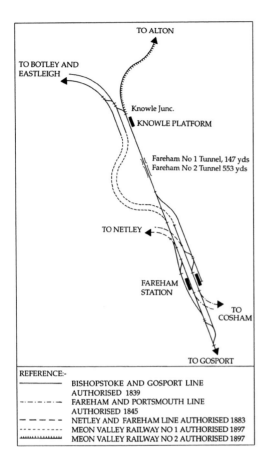

TO ALTON

TO BOTLEY AND
EASTLEIGH

Knowle Junc.
KNOWLE PLATFORM

Fareham No 1 Tunnel, 147 yds
Fareham No 2 Tunnel 553 yds

TO NETLEY

FAREHAM
STATION

TO
COSHAM

TO GOSPORT

REFERENCE:-
——————— BISHOPSTOKE AND GOSPORT LINE
 AUTHORISED 1839
-·-·-·-· FAREHAM AND PORTSMOUTH LINE
 AUTHORISED 1845
- - - - - NETLEY AND FAREHAM LINE AUTHORISED 1883
········ MEON VALLEY RAILWAY NO 1 AUTHORISED 1897
ᴧᴧᴧᴧᴧᴧᴧ MEON VALLEY RAILWAY NO 2 AUTHORISED 1897

An unknown navvy killed by a roof fall in
Privett Tunnel *c.* 1899. *Author's collection*

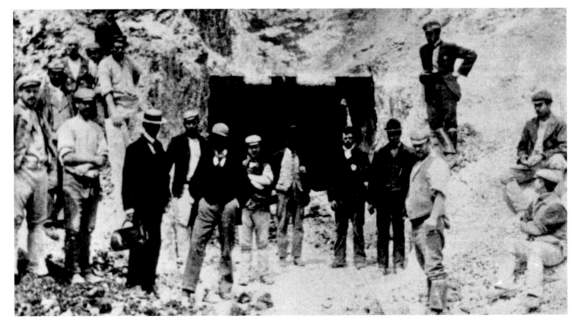

The south portal of West Meon Tunnel under construction, *c.* 1899. It is likely that the straw-
hatted gentleman holding a leather bag in his right hand has come to pay the navvies their
weekly wage. *Author's collection*

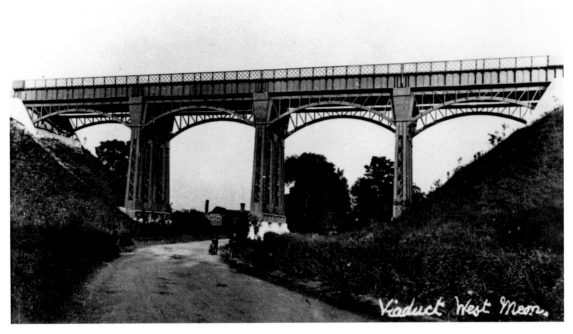

West Meon Viaduct was an unusual design. It is of steel on a concrete base. The photograph dates from the early 1900s. *Author's collection*

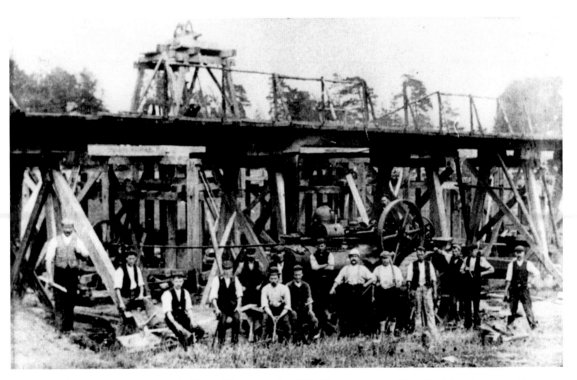

Bridge construction over the River Meon, south of Wickham, *c.* 1900. The pile driver is powered by a traction engine. *Author's collection*

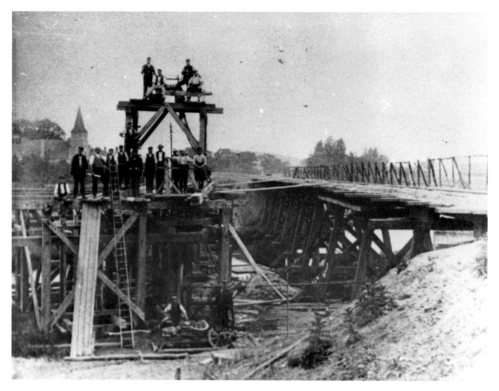

Construction of a bridge over the River Meon, south of Wickham *c.* 1900. *Author's collection*

was modified for use by Up trains, all Down traffic using the tunnels line and thus obviating conflicting movements of trains at Knowle Junction box. From 6 May 1973 the deviation line was completely closed and partly used for the M27 motorway and BR secured the rebuilding and strengthening of the tunnel line in exchange for the use of the avoiding line land.

An economy was effected on 17 February 1935 when Butts Junction signal box closed and the former double track from Alton became two parallel single lines. Electrification to Alton in 1937 caused the introduction of M7-worked push-pull train services over the Meon Valley line. The branch closed to passenger traffic from 7 February 1955. A local reporter writing about the line's closure was told about the Drummond-designed tank engines. Mishearing and miscomprehending, his report rhapsodised over 'tank and drum' engines! On the same date, West Meon, Privett and Tisted stations closed to goods. Fareham to Droxford closed to freight on 30 April 1962 and in June of that year a large number of 'cripple' wagons were stored in the sidings before scrapping. They were brought from Eastleigh to Fareham by 'West Country' class Pacifics on running-in turns, the wagons then being taken up the branch by a Q class 0-6-0.

Following the cessation of goods trains, the Knowle to Droxford length was leased to Charles Ashby for trials of the one-man-operated Sadler Pacerailer — a diesel railcar with a Strachan's body on an AEC 'Reliance' coach chassis with flanged, rubber-tyred wheels. A nine-litre engine offered a speed of 70 mph and fuel consumption of eleven miles per gallon. It was planned to use it eventually on the Cowes branch on the Isle of Wight. The experiment was terminated when vandals set the car alight. Ashby's headquarters at Droxford also had 'Terrier' 0-6-0T No. 32646 and a passenger coach

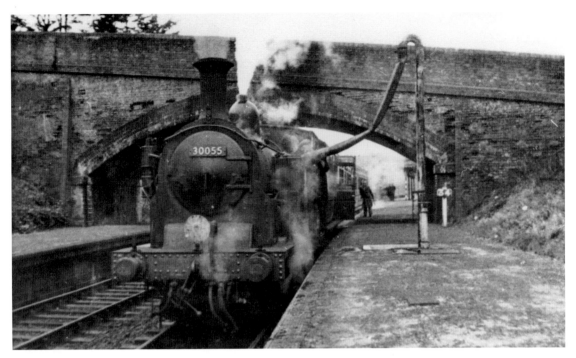

M7 class 0-4-4T No. 30055 is watered at West Meon, when working the penultimate train on the last day, 5 February 1955. *Author's collection*

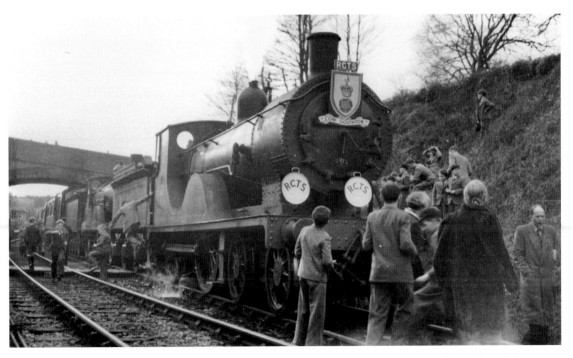

T9 class 4-4-0s No. 30301 and No. 30732 at West Meon with the Railway Travel & Correspondence Society's special on 6 February 1955, the day following the last regular passenger service. The first locomotive has wide splashers, while the second has the narrow variety, with a raised portion to accommodate the coupling rods. It also has a narrower cab. *John Bamsey*

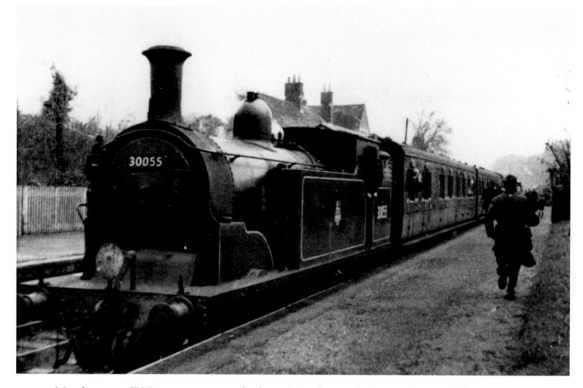

M7 class 0-4-4T No. 30055 at Droxford, working the penultimate train on 5 February 1955, the last day of regular working. *Author's collection*

for comparative testing of a branch line steam train against his new railcar. His lease terminated at the end of 1969 and BR removed the connection at Knowle Junction.

Alton to Farringdon closed to goods traffic on 5 August 1968. Farringdon originally only had a siding, but a short platform opened in 1931 and until 8 July 1934 was called Farringdon Platform. Tisted was the first of the standard substantial brick-built stations with a two-storey stationmaster's house, booking office with wood panelling to dado level and a ceiling taken into the pitch of the roof. Access to the platform was by a set of impressive sliding doors. During the Second World War a long refuge siding south of Privett station was used for stabling restaurant cars out of use for the duration. Privett station was at the line's summit, 519 feet above sea level.

The timber footbridge at West Meon station was later replaced by a drop in the platform. At Droxford two of the railway's cottages suffered such severe bomb damage in the Second World War that they had to be demolished. At the beginning of June 1944 the LMS Royal Train was stabled at the station for four days and used as the D-Day headquarters of the Supreme Allied Expeditionary Force, Eisenhower, Churchill, de Gaulle and Smuts controlling the initial phases of the Normandy landings.

Knowle Asylum Halt was opened on 1 May 1907 and was renamed Knowle Halt on 5 October 1942. It was only served by Meon Valley trains. Passengers travelling to the 100-foot platform were advised to situate themselves in the rear portion of the train to avoid it having to draw up twice. The Working Timetable Appendix, 1911 stated:

Knowle Asylum Halt.—This Halt Platform, 100 feet in length, is situated between Wickham and Fareham Stations. Passengers travelling to and from the Halt should be accommodated, as far as possible, in the rear portion of the Trains so as to avoid to necessity of Trains pulling up a second time.

No Staff is provided at the Platform; except when otherwise arranged, Guards of Trains stopping at the Platform must note the number of Passengers joining the Trains and see that their fares are collected at the termination of their journey. The Guards, except when otherwise arranged, will also be responsible for the collection of Tickets from Passengers alighting. These Tickets must afterwards be delivered up at Wickham or Fareham Station, as the case may be, for despatch to the Audit Office in the usual way.

Extract from the SR Working Timetable Appendices 1934.

The halt closed to passengers on 12 August 1963, but a Transport Users' Consultative Committee forced reopening the next day. Passenger traffic was finally withdrawn on 6 April 1964. The asylum's siding for coal and stores closed on 30 April 1962.

Fareham was the junction with other lines and keeping a connection was most important, as a story by Roger Arnold, regarding Sir Herbert Walker, the SR's general manager, reveals. In the 1920s: 'We approached Fareham and just as our train came to a halt I espied another M7 0-4-4T heading a two-coach salmon and umber outfit standing in the bay. The guard was fingering his green flag ready to wave it just as we drew to a halt. But he did not! A stentorian roar from the footbridge came like a thunderclap to Guard Grant, "George Grant, hold that train!"' As it seemed to Roger Arnold, 'A huge square-shouldered man in a tweed overcoat, with pince-nez gold spectacles, came down and hurtled over the timber crossing from the island to the bay platform with the alacrity of a young athlete, rather than a staid man in his forties. Once more his instinct for the detail paid off. With his furled umbrella like a foil at the ready, he came up to the startled guard. "Your name is George Grant? Mine is Herbert Ashcombe Walker. You were about to start this train before the passengers from the 5.50 p.m. from Southampton could join, although this is the last train up the Meon Valley today!"

By this time the capless stationmaster came running up to see what had caused the disturbance. Before he could collect his thoughts, Walker was speaking again, "Your name is Mr Peter Cooper; does this heinous thing happen every evening? If it does, let me assure you it will not again without your coming to Waterloo." A faint cheer arose from passengers within earshot. By then Walker had boarded the train and from a first class compartment was asking Cooper if he could telephone Alton. "Yes, sir." "Then tell Mr Smith that this train connects with the 8.20 p.m. to Surbiton and Waterloo and if it does not do so then HE can come to Waterloo and see me in the morning!"'

Strawberries and other soft fruit provided heavy traffic in season, especially at Mislingford Siding and Wickham, and out of season the fruit vans were stabled at West Meon. In the branch's later years sugar beet became increasingly important and at the time of closure was the line's most important traffic and was dealt with at Droxford and Farringdon after 1955, the Up platform at Droxford being rebuilt to carry beet lorries.

M7 class 0-4-4T No. 30056, near Alton, *c.* 1950. Its tank sides are lettered 'British Railways'. Notice the electrified rail immediately on the camera side of the train. *Lens of Sutton*

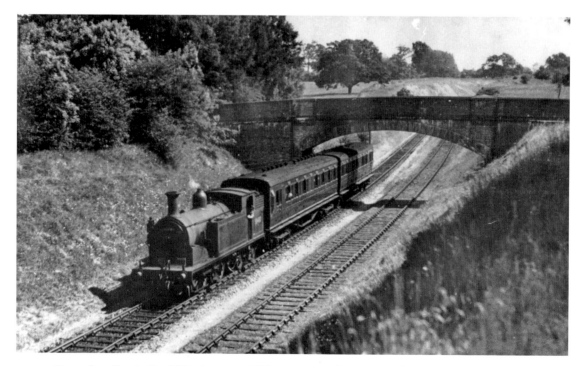

Up push-pull train fitted M7 class 0-4-4T No. 480, propels a two-coach set, just south of Privett, 1950. The locomotive is in BR livery, but has no sign of ownership. *E. C. Griffiths*

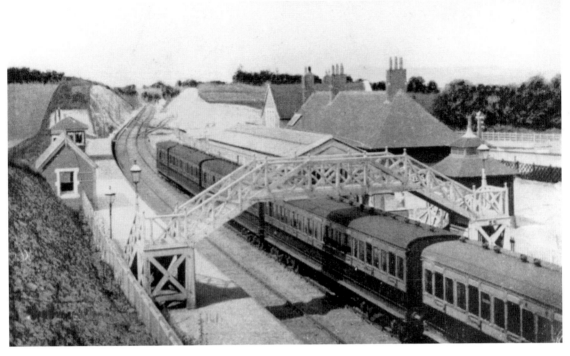

West Meon station *c.* 1903. *Author's collection*

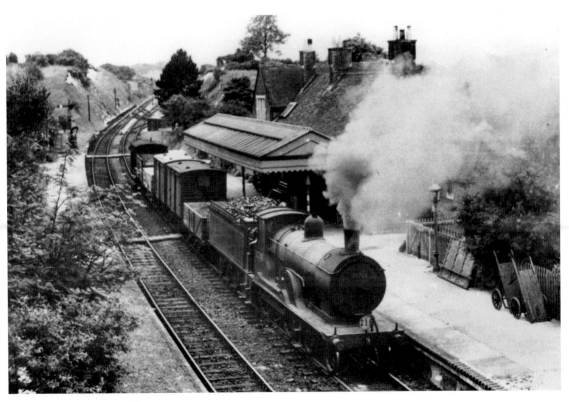

T9 class 4-4-0 No. 30708 leaves West Meon with the 3.40 pm goods, 9 June 1949. *E. C. Griffiths*

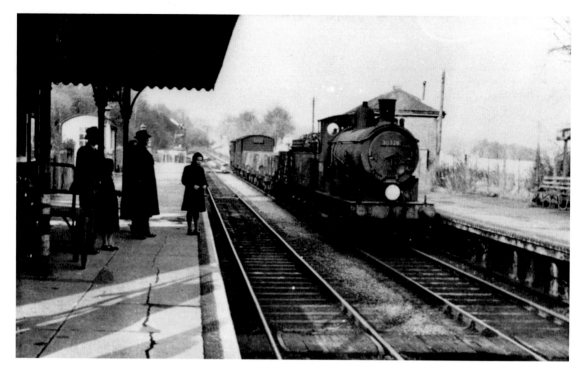

700 class 0-6-0 No. 30326 enters Wickham, 5 February 1955, with a Down goods. *Author's collection*

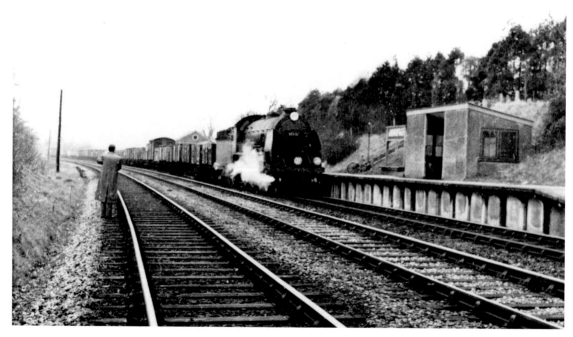

An N15 class 4-6-0 passes Knowle Halt with a freight train for Fareham *c.* 1960. Notice that the Meon Valley line serves the platform, while the double Botley and Eastleigh lines, left, do not offer this facility. *Lens of Sutton*

Right: The west end of Fareham Tunnels, 2 May 1996. *Author*

Below: Fareham, view towards Knowle Junction *c.* 1905. On the left is a Southampton to Portsmouth train via Netley. Cattle wagons stand on the far left. *Author's collection*

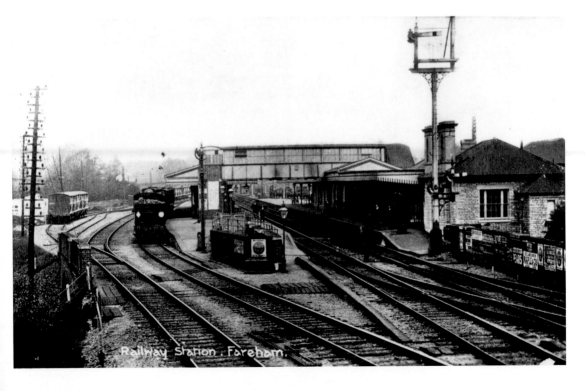

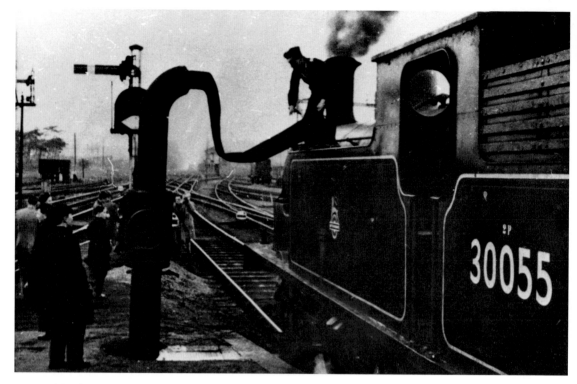

M7 class 0-4-4T No. 30055 is being watered in the bay platform at Fareham for the penultimate Meon Valley passenger train, 5 February 1955. *Author's collection*

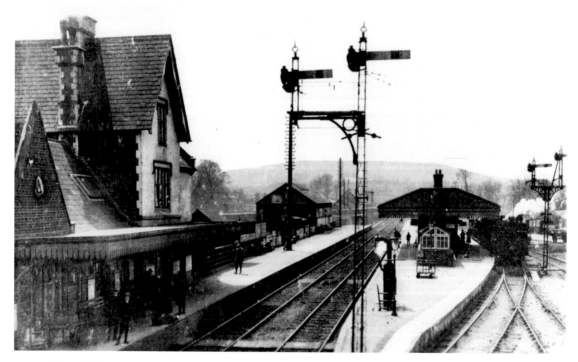

Petersfield, view Up, *c.* 1910. Branch trains used the right-hand platform. *Author's collection*

PETERSFIELD TO ROGATE

Only a couple of miles of the Petersfield to Midhurst line lay in Hampshire before it crossed into Sussex. It was built under the Petersfield Railway Act of 23 July 1860. The first sod was cut on 4 April 1861 at the site of Elsted station in the presence of a lively crowd from the Red Lion, Petersfield – 'Old coaches, used years since, when railways were not thought of, were brought out, gaily decorated with Volunteer flags'. It amalgamated with the LSWR on 22 June 1863 and opened on 1 September 1864. Latterly worked by 0-4-4Ts of T1, O2 and M7 classes fitted for push and pull operation, the line closed to all traffic on 7 February 1955. Freight trains had been worked by ex-LBSCR 0-6-2Ts of the E4, E5 and E5X classes and C2X and Q class 0-6-0s.

BENTLEY TO BORDON

When the War Office asked the LSWR to build a line to serve a new camp in Woolmer Forest, the LSWR obtained powers under a Light Railway Order of 6 October 1902. In usual light railway fashion level crossings were gateless, had cattle grids and were subject to a speed restriction of 5 or 10 mph Unusually, instead of a contractor being engaged, the LSWR's engineer's department carried out the work of building the four-and-a-half miles of line, completing the task in only eighteen months. Single track was laid, but sufficient land taken for double track.

The line opened on 11 December 1905 and the shelterless intermediate Kingsley Halt opened on 7 March 1906 with the inauguration of a steam railcar service by H13 class No. 9. Later, 2-2-0T motor tanks and trailer cars appeared.

Comparative statistics of passenger trains working on the Bordon Branch:

	Railcar	Motor Tank	O2 class 0-4-4T
Pounds of coal burnt per mile	13.2	18.6	26.8
Cost of working per mile	3s 4d	5s 9d	10s 6d

Most of the station buildings at Bordon were of corrugated iron, including the goods and the locomotive shed. The latter, little used, was abandoned in 1951. Bordon station was capable of handling up to four 10-coach trains. The station was lit from a small coal-gas producing plant. At Bordon the LSWR built ten terraced houses for staff and a detached station master's residence. The partition walls between the houses were of brick, but those within the house were tongue and grooved timber. The earth privy was outside.

The First World War brought increased traffic and on Sunday evenings in 1916 four special trains left Waterloo for Bordon. A large proportion of the branch goods traffic was exchanged with the Longmoor Military Railway. The timetable in the early 1930s was most curious as no weekday Down trains were run, only two early morning Up trains, while on Sundays no Up trains ran, but there was an early morning Down. Therefore, if you caught the 8.44 a.m. from Bordon on Monday you could not return by rail until the following Sunday, while if you detrained at Kingsley Halt you were unable to return as the Sunday train did not call there! The largest engines allowed on the branch until 1941 were 4-4-0s, then a 2-6-0 was tried. Its weight damaged an underbridge and services had to be suspended. This bridge was repaired and strengthened by the Royal Engineers and subsequently 2-6-0s were permitted to work

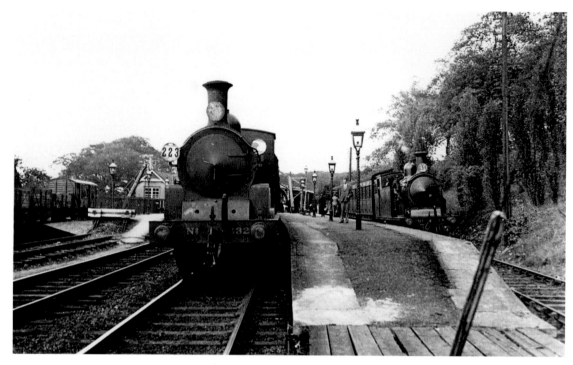

Bentley station *c.* 1932. A12 class 0-4-2 No. 632 is on the left, with a Waterloo to Southampton Terminus train and, on the right, is M7 class 0-4-4T No. 28 with a Bordon train. *Lens of Sutton*

M7 class 0-4-4T No. 30028 near Kingsley Halt propelling a Railway Enthusiasts' Club special. *Lens of Sutton*

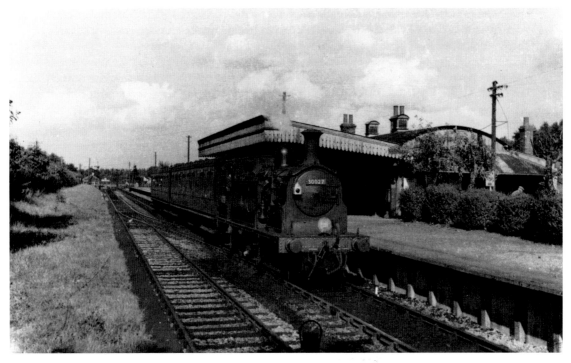

M7 class 0-4-4T No. 30027 at Bordon with a push-pull train. Note the rear lamp attached to the smoke box door. *Lens of Sutton*

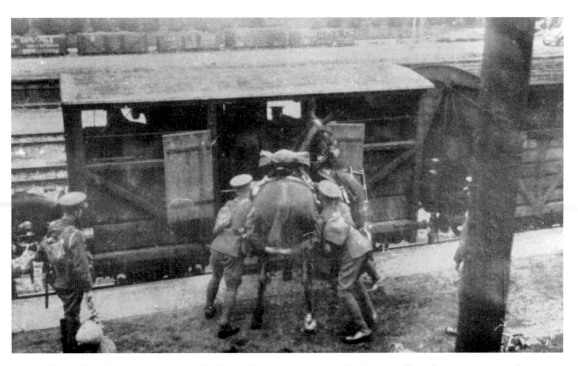

Not all enjoy the prospect of rail travel – attempting to load an artillery horse into a cattle wagon at Bordon *c.* 1930. *Author's collection*

over the branch. Latterly the branch passenger train service consisted of an M7 class 0-4-4T and a two-coach push-pull set. The regular passenger service was withdrawn on 16 September 1957 and the line closed completely on 4 April 1966.

The Association of Train Operating Companies' report, 'Connecting Communities', published in June 2009, put forward a positive business case for restoring the branch to Bordon. The single track, electrified branch would terminate at a new station site on the formation of the former Longmoor Military Railway and set half a mile nearer the town centre. This line would ease the pressure on Liphook and Farnham stations, at both of which car parking is fully utilised. Apart from serving London, rail access to Farnham, Aldershot and Guildford would be of value, reducing the pressure on local roads and the daily traffic congestion experienced in these towns. The proposed half-hourly train service could alternate with the Alton to Waterloo service once an hour, or form a portion,(attached at Farnham), every half hour. It could operate as a shuttle to Aldershot connecting with Guildford, Ascot and Waterloo services.

THE LONGMOOR MILITARY RAILWAY

Longmoor Camp was initiated in 1900 to provide accommodation for soldiers returning from the South African War. The first railway troops, the 53rd Railway Company of the Royal Engineers, arrived in May 1903 to move huts from Longmoor to Bordon, a distance of five miles. They were shifted by the ingenious method of laying two parallel narrow gauge tracks about 24 feet apart to carry trolleys on which the huts were transported. Haulage was achieved by laying out a cable, attaching it to a convenient tree and then winding it in on a steam winch. The fastest time for making the journey was a day.

In 1905 a parallel standard gauge line was laid to connect with the Bordon Light Railway. Standard gauge traffic began on the Woolmer Instructional Military Railway in 1908, its name being changed to the Longmoor Military Railway in 1933. Apart from carrying supplies to and from the camp, the line had the purpose of training railwaymen for military working. As well as for regular soldiers, it was used for the annual summer training of the Supplementary Reserve units recruited from British railway companies. Over forty trades were taught including those of surveyors, draughtsmen, platelayers, enginemen, signalmen, traffic control staff as well as workshop staff, comprising such skills as boilermakers, loco fitters and welders. Railway clerical work such as checking and store keeping was also taught. There were three departments which dealt with railway construction, operating and workshop practice respectively. Longmoor training was aptly summed up in the remark: 'You can tell a Longmoor-trained Sapper anywhere, but you can't tell him much.'

The line offered the opportunity of experiencing double and single line working with a variety of token instruments and the use of the telegraph line-clear message system. To give staff the chance of a longer run, the construction of the Hollywater Loop, four miles in length, was surveyed and laid in 1932 for training purposes, but then lifted. Relaid in 1942 it added an oval to the layout, so that if required trains could keep going round and round Hornby-style.

Work on the three-and-a-half-mile-long line southwards from Longnoor to Liss was started in 1924 and opened in 1933. Exchange sidings with the SR were added at Liss in 1942.

In 1933 the Longmoor Military Railway was run by 22 officers and 385 other ranks. Stock that year consisted of six engines and over 100 coaches and wagons,

most of the former being ex-First World War GWR ambulance train vehicles returned from France. To offer further experience the line had two internal combustion-engined railcars. There was an extensive locomotive shed and workshops. Among the larger engines using the line in the 1940s were British and USA 'Austerity' 2-8-0s and the British 2-10-0s; G16 class 4-8-0Ts Nos 30494 and 30495 loaned by BR in October 1954 were used mainly between Bordon and Longmoor.

Unfortunately a fatal accident occurred on 13 October 1956 when 0-6-0DE WD No. 877, built by English Electric and the LMS, was involved in a head-on collision with another LMS-built engine, WD No. 512, a Stanier 8F class 2-8-0. The accident happened on the single line between Longmoor Downs station and Liss Forest Road station. As a result six soldiers lost their lives and twelve were injured. The diesel was scrapped but the 2-8-0 was left unrepaired until purchased by BR in 1957 when it was put into working order and numbered 48775.

Traffic at Longmoor was heavy during both world wars. On some days during the Second World War over 800 wagons were exchanged with the SR. The line offered free travel to passengers, including civilians, provided they held a ticket stipulating that they travelled at their own risk. The number of train operations declined from 1948. Oakhanger to Bordon ceased on 4 April 1966 with the closure of the Bordon Light Railway and complete closure of the Longmoor Military Railway came on 31 October 1969, and subsequently parts of the line were used for filming *The Young Winston*. The line had been previously used for filming *The Great St Trinian's Train Robbery*.

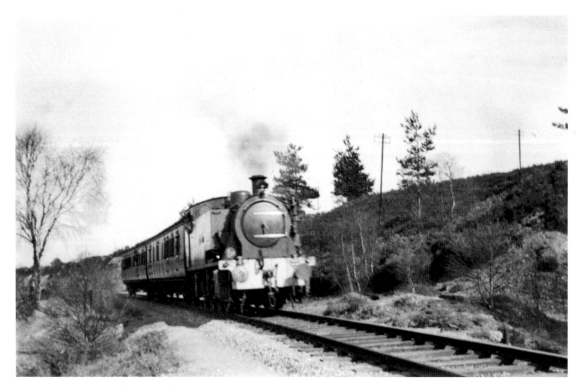

Longmoor Military Railway 0-6-2T *Kitchener* built by Bagnall in 1938, with a train of ex-GWR stock, 1940. *E. J. M. Hayward*

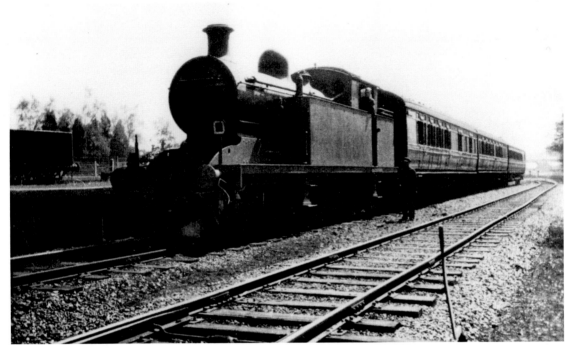

An ex-LBSCR 4-4-2T at Longmoor. *Colin Roberts's collection*

Instruction in a guard's duties, Longmoor. *Author's collection*

WD 0-6-0ST No. 156 at Longmoor, 22 October 1967, with two condemned ex-BR coaches. To the right is a steam crane and runner wagon. *R. A. Lumber*

A steam crane lifts WD 0-6-0 No. 70195, ex-GWR Dean Goods No. 2531. *Author's collection*

WD 2-10-0 No. 600 *Gordon* at Longmoor, 28 September 1968. This engine is now preserved. *Revd Alan Newman*

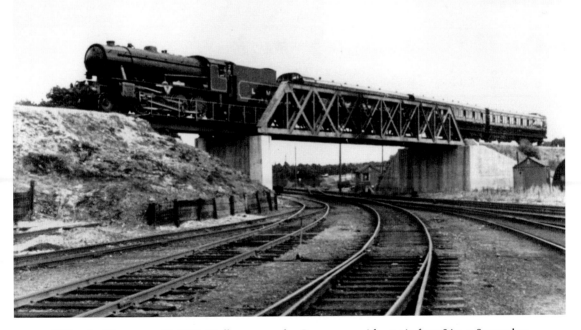

WD 2-8-0 No. 79250 *Sir D McMullen* approaches Longmoor with a train from Liss, 3 September 1949. Notice the wall of rails and sleepers retaining the embankment. The bridge spans the loco and traffic yards. *Pursey Short*

The Southampton Area

EASTLEIGH TO ROMSEY

The line from Eastleigh, (then known as Bishopstoke), to Romsey was part of the Bishopstoke to Salisbury line authorized on 4 July 1844. It was confronted with initial problems: landowners proved unusually obstructive; then, instead of using a well-established contractor, a small contractor was used in an attempt to save money; finally, the alternating rain, frost and thaw caused earthworks to slip and then freeze solid. Following three postponements the line eventually opened to coal and goods traffic on 27 January 1847. Passenger traffic started on 1 March 1847 and, until the opening of the direct line to Salisbury on 1 May 1857, this route was the main line to London. The intermediate station at Chandler's Ford closed to goods on 1 June 1964 and to passengers on 5 May 1969, the line being singled on 1 May 1972. A new platform was built approximately on the site of the original Down. Opened on 18 May 2003 it is 110 yards in length, it can accommodate a 4-car train. The ticket office and facilities opened 13 September 2003. Relatively high fares resulted in a successful campaign to reduce them in order to bring rail into competition with the quarter-hourly bus service. Today Chandler's Ford enjoys an hourly service each way daily.

EASTLEIGH TO FAREHAM

The London & Southampton Railway sought Portsmouth traffic and to that end obtained an Act of 4 June 1839 to construct a branch from its main line at Bishopstoke (Eastleigh) to Gosport on the opposite side of Portsmouth Harbour. This Act also changed the company's name to the London & South Western Railway. On 15 July 1841 a portion of Fareham Tunnel collapsed and this section was opened out to make a deep cutting with a tunnel at each end.

The fifteen-and-three-quarter-mile-long branch opened on 29 November 1841. The line closed four days later until 7 February 1842 owing to Fareham Tunnel becoming unsafe. On 3 January 1842, while assisting strengthening work, 2-2-0 No. 40 *Fly* was derailed and damaged in the cutting between Fareham No. 1 and No. 2 Tunnels when an earthslip burst the retaining wall.

In 1873 an accident occurred at Botley when an axle of the penultimate coach broke. Fortunately the fractured wheel set passed safely beneath the end coach and the train stopped within a distance of about 100 yards. During the Second World War, two 4-4-0s running light engine fell into a bomb crater and had to be lifted out with the aid of Nine Elms 45-ton crane. Their problems were still not over. Towed back to Eastleigh by the breakdown train, they were bombed by a night raider.

The intermediate stations of Botley and Fareham still remain open and a new station at Hedge End opened on 9 May 1990. Botley, the principal intermediate station, at one time despatched very heavy strawberry traffic. For instance, on 29 June 1923, 64 vans were required to load 66,017 baskets, bringing in a revenue that day of £571 19s.

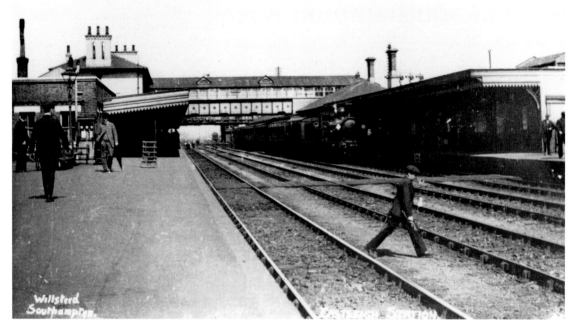

An Adams' 4-4-0 enters Eastleigh *c.* 1905, with a Down train bearing the Southampton, Eastleigh and Salisbury route code. *Author's collection*

Snow at Eastleigh 25 April 1908. On the left 460 class 4-4-0 No. 460 heads a train to Portsmouth. Men are at work clearing the track. *Author's collection*

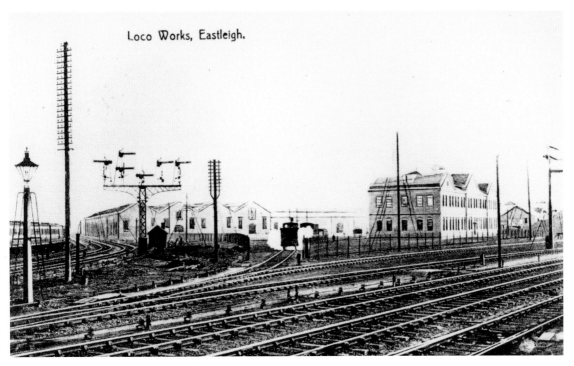

View from Eastleigh station *c.* 1908: the Botley and Fareham line, left and the Southampton line, right. *Author's collection*

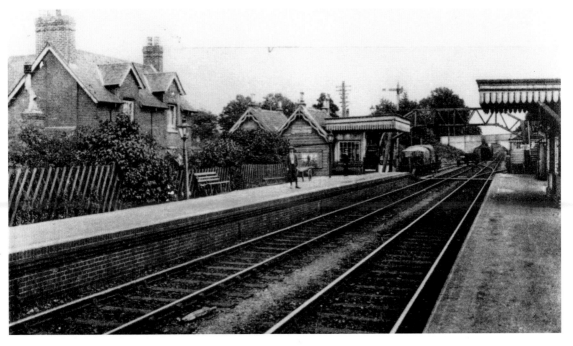

View of Chandler's Ford, looking towards Eastleigh. A goods train is being shunted at the far end of the station. *Author's collection*

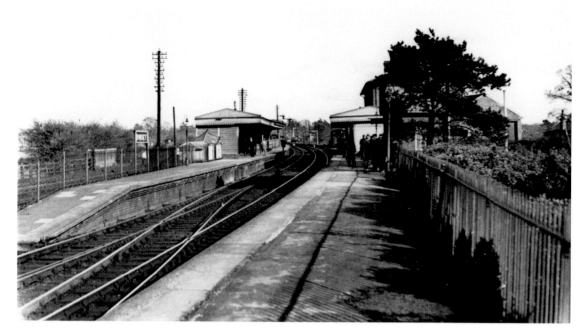

View of Romsey, looking towards Southampton. *Author's collection*

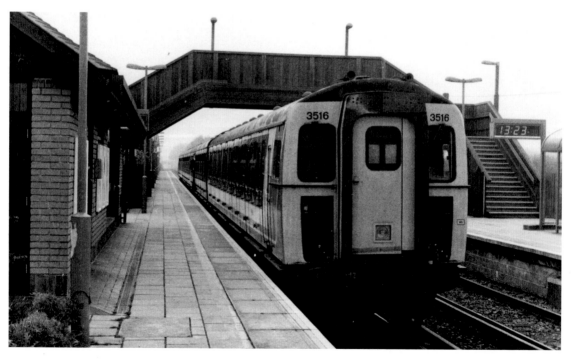

Rear view of EMU Class 423/0 No. 3516 at Hedge End 2 May 1996, working the 12.48
Portsmouth Harbour to Winchester. *Author*

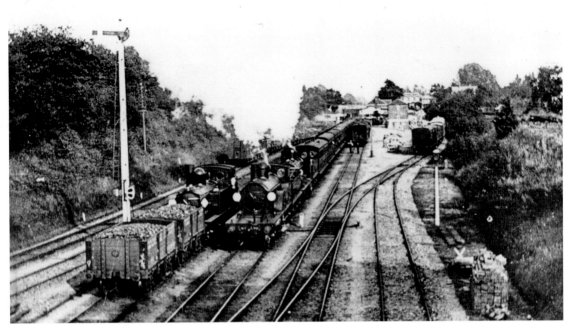

A double-headed fruit special leaves Botley, *c.* 1908, behind a 4-4-0 (probably X2 class No. 596) and a Jubilee 0-4-2. The Bishop's Waltham branch tank engine on the left is shunting coal wagons. *Author's collection*

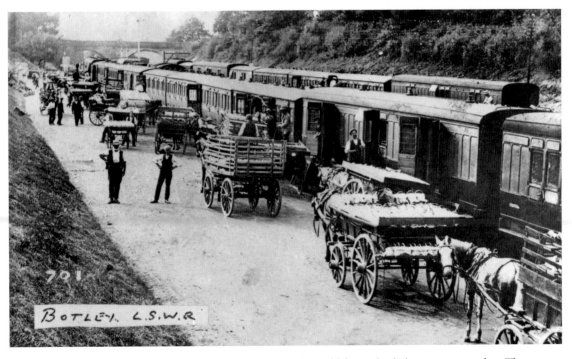

Strawberries being loaded at Botley, *c.* 1908, some into old four-wheeled passenger coaches. The scene was photographed before 1911 when the left-hand arch of the bridge was replaced by a steel span to permit the head shunt to be lengthened. *Lens of Sutton*

D15 class 4-4-0 No. 30467 leaves Fareham with the 16.48 Portsmouth to Eastleigh, 25 September 1949, composed of GWR stock and travelling via the Fareham Tunnel. The fireman collects the staff for the single line section ahead. *Pursey Short*

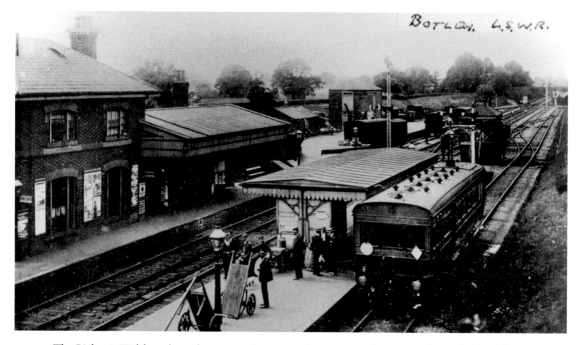

The Bishop's Waltham branch steam railcar at Botley *c.* 1910, view towards Eastleigh. A lamp boy is climbing the signal post. *Author's collection*

Temporary additional staff consisted of a foreman, 6 clerks, 30 porters and about 13 loading boys. Today Botley has a flourishing Aggregate Industries Limited stone terminal receiving about two trains weekly.

In 1849 Knowle Farm was chosen to be the site for the Hampshire County Asylum. Requests were made for a station to serve it, as well as a siding, or tramway, for coal deliveries. The railway company declined because the station would have been unremunerative. In May 1849 petitions were presented from local residents, some promoting and others opposing such a station. By September the railway agreed to stop two trains each way if the station and tramway were constructed by the Asylum authorities and that the average number of passengers per train was at least three. Discussions continued through 1850, but then stopped. In November 1906 when a new halt was approved for a sum of £53, the LSWR Traffic Committee stated that there was a 'long standing custom of stopping trains at Knowle Junction on certain days for the convenience of persons visiting the Hants County Asylum.' Presumably passengers returned to their destinations via Fareham.

BOTLEY TO BISHOP'S WALTHAM

The Bishop's Waltham Railway Act was passed on 17 July 1862. Work on the three-and-three-quarter-mile-long branch proceeded quickly and the track was near completion on 17 April 1863, when the company secretary reported that the Board of Trade inspector had received a month's notice of opening — yet on this date no tenders for a station at Bishop's Waltham had been sought! On 8 May the directors wished to limit its cost 'as much as practicable', so arranged with Messrs Bull of Southampton to erect a temporary station for £103, this work taking only a fortnight.

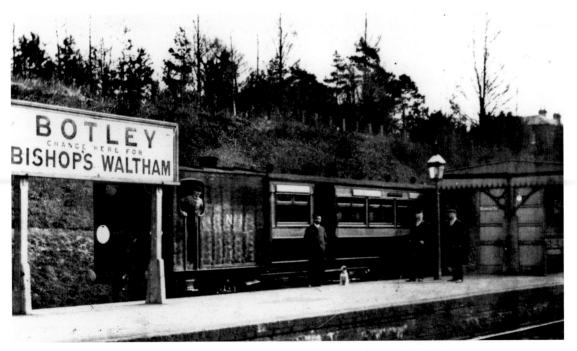

H12 class railcar No. 1 at the Bishop's Waltham branch platform, Botley *c.* 1904. *Author's collection*

The delay meant that Captain Rich of the Board of Trade was unable to carry out an inspection until 28 May 1863. He then made several criticisms insisting that the rails should be joined by fishplates round the sharp 242-yard radius curve approaching Botley and commenting that 'This line not being fished, and having many curves, should not be worked at great speed'.

Receiving an undertaking that only tank engines would be used, he did not insist on the installation of a turntable. His report stated: 'There is no junction for passengers with the London & South Western Railway at Botley. The passengers are to be deposited on an intervening platform'.

The line opened on 1 June 1863. An Act of 22 June 1863 authorised raising further sums to make improvements to the line, such as a permanent station at Bishop's Waltham. Of pleasing and imposing design, it had red and yellow brick walls and a roof part slate and part tiles, while the crenellated chimneys were red brick with yellow chevrons.

In January 1866 the working company, the LSWR, required an engine shed at Bishop's Waltham but as insufficient capital was available the LSWR paid for the timber structure, charging the local company six per cent interest. The shed was removed in July 1931. Its inspection pit had the unfortunate propensity to flood each time exceptionally high tides came up the Hamble River.

'Minerva' class 2-4-0WT *Salisbury* was shedded at Bishop's Waltham. In March 1867, and again in October 1868, its driver was fined for 'failing to ensure that the fire was correctly banked at night to ensure that the first train of the day departed punctually'.

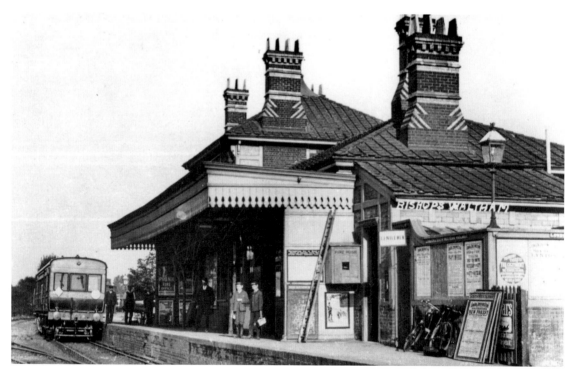

Steam railcar at Bishop's Waltham *c.* 1910. Posters advertise: New Forest; Waterloo; the Continent and Lynton. 'D' on the buffer beam indicates that it is the driver's end. Notice the ornate chimney brickwork. *Author's collection*

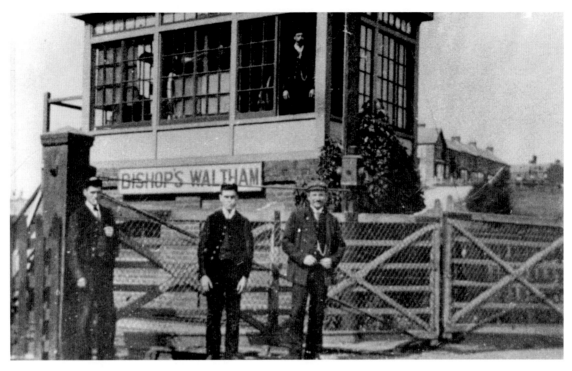

Bishop's Waltham signal box *c.* 1920. Notice the netting on the crossing gates to prevent them being climbed, or small animals squeezing through. *Author's collection*

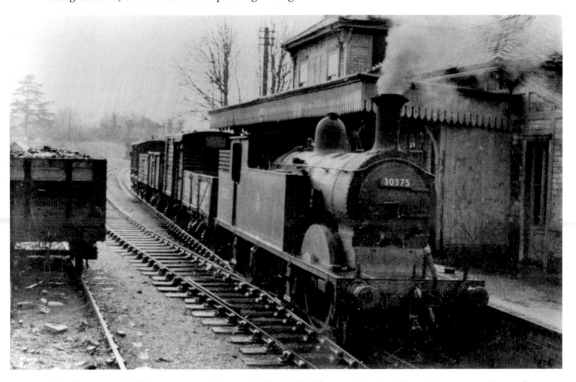

M7 class 0-4-4T No. 30375 arriving at Bishop's Waltham with a freight train *c.* 1955. *Lens of Sutton*

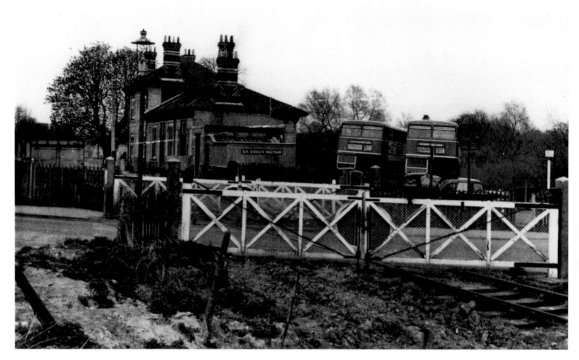

Bishop's Waltham station was served by double-deck buses – Eastern Coachworks bodies on Bristol chassis. *Lens of Sutton*

Financial matters became so desperate that the entire board of directors resigned on 27 February 1869, so it was then a most peculiar railway company — no directors, no secretary and no engineer, yet the LSWR still continued to work it. To ease problems, the LSWR attempted to buy the line, but as the company lacked directors and secretary, negotiations proved difficult for there appeared no one with whom to negotiate. Eventually Archibald Scott, the LSWR's General Manager, negotiated with S. C. Ridley, the contractor who held a judgement against the Bishop's Waltham company. As a result five directors were elected, Ridley being appointed chairman, and the last meeting was held on 30 December 1881, which confirmed the sale of the line to the LSWR for £20,000.

A steam railcar was introduced on 1 October 1904. Although cheap to run, numerous complaints of severe oscillation of the railcars were received from regular travellers. A modified series of cars was built at Eastleigh at a cost of £1,475 each and these were run in over the branch. A compromise was a C14 class 2-2-oT and separate coach for push-pull working. Following the outbreak of the First World War, the branch reverted to operation by ordinary tank engines.

Comparative statistics for passenger trains working on the Bishop's Waltham Branch:

	Railcar	C14 Class 0-2-2T	O2 Class 0-4-4T
Pounds of Coal burnt per mile	11.1	16.9	28.9
Cost of Working per mile	3s 1d	5s 8d	9s 4d

With increasing road competition and the inconvenience of having to change trains at Botley and Eastleigh in order to reach Southampton or Winchester, passenger services were withdrawn on 2 January 1933 saving almost £1,000 annually. Goods services lingered on for another twenty-nine years. Immediately following the Normandy invasion in 1944 the branch was treated as a long siding for storing empty tank wagons. Movements to add or retrieve wagons were carried on at night when wagons could be placed on the Down main line at Botley, single-working being instituted over the Up main. M7 class 0-4-4Ts were used until the 1950s, when Ivatt Class 2MT 2-6-2Ts appeared. The branch was closed to goods on 30 April 1962, the last train actually running on 27 April.

At Bishop's Waltham the line bifurcated, one siding leading to the clay works and the other to the gas works. On 23 December 1909 a halt opened at Durley Mill. At some point during the First World War a small crowd awaited the return of an unpopular curate. The railway staff at Botley neatly obviated a confrontation by arranging for him to travel in a van attached to the passenger train. On arrival at Bishop's Waltham, the van was taken to the appropriately ecclesiastical-looking goods shed where he was able to alight unseen by the crowd.

THE ROYAL PIER BRANCH, SOUTHAMPTON

In 1870 it was proposed to extend the Town Quay branch to the Royal Pier to facilitate traffic to and from the Isle of Wight. This new line was formally opened on 26 September 1871 when LSWR dignitaries were conveyed, in railway coaches drawn by three horses, from the ticket platform just outside Southampton Terminus station to the Pier. It opened to the public the following day. Normal trains consisted of two coaches, first and second class respectively, and a guard's van. Third-class passengers were expected to walk. In December a Southampton resident, concerned about dangerous working, observed that some of the trains proceeded at a trot and the driver rode on the buffer of the first coach without holding the reins.

Due to the difficulties raised by the large number of wagons passing to and from the Town Quay, objections to using steam power were overcome when in February 1876 the LSWR's Southampton Superintendent met the Borough Engineer. Early the next month they issued the statement:

> It is considered that small steam locomotives could be used between the Town station and the Royal Pier both to the benefit of the Company and the travelling public, providing certain rules were enforced namely:
>
> (1) The maximum speed should be restricted to 5 mph
> (2) The locomotive should be accompanied by a man with a red flag and a bell should be rung when crossing public roads.
> (3) The weight of the locomotive should be restricted to that of the largest Southampton Docks Company's tanks, that is to say 13 tons.
> (4) That special locomotives like the Dock engines with powerful brakes and exhaust steam passing to the tank should be used.
> (5) The permission granted should be for one year only but should then be renewable.
> (6) The responsibility of operating steam locomotives should rest entirely with the Railway Company.

Receiving this approval, the LSWR borrowed the Dock Company's 0-4-0ST *Sir Bevis* for tests to and from the Royal Pier and wrote to the council on 17 March 1876 that at 5 mph this engine could be stopped within its own length.

As the LSWR had no suitably light locomotive an 0-4-0ST was ordered from Alexander Shanks, Arbroath at a cost of £1,025. This engine, named *Southampton*, started work on 21 September 1876. It was highly distinctive for the exhaust steam pipes of the condensing gear ran in high arches from the smokebox to the square saddle tank. Adams, the LSWR's locomotive engineer, said that it had one of the most efficient condensing systems he had encountered during his many years' experience with steam engines, both ashore and afloat. It was so successful that a sister engine, *Cowes*, was purchased. Both were required to be in steam and when one was stopped, for washout or repairs, horses had to be substituted. Alfred Giles, contractor for Cuxhaven Harbour, Germany, offered a similar engine *Ritzebuttel* for sale at rather less than half the new price, so it was secured.

The 2 mph maximum stipulated by the Locomotives Act, 1865, for travel on a public highway was regularly exceeded and the LSWR fined up to £10 for this misdemeanour. By Order of 29 July 1881 the Board of Trade raised the limit to the 5 mph which had been approved by the Southampton Council.

Ritzebuttel was replaced on Royal Pier services in April 1900 by an ex-Southampton Dock Company's locomotive; *Southampton* and *Cowes* went early before 1907 when C14 class motor tanks had taken over the Pier working. *Southampton* was sold in December 1915 to Kynoch Limited, Longparish for £265.

In 1890 the Royal Pier was virtually rebuilt, passengers enjoying a covered station in direct communication with steamers. This new pier opened on 2 June 1892. From

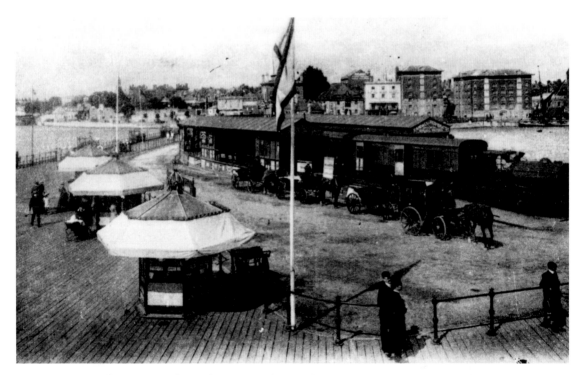

0-4-0ST *Clausentum* with coach Set 77 on the Royal Pier, Southampton, *c.* 1905. *Clausentum* is the Roman name for Southampton. *Author's collection*

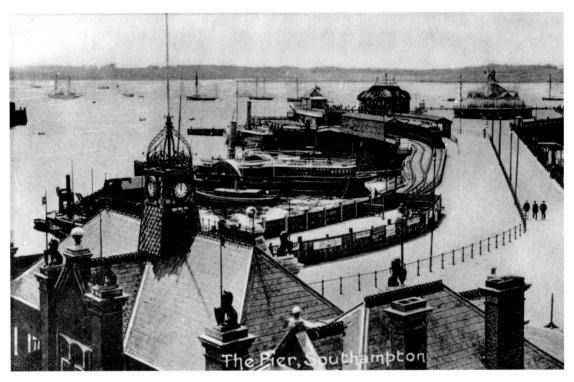

The Royal Pier, Southampton, with the railway on its left-hand side. Two paddle steamers and a steam launch can be seen. *Author's collection*

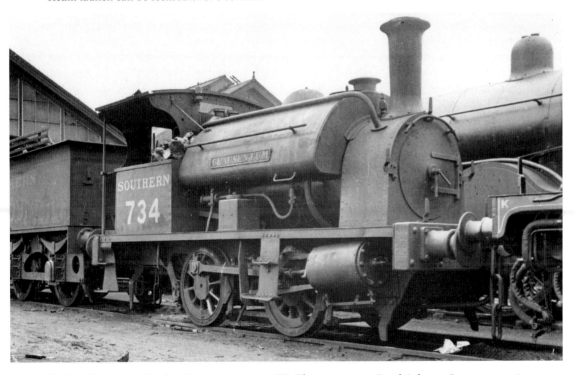

Ex-Southampton Docks Company's 0-4-0ST *Clausentum* at Eastleigh, 23 January 1938. *Arthur C. Roberts*

9 December 1912 steam railcars No. 1 and No. 7 were used on the Southampton West-Southampton Terminus-Royal Pier service. In 1913 the portion of the pier on which the railway was situated needed major repairs costing approximately £6,000. The passenger service was withdrawn in September 1914 and never restored.

NETLEY HOSPITAL RAILWAY

On 19 May 1856 Queen Victoria laid the foundation stone of the Royal Victoria Hospital, Netley, which was to accommodate military patients returning from overseas service, initially, of course, from the Crimean War. It was a vast building, a quarter mile in length, its south-western side enjoying an uninterrupted view of Southampton Water. During building operations 2-2-0 locomotives were used, not to haul wagons, but to power mortar-mixers.

The hospital's first patient was admitted on 11 March 1863. A landing stage made access from the water easy, but by land the hospital was about three-quarters of a mile from Netley station which did not open until 5 March 1866. A special hospital platform was provided on a siding by Hound Road at the eastern end of the goods yard, but was far from satisfactory as it was unroofed until 1898 and without a waiting room until 1899.

That year the War Department asked the LSWR to lay a branch line just over half a mile in length. Undulating, with gradients generally falling at 1 in 70 towards the hospital, it proved difficult to work, especially in autumn when the rails were damp and covered with fallen leaves from overhanging trees.

The line opened on 18 April 1900 and the first two trains arrived on 23 April with casualties from Ladysmith. The flat-bottomed rails were spiked directly to the sleepers. The line was worked with train staff fitted with a key for unlocking the ground frame at the hospital. A 196-foot-long covered platform was connected to the hospital by a covered way. A small ticket office was manned, when required, by Netley station staff. Later in 1900 a siding was laid at the hospital to stable five ambulance coaches in a corrugated iron shed, the hospital's steam supply available to warm them before use. To accommodate all the Boer War casualties, 100 huts were built, doubling the number of beds to 2,000.

Between 24 August 1914 and 31 December 1918 approximately 1,200 hospital trains arrived at Netley. During the First World War sometimes a second engine was required to assist a heavy train and occasionally this was a GWR 0-6-0. Each Tuesday and Friday a train left with discharged patients.

Immediately prior to the Second World War rail movements on the hospital line averaged about five a year. K10 4-4-0 No. 142 arrived at Netley Hospital in 1942 with about twenty horse boxes. Their occupants had been bombed out and were brought to enjoy the grass in the hospital grounds. Very few hospital trains arrived at Netley until 1944, by which time it had been taken over by the American authorities. In order to use heavier locomotives, the track was relaid with good second-hand bullhead rails on fresh ballast. Following D-Day, casualties were brought by road but, when treated and fit to travel, were moved by ambulance trains to other hospitals for further treatment and convalescence. In June and July 1944, up to five fourteen-to-sixteen-coach trains left Netley Hospital daily with an engine at each end. Locomotives were ex-LSWR and 'Schools' class 4-4-0s, Maunsell 2-6-0s, while 'foreigners' including LNER Class B12/3 4-6-0s and a GWR 2-6-0 also appeared. Wet rails, combined with the steep gradient, could cause the trip up to the main line to take as long as forty-five minutes on occasions. The last train over the line was on 30 August 1955, when 700 class

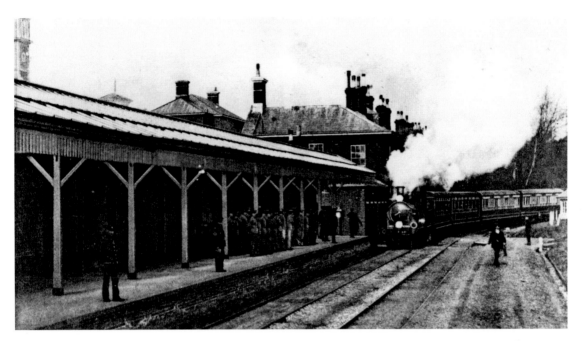

An ambulance train, headed by 395 class 0-6-0 No. 442, arrives down the gradient into Netley Hospital station, *c.* 1914. The third and fourth coaches were normally stabled at the Hospital. *Author's collection*

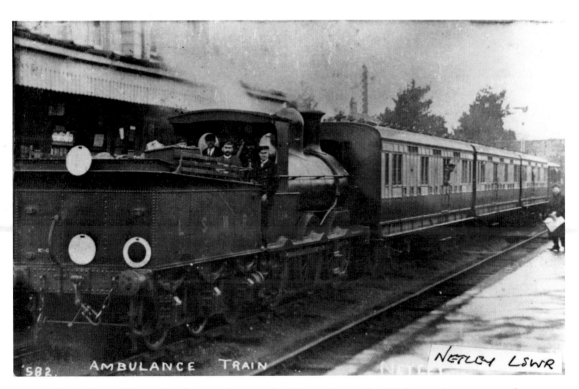

Single-framed Beyer Goods 0-6-0 locomotive No. 336, entering Netley station, *en route* for Netley Hospital, *c.* 1914. Its tender bears the No. 6. *Author's collection*

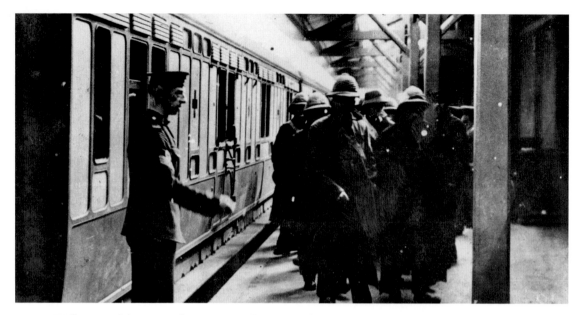

Walking invalids arriving by train at Netley Hospital, *c.* 1914. Notice the cross on the ambulance coach. *Author's collection*

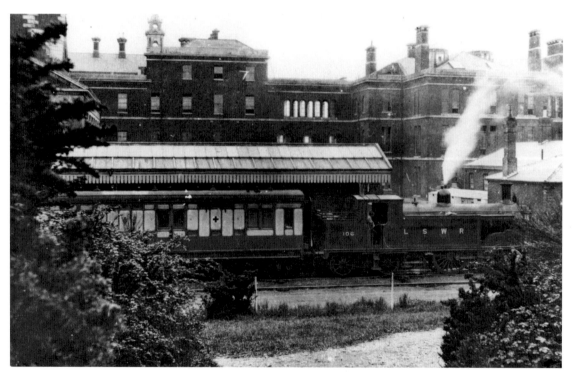

M7 class 0-4-4T No. 106, ready to depart from Netley Hospital, *c.* 1914. *Author's collection*

0-6-0 No. 30350 hauled out the remaining ward cars. The hospital and station were demolished in 1967 though the chapel still remains.

THE HAMBLE OIL TERMINAL BRANCH

A one-and-a-half-mile-long standard gauge line ran from just west of Hamble Halt to a jetty on Southampton Water. Between the two gated level crossings over the B3397, the branch passed almost through the centre of Hamble Airfield which had been set up before the First World War. The line opened in about 1919 and served a BP oil distribution depot. Originally worked by an Avonside 0-6-0ST, internal-combustion powered locomotives were introduced from the 1930s.

When the Duke of Edinburgh came to officially open the College of Air Training in 1961, an 'H' for 'helicopter' was laid on the field near the building to indicate where it should land. Just before his arrival the BP diesel locomotive hauling a tanker train stopped between the 'H' and the control tower as a bearing was defective, preventing it from being moved. As the Duke was about to land, the problem was solved by moving the 'H' 200 yards up the airfield, but this gave him a longer walk. He commented on the strange sight of a railway engine in the middle of an airfield.

Before a train was allowed to cross the airfield, air traffic control's permission had to be sought and priority was given for planes — not trains. Due to the 1 in 40 rise, three loaded four-wheel tank wagons was the maximum load permitted.

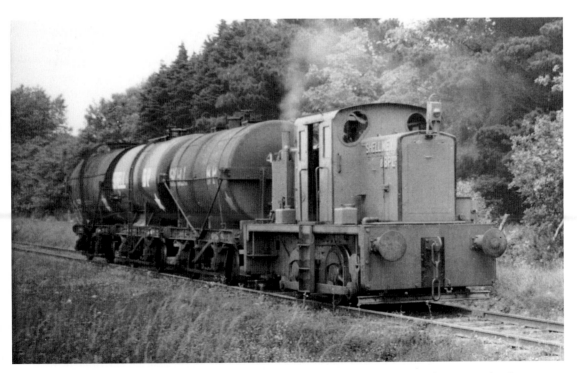

Shell Mex & BP Company's John Fowler 0-4-0DM, Works No. 22973, built in 1942, hauls a loaded train from the jetty to the main line, 30 June 1954. *Revd Alan Newman*

South-East Hampshire

FAREHAM TO GOSPORT

Gosport station, designed by Sir William Tite, was in a delightful Italianate style with a colonnade of fifteen sturdy Tuscan pillars. At each end was a large pavilion. The fact that the chimneys were no higher than the train shed roof was due to the military requirements that the building should be kept low so as not to interfere with the fortifications. Gosport station cost £10,980, whereas Eastleigh and Fareham were built for £1,509 and £1,391. Although Gosport was built with two platforms, in practice only one was required and the other was turned over to goods or cattle use. Early in 1875 part of the passenger station roof was destroyed by fire, but the rest saved due to the prompt assistance of the Royal Marines. One curiosity was Gosport Station Club, which opened on 15 March 1930. It was a licensed club for railway staff with a full-time steward providing food and drink. Members enjoyed play at card and billiards tables.

On 1 April 1845 the electric telegraph was brought into use over the 88 miles between Nine Elms and Gosport. However, the main purpose of this was to assist the Admiralty, and not the railway, since it was a far superior system compared with the former naval system of a series of mechanical semaphores set on vantage points. The public was also allowed to use this electric telegraph, which was the longest of its kind in England. On 25 May 1845 Mr Staunton at Gosport and Mr Walker at Nine Elms played the first telegraphic chess match. Progress was telegraphed to fans at Southampton. The players were only allowed about fifteen seconds to make a move. Unless they were granted a reduction, normal charges were 3s for a single message or 5s for reply paid. And the result of the match? A draw was declared after nine hours.

From 1846, when Queen Victoria's Osborne House on the Isle of Wight was completed, Her Majesty normally passed through Gosport station *en route* to her own private station in Royal Clarence Yard adjacent to the pier where her yacht was moored. This 605-yard extension through the fortifications opened on 13 September 1845. The single curved platform, 520 feet in length, was covered and a carpet laid between her coach and the royal yacht. Although waiting rooms were provided, time-keeping was normally such that they were not required. This station was used by the funeral train when her body was carried to Victoria station on 2 February 1901. King Edward VII was not as enthusiastic about Osborne House as his mother and, following his coronation, this private station fell into disuse.

Other traffic continued to use Royal Clarence Yard and the Working timetable Appendix for 1911 ruled:

Whenever it is necessary for traffic to be worked from Gosport Station to Royal Clarence Yard, or *vice versa*, a written advice must be sent by the Station Master at Gosport to the Superintendent of the Royal Clarence Yard, stating the time at which it is proposed to carry out the transfer operation, in order that arrangements may be made for the Clarence Yard gates to be opened.

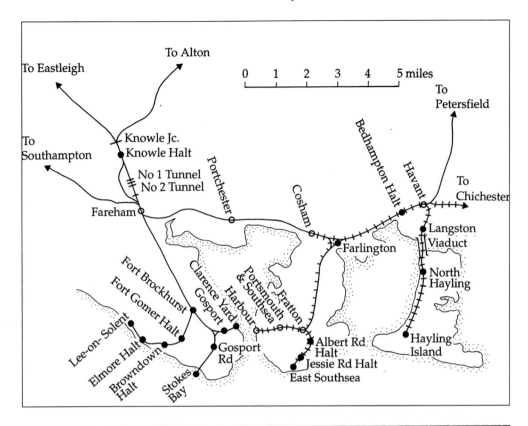

Queen Victoria and the French President Louis Phillipe, detrain at Gosport from the royal carriage, October 1844. *Author's collection*

The exterior of Gosport station, August 1933. *Author's collection*

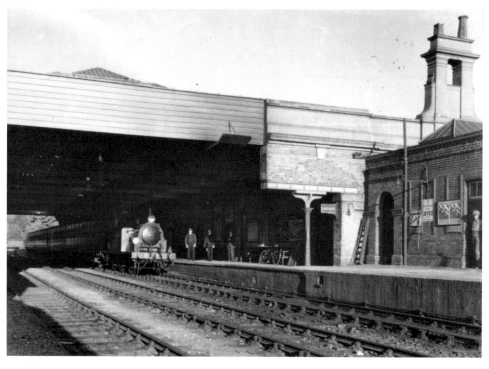

D1 class 0-4-2T No. B626 at Gosport with a four-coach train for Fareham, *c.* 1938. *Author's collection*

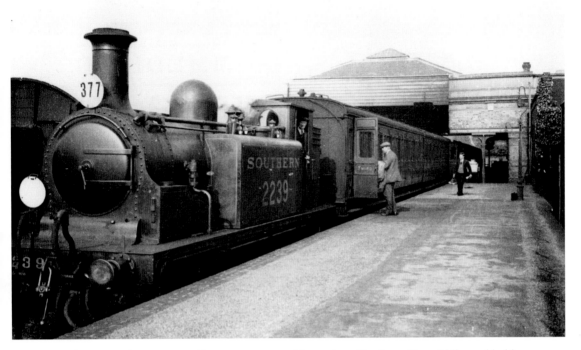

D1 class 0-4-2T No. 2239 at Gosport, *c.* 1934, with a train to Fareham. The middle road holds a line of goods wagons ready for departure. *Author's collection*

An advice must also be given to the Ganger at Gosport Station, so that the Railway Lines which cross the Public Roadways may be examined before the traffic passes over same.

On receiving a notification that the gates are open and that the Line is clear, also that the Permanent Way is in order, the transfer operation may take place. A Shunter, provided with red and green flags, and a hand lamp after daylight, must in all cases walk in front of the train or Light Engine; another Shunter must ride on the Engine when the Train is being hauled and on the leading vehicle, if possible, when the Train is being propelled, in order to safeguard the movements.

The speed of Trains and Engines when passing over the Public Roadways must not exceed 4 miles an hour.

The Boer War period saw increased activity at Fort Brockhurst station, close to the building which provided its name. Many cavalry units arrived at the fort after the war to be demobilized before joining special trains home. Named Brockhurst when opened in 1865, it had 'Fort' added on 22 November 1893 to avoid confusion with Brockenhurst as the names looked very similar on a luggage label.

On 24 January 1906 an electric tramway opened between Gosport ferry and Fareham, its quarter hourly service, (seven-and-a-half minute headway as far as Brockhurst), bettering that of the railway which only provided a half hourly frequency. Passenger traffic increased during the First World War, as did freight, especially stores to Royal Clarence Yard. Hospital trains carried patients to Haslar Naval Hospital, Gosport. In 1899 the Admiralty paid the LSWR £560, together with £30 annual

London and South Western Railway.
(945)

From *Wickham*

To *Gosport*

Route *Ely 9305*

Date *4 - 4 - 1913*

[W. & S. Ltd.]

LONDON & SOUTH WESTERN RAILWAY.
(1183 N)

IMMEDIATE.

BEER FOR TROOPS

From **READING** Station.

To *Gosport* Statio

Date

Wagon labels.

LONDON & SOUTH WESTERN RAILWAY.

SPECIAL NOTICE No. 136, 1901.

INSTRUCTIONS TO STATION MASTERS, INSPECTORS, ENGINEMEN, GUARDS, SIGNALMEN, PLATELAYERS, GATEMEN, AND ALL CONCERNED
AS TO

A SPECIAL TRAIN,

CONVEYING THE BODY OF HER LATE MAJESTY

QUEEN VICTORIA

HIS MAJESTY KING EDWARD VII.,

HIS IMPERIAL MAJESTY THE GERMAN EMPEROR

AND OTHER ROYAL PERSONAGES

FROM

THE ROYAL CLARENCE YARD, GOSPORT, TO HAVANT JUNC.,

En route to

VICTORIA STATION (L. B. & S. C. RLY.)

ON SATURDAY, 2ND FEBRUARY.

ROYAL CLARENCE YARD to HAVANT JUNCTION en route to VICTORIA.

	L. & S.W. Co.'s Pilot Engine.		L.B. & S.C. Co.'s Pilot Engine.		Royal Train.		
	ARR.	DEP.	ARR.	DEP.	ARR.	DEP.	
	A.M.	A.M.	A.M.	A.M.	A.M.	A.M.	
Royal Clarence Yard	8 45	
Gosport	8 35	8 48	The 8.45 a.m. Train Portsmouth Harbour to Southampton to be held back at Port-
Fort Brockhurst	8 38	creek Junction until the Royal Train has
Fareham	8 44	...	8 48	8 54	B58	passed Fareham Junction
Botley	...	8 55	
Cosham	8 57	9 7	A.—Set down L. & S. W. Co.'s Pilotman.
Cosham Junction	8 58	9 8	
Farlington Junction	9 0	9 10	The Royal Train will not stop to set down
Havant	9A3½	...	9 13½	Pilotman.
Havant Junction	9 4	...	9 14	B—Change Engines.
Victoria							
(L.B. & S.C. Ry.)	1050	...	11 0	...	

Sub-Inspector Langdown to travel on the Pilot Engine between Royal Clarence Yard and Havant. Inspector Elliott to be at Fareham. Chief Inspector Greenfield in charge of the Train, as between Royal Clarence Yard and Havant, assisted by Chief Inspector Ottaway.
No Train or Engine must be allowed to pass the Royal Train on the opposite line of rails.

Notice re Queen Victoria's Funeral Train.

maintenance, for a bogie ambulance coach to carry twelve cot cases and twelve sitting cases of naval invalids from Southampton to Gosport. Its exterior was 'finished in mahogany, varnished and embellished with the Naval arms'.

During the First World War railway wagons used the Gosport & Fareham Electric Tramway's line to reach the naval yard at Bedenham. This was because its gauge of 4 foot 7¾ inches allowed railway wheels to run in the track grooves with their tyres clear of the running surface. Bedenham Magazine Depot was served by a siding, opened in June 1911 from the main line and extended in March 1914 to another magazine depot at Priddy's Yard. On 4 March 1934 the Gosport branch was singled with a passing loop retained at Fort Brockhurst.

The armament depot at Frater brought traffic to the branch, as did the siding to the Ashley Wallpaper Company between Fort Brockhurst and Gosport. On the night of 10/11 March 1941 incendiary bombs ignited the timber roof of Gosport station and the conflagration proved too much for the fire-watchers. The replacement roof only covered the goods, not passenger, platform.

Gosport had a two-road, brick-built engine shed. No turntable was provided, locomotives using the adjacent triangular junction. The building had been partially demolished by 1953, yet the track remained as an engine siding, but was completely out of use by 1962.

Passenger traffic was withdrawn from the Gosport branch on 6 June 1953. The last train left Fareham with only thirty-five passengers. Tickets from Portsmouth Harbour could still be booked at Gosport station and freight traffic continued. In 1966, 16,000 tons of coal and coke and 84,000 parcels were handled in addition to Admiralty traffic at Frater. Unusual visitors to the line in the late summer of 1959 were ex-GWR 2-6-0s No. 7305 and No. 7308, both shedded at Banbury and which had worked through on pigeon specials.

The opening in December 1968 of a six-acre coal concentration depot at Fratton to serve Portsmouth and district caused Gosport yard to be closed on 6 January 1969. Subsequently track was lifted.

STOKES BAY BRANCH

The Stokes Bay Railway & Pier Company was formed to provide a short route to the Isle of Wight. It involved the construction of one-and-a-half miles of line from the LSWR just west of Gosport station to the pier at Stokes Bay, where passengers could easily step from train to ferry. Its Act was passed on 14 August 1855. The railway's engineer was Hamilton Henry Fulton whose greatest project was the Manchester Ship Canal. Oyster Bed Lake and Stoke Lake were crossed on cast-iron girders placed on timber piles with piers set 30 feet apart. Owing to a shortage of funds the railway's construction did not start for four years.

On 5 January 1863, when Captain H. W. Tyler arrived to carry out the Board of Trade inspection, he was unable to run a test engine over the line due to the contractors, Messrs Brassey, having lifted a rail as a result of a financial dispute with the railway directors. The LSWR engineer recommended additional piles to support the portion of the pier carrying the station and also that the platforms be lengthened by 60 feet to accommodate seven coach trains. Tyler inspected the line on 30 March 1863 and passed it, the Stokes Bay Railway opening to the public on 6 April 1863. Although Queen Victoria herself never used this route, her advance luggage did, joining the Royal Train at Basingstoke. Messrs Brassey eventually obtained a judgement against the railway company and the rent paid by the LSWR went to him to settle outstanding claims.

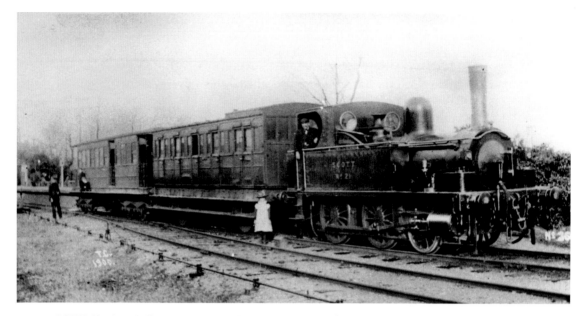

LSWR Engineer's Department 2-4-0T No. 21 *Scott* on loan at Fort Brockhurst, 26 December 1900. *Author's collection*

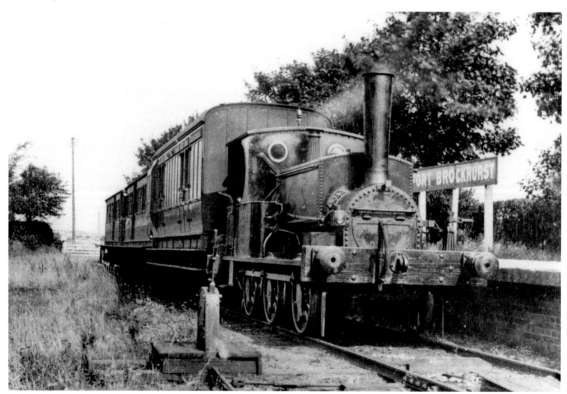

The LSWR Manning Wardle 0-6-0ST No. 392, with fluted safety valve cover and timber buffer beam, waits at the branch platform at Fort Brockhurst with a Stokes Bay train *c.* 1900. The engine has a coupling hook, but no coupling. The leading vehicle is an LSWR fruit van. Notice the flat-bottomed rails spiked directly to the sleepers, and the point lever is on the left. *Author's collection*

Initially trains to Stokes Bay reversed at Gosport, but from 1 June 1865 two of the five daily trains ran direct. No freight facilities were provided at Stokes Bay. Vessels experienced difficulty in coming alongside the pier when a south-westerly gale was blowing and the railway was required to have a boat for life-saving. In 1911 it was unseaworthy and a replacement was purchased at a cost of about £14. In 1869 complaints were received that passengers on the pier were annoyed by touters trying to get them to patronise certain Isle of Wight hotels.

The company's financial difficulties continued and the LSWR purchased the line on 1 January 1872. From 1 May 1874 through coaches ran from Waterloo to Stokes Bay in two hours forty-five minutes, travelling non-stop from Eastleigh. That year water hydrants were laid for the protection of the station and pier in case of fire. The following year the LSWR purchased the pier and ferry, but the opening of the waterside Portsmouth Harbour station on 2 October 1876 partly nullified Stokes Bay's advantage. Through tickets could be used for return by either route. In 1884 the LSWR advertised the Stokes Bay ferry as the 'Family Route' — as no change to tram or cab was necessary to reach the steamer. The pier was rebuilt in 1896 at a cost of more than £6,000 and in 1898 the two viaducts were replaced by single span bridges and embankments.

On 15 January 1884 2-4-0WT No. 248, running bunker-first at 45 mph, was derailed north of Brockhurst station together with its train consisting of a six-wheel composite coach and four-wheel brake van. Colonel F. H. Rich, the Board of Trade inspecting officer, commented regarding the vehicles 'each and all liable to run very unsteadily at high speed'. Luckily none of the ten or so passengers was seriously hurt.

As the railway staff at Stokes Bay were unable to find suitable housing locally, in May 1899 the LSWR built a row of five cottages for £1,235. As ferry traffic became light in the winter half of the year, from 1902 the steamer service was suspended from 1 October until the end of May. From 1911 a through GWR coach ran from Reading to Stokes Bay. Steamers were not provided in the 1914 summer timetable and from 1 November 1915 Stokes Bay and Gosport Road, (opened 1 June 1865), stations closed. In 1918 the Admiralty used the pier as an experimental station for torpedo research, running torpedo trolleys along the pier's standard gauge track. In 1922 the Admiralty took over the line permanently, munitions or fuel arriving by rail, the branch being worked as a long siding. The track, except on the pier, had been removed by 1936.

One of the greatest events on the branch was on 16 August 1902 the day of a naval review to mark the coronation of King Edward VII. Stokes Bay was one of the best vantage points on land to see the vessels. The LSWR charged 5s. for admission to the pier, but reduced it to ls for the evening illuminations and fireworks. An augmented service of thirty-two trains ran between Fareham and Stokes Bay; Gosport station was closed for much of the day and used for stabling empty stock awaiting return. Between 10 p.m. and midnight Stokes Bay despatched trains every few minutes, including two return specials to Waterloo and through trains to Salisbury and Woking.

LEE-ON-SOLENT BRANCH

The Lee-on-Solent Railway was not built under an Act of Parliament, but was one of the very few constructed under an order of the Railway Construction Facilities Act of 1864. Powers were granted on 14 April 1890 to construct a branch from the Fareham to Gosport line at Fort Brockhurst. The intention was to develop the hamlet of Lee Britten into a resort, but construction proceeded slowly until early 1893 when Messrs Pauling & Elliott took over.

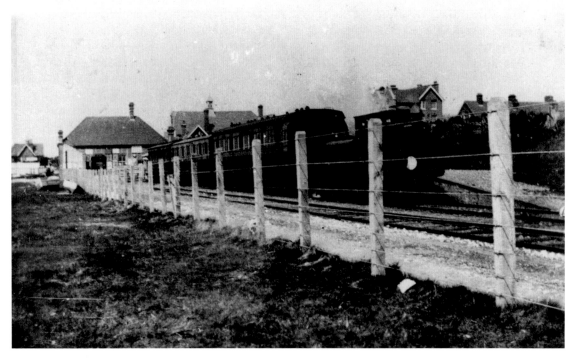

Ex-LBSCR Terrier 0-6-0T No. 0607 at Lee-on-Solent. *Author's collection*

Signalman Ted Gates surveys the scene of dereliction at Gosport Road *c.* 1930. Beyond the footbridge a sleeper secured across the track marks the terminus. *Lens of Sutton*

The line was inspected by Major Yorke on 15 July 1893. He found that the permanent way consisted of flat-bottomed rail spiked directly to the sleepers. Platforms at the intermediate halts and Lee-on-Solent were only four inches high and devoid of shelters and booking offices, and in places the line had been built outside its legal limits. Yorke deemed the works incomplete, so failed to grant a certificate. He carried out a reinspection on 7 May 1894 and gave provisional sanction for opening on 12 May in readiness for the Whit Monday traffic two days later.

The inaugural train service from Fort Brockhurst consisted of eight each way on weekdays and three on Sundays, all of which called at the intermediate halts of Browndown and Privett if required. (Privett was renamed Fort Gomer in October 1909 to avoid confusion with the Meon Valley station of that name.) A lad with a red flag signalled to the driver if he was required to pick up passengers. Those wishing to alight were required to inform the guard before leaving the terminus. Between Fort Brockhurst and Fort Gomer, the Lee-on-Solent Railway ran unfenced like a tramway beside the road and then followed the Boundon to Lee-on-Solent coast road. Through bookings could be made to main line stations and cheap returns were issued to Portsmouth via the Gosport ferry.

Rolling stock consisted of a hired LSWR Engineer's Department 2-4-0T No. 21 *Scott* and 0-6-0ST No. 392 *Lady Portsmouth*, the latter having worked on the construction of the Bentley & Bordon Camp Light Railway and arrived at Lee-on-Solent in 1898. The two coaches were tramway-pattern light-weight bogie vehicles with longitudinal seats and end platforms. Due to the light permanent way, speed was limited to 10 mph.

In June 1908 the LSWR broke the news that both the locomotives which the company hired were worn out and that no other suitable engines with an 8-ton axle loading were available. The company never paid a dividend; in fact, expenses usually exceeded receipts and in 1908 the respective figures were £1,502 and £712. As this state of affairs could not continue, on 26 July 1909 the LSWR took over the working. H13 class railcar No. 9 was introduced on 1 August, joined by No. 10 from 1 September. The railcar service offered ten trains on weekdays and five on Sundays. The railcars lasted until October 1915 when push-pull trains took over permanently. The branch locomotive was kept at Lee-on-Solent which had only very basic facilities — just a water tank and coal stage, no shed being provided.

One interesting engine which worked the branch was 0-6-0T No. 735, ex-LBSCR 'Terrier' No. 668 *Clapham* which had been purchased in 1903 by the LSWR to work the Lyme Regis branch, but had not proved to be the success hoped for. After reboilering in 1912, No. 735 was fitted with mechanical push-pull train gear and worked the Lee-on-Solent branch. It continued working the branch until October 1919, but when no substitute could be found, was overhauled and returned to traffic with an Adams' stove pipe chimney welded to the Stroudley base.

Elmore Halt opened on 11 April 1910 and, like all the other intermediate halts, closed on 1 May 1930. As a result of the road competition the line closed to passenger traffic on 1 January 1931 and to goods on 30 September 1935, ex-LBSCR D1 class 0-4-2Ts appearing on final trains. The track was soon lifted beyond Browndown Halt, and the remainder lifted in 1940, but the line to Pound Lane Crossing was retained as a coal siding until 1946.

FRATTON TO EAST SOUTHSEA

The one-and-one-quarter-mile-long Southsea Railway owed its existence almost entirely to the persistence of Lt. Col. Edwin Galt, resident of Southsea and former Mayor of Portsmouth. He wanted a direct line to Southsea from the north to facilitate through traffic, but only succeeded in getting a trailing junction. This meant either the inconvenience of shunting through coaches, or Victorian families, with a mountain of trunks and cases, having to struggle over the footbridge from main to branch platform. Acts of 28 August 1880 and 2 August 1883 authorised the line's construction, the first sod of which was cut on 26 March 1884. The branch was level and easy to construct, even ballasted with gravel excavated along its route.

Southsea terminus was a red-brick building with terracotta dressings. Situated about one quarter-of-a-mile from the sea front, it had three platform roads. The line opened on 1 July 1885 and an unusual feature of the special passenger train was an open wagon in its centre containing a band. Public services began the following day with fifteen trains each way, six carrying through coaches to or from London. The LSWR operated it initially, but, being a joint line, the LBSCR started its first operating cycle on 1 July 1886. The Southsea Railway was conveyed to the joint companies on 8 June 1887 for £74,905 1s 0d. In 1886 W. H. Smith paid £500 yearly for bookstalls at Fratton and Southsea in addition to 5 per cent of their takings. In May 1896 the name of the terminus was changed to East Southsea, as Fratton or Portsmouth stations were closer to most parts of Southsea. The Joint Committee felt that heating trains for a six-minute journey was not worthwhile and so the railway lost the potential advantage of passenger comfort to the convenience of horse-drawn trams, which generally dropped passengers off closer to their destination.

The line's revenue declined from 1893 and fell even more from 1901 when the tramways were electrified. In 1902 the branch working expenses of £2,149 did not balance well against receipts of only £287. The joint Committee proposed reducing expenses by:

The seal of the Southsea Railway.

1) abolishing signalling and making the former Up line a siding and working passenger traffic both ways over the former Down line
2) unstaffing East Southsea station and getting the guard to issue tickets
3) using a steam railcar.

The first railcar was ready in April 1903, ran brief trials on the branch and was then loaned to the GWR, who tried it at Stroud and eventually built its own large stud. Railcar No. 1 commenced its regular working of the branch on 1 June 1903 operating a twenty-minute interval service from 8.00 a.m. to 7.30 p.m., its introduction causing a withdrawal of through coaches. It worked alternate days with No. 2. Both lacked the ability to raise sufficient steam and for rush-hour services had a steam engine attached, completely cancelling out any saving. In September 1903 No. l's vertical boiler was replaced by a larger version in the horizontal position. This steamed rather better and No. 2 also was modified enabling the pair to work all traffic unaided. Occasionally the railcars stopped with the piston towards the top of the stroke — this meant the driver had to ease his 24½ ton vehicle forward a few inches from dead centre with a long pinch bar The locomotive section of both cars was painted Drummond green, but the coach section of No. 1 was in the LBSCR livery of chocolate and cream and No. 2 in the LSWR salmon and dark brown. Lettered 'SW & LB&SC Joint', they were one of the few examples in England of a joint line having its own locomotive power.

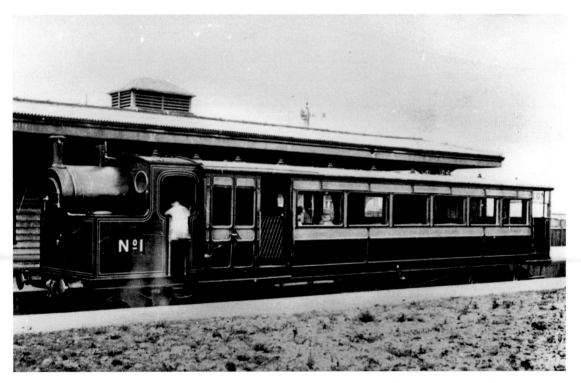

Joint LSWR/LBSCR railcar No. 1 at Fratton, 1903, with a horizontal boiler. *Author's collection*

East Southsea Line.—The Branch Line from Fratton to East Southsea is worked as a Single Line, the Services being performed by a Steam Motor Carriage which provides First and Third Class accommodation only, and is under the control of the Station Master at Fratton, to whom all amounts taken by the Conductor of the Motor must be remitted, and who must visit East Southsea daily to inspect the general Station appointments. No Parcels Traffic or Telegraph business can be dealt with at East Southsea.

An Electric Bell and Plunger have been provided in the Porters' Room at East Southsea, and the person in charge of the platform will be held responsible for giving a departure Signal of two beats to the Signalman at Fratton Yard Box when the Motor Carriage starts.

The Signalman at Fratton Yard Box must give a departure Signal of two beats to East Southsea when the Motor Carriage leaves Fratton.

The Signals in each case must be acknowledged by being repeated.

The authority for travelling between Fratton and East Southsea is a Diamond-shaped Staff labelled " East Southsea and Fratton," and the Motor Carriage must not be started on its journey unless the Driver is in possession of the Staff.

The Guard on the return journey from East Southsea to Fratton, after having issued the necessary tickets, must keep a sharp look-out ahead, and be prepared to apply the hand-brake should it be necessary to do so. This, however, in no way relieves the Driver of his responsibility.

When the Driver requires the assistance of the Guard's brake, he must give three or more short, sharp whistles and the Guard must immediately apply the brake.

The Guard must apply the brake when approaching Fratton and East Southsea Stations, or either of the Halts.

An Electrical Plunger is provided at the Collector-Guard's end of the Motor Carriage operating an Electrical Bell in the Driver's Cab, and the Guard, should anything unusual occur necessitating the Motor Carriage being stopped, must ring the bell to the Driver.

The bell must also be operated by the Guard when he desires the Motor Carriage started.

The Motor Carriage must carry the usual Red Tail Light after dusk, or during fog or falling snow.

In the event of the Motor Carriage becoming disabled between Fratton and East Southsea, the Guard must take the Staff to Fratton to obtain what assistance is necessary, and inform the Signalman at the Fratton Yard Box what has occurred.

The Station Master, or person in charge of the Station at Fratton, must take all necessary steps to obtain an Engine (or another Motor Carriage) to go to the assistance of the disabled Motor Carriage. The Guard must hand the Staff to the Driver of the assisting Engine appointed to proceed to the assistance of the disabled Motor Carriage, and accompany him to the place where he left the Motor Carriage, and the Guard must not on any account allow the Staff to pass out of his possession until he hands it over to the Driver of the assisting Engine, and the Driver of the assisting Engine must not allow it to pass out of his possession until the disabled Motor Carriage is removed clear of the Section.

The Driver of the disabled Motor Carriage must not allow it to be moved until the assisting Engine has arrived.

Extracts from the SR Working Timetable Appendices 1934.

WORKING OF RAIL MOTOR CARS.

The Cars must be dealt with as ordinary Passenger Trains when running in passenger services, and as Light Engines when running empty.

The Cars are constructed to carry 1st and 3rd Class Passengers. No 2nd Class accommodation is provided, and 2nd Class tickets must not be issued locally to Passengers who wish to travel by the Cars, but the holders of return halves of 2nd Class tickets and 2nd Class season tickets may be allowed to travel 1st Class in the Cars.

A compartment to hold about 1 ton of Passengers' Luggage is provided in each Car.

The Cars are fitted with the vacuum automatic and hand brakes which can be operated from either end. A Driver and Fireman will be provided on each Car, and the Driver must on all occasions ride at the leading end of the vehicle.

Passengers must not be allowed to smoke in the Car.

The Car must carry the Head Signals applicable to the Line over which it works.

If necessary, a coach may be attached to the Car as a Trailer, and, provided a coach is not attached, one or two horse boxes, or other such four-wheeled vehicle, may be attached to the rear of the Car, but these vehicles must be fitted with the vacuum automatic brake.

When an ordinary coach is attached to a Car as a Trailer, the Passengers joining at the halts must, if there be room, ride in the Car in order that tickets may be issued to them.

The Conductor-Guard must carry with him a complete Guard's equipment, in order that he may obey the General Rules and Regulations in the event of the Car being stopped out of course, or through an accident, &c.

The Conductor-Guard must use every care in getting the Passengers into and out of the Car safely and quickly, and must not permit Passengers to ride on the gangway between the 1st and 3rd Class compartments.

Tickets held by Passengers in the Car must be examined by the Conductor-Guard, and the tickets of Passengers alighting at the Halts must be collected by him.

Should the Driver at the leading end of the vehicle require the assistance of the brakes worked from the rear end of the Car, he must give three or more short sharp whistles, and the man at the rear must then immediately apply the brakes.

The Passenger compartments in the Cars are fitted with Pintsch's patent system of incandescent gas lighting, and the Conductor-Guard must see that the Cars are lighted as and when required.

The railcars achieved what they were set out to do — to balance the branch's books:

Year	Working Expenses	Receipts
1903	£1,934	£185
1905	£724	£818
1906	£499	£611

The single fare was a penny, but as through fares were equal to threepence for branch travel, crafty passengers rebooked at Fratton. To seek further traffic, on 1 October 1904 halts were opened at Jessie Road Bridge and Albert Road Bridge, while at the terminus a deviation was made to a new single platform at East Southsea, the old large terminus being closed and later taken over by a firm of motor engineers. From 1 January 1906 the annual cycle of working changed to fiveyearly, but as the railmotors were jointly owned, the only difference was whether it was the LSWR, or LBSCR side of Fratton shed which maintained them.

As the branch was so short, unless a train departure was imminent, it was quicker to walk — even on foot, East Southsea to Fratton took only twenty minutes. Because late running of a Down main line train could throw the branch timetable into disorder and make the next Up main line train late, it was the practice to save time by collecting on the Down trip, passengers from the intermediate halts who were known to be destined for Fratton so that the return trip could be non-stop. Acceleration of the railcars could be 0-45 mph in thirty seconds, and one journey from Fratton to East Southsea and back was made in the exceptional time of five minutes fifty seconds, including calling at all stops.

No goods traffic was worked latterly, though one goods wagon was annually filled with hay cut from the embankments and sold to more than cover the cost of its cutting by hand.

Trains were withdrawn from 8 August 1914, a chalked notice reading: 'No Moor Tranes to East Southsea. Fishal'. Track was lifted in 1925-26 and the land was sold to a local builder.

The first engine shed at Fratton was a four-road building on the north side of the main line. In about 1890 a roundhouse was built of brick on the south side of the line and jointly owned by the LSWR and LBSCR. The 50-foot diameter turntable was common user, but each company had separate locomotive stalls, coal stages and offices. Each company maintained about thirty-five engines at the shed. It closed in November 1959, but the building continued to house a visiting steam engine and some ex-SR locomotives scheduled for preservation.

HAVANT TO HAYLING ISLAND

Road access to Hayling Island was via a bridge built in 1824, but the Hayling Island Railway Act of 23 July 1860 authorised a branch from the main line at Havant. An embankment approximately parallel with the western shore of the island was to reclaim more than 1,000 acres of mudflats. This scheme was modified by an Act of 14 July 1864 which gave powers to construct two extensions and make docks. The line between Havant and Langston opened on 12 January 1865 and in addition to passengers, dealt with coal, gravel and timber, Langston Quay at the end of a 682-yard-long spur being busy with shipping.

The embankment scheme was plagued by the sea washing it away and an Act of 12 August 1867 gave powers to abandon this section of line and to use a new route to the southern beach. The completed line opened to the public on 17 July 1867. The Receiver was called in during 1869, but creditors were paid and he was discharged by 1872. At first the railway was worked by a contractor, but on 25 December 1871 was leased to the LBSCR, the Hayling Railway continuing to own the line until 1923.

The most important engineering feature of the branch was Langston Bridge, a timber trestle with a 30-foot swing span. It was 370 yards in length and comprised forty-nine spans, of which the highest was 25 feet above high water. Regulations stipulated that vessels must not sail through, but must tie up at mooring posts and be warped through. This required two railwaymen to be present — a signalman to work the box, disconnect and reconnect signal wires, and a lengthman to remove and replace the locking fishplates and push the span open. Masters and pilots were given the following guide:

> On a vessel approaching the railway bridge, the Bridgeman will hoist on the flagstaff at the centre of the bridge, a white flag by day and a white light by night to denote that the vessel is seen. If the bridge can be safely opened, a black ball will be hoisted by day and a green light by night. When the bridge is actually open a red flag will be hoisted by day and a red light by night and shown when the bridge is about to be closed again for the passage of trains.

Weight restrictions over the bridge limited branch motive power and for its last seventy-three years it was worked by 'Terrier' class 0-6-0Ts. Their load was limited to four coaches for a non-stop run to Hayling Island, or three when a train called at Langston and North Hayling. Latterly, spark-arresters were fitted to their chimneys to protect lineside crops. The engine shed at Hayling Island closed in 1894 when locomotives were transferred to Fratton. Previously there had been a shed at Langston when that station was the terminus. Hayling Island station, (named South Hayling until 1 June 1892), was a picturesque building, half-timbered with herringbone-pattern brickwork, its roof tiles of two designs. Its end walls were later tiled. At about the turn of the century there was a siding just south of North Hayling Halt so that oysters could be transferred directly from boats to wagons brought empty on the rear of an Up train and collected by a subsequent working. No separate freight trains were run, one train each way designated as 'mixed'. Latterly, the normal weekday service of fourteen trains each way required only one engine, but this was increased to twenty-four trains during summer weekends and three engines were required. The most intensive service possible was every half hour. Traffic was much heavier in summer than in winter as these figures show:

	Tickets Collected	Tickets Issued
March 1961	2,077	1,705
August 1961	32,176	7,019

5,000 passengers were carried daily at peak periods and on one summer Sunday in 1961 about 7,000 passengers were carried.

In 1963 Langston Bridge required repairs at a cost of £400,000. As this would have been uneconomic, the line closed on 4 November 1963. The last train comprised six coaches and, as it was heavier than one engine could handle, a locomotive was coupled at each end in order to spread the weight on the aged timber viaduct.

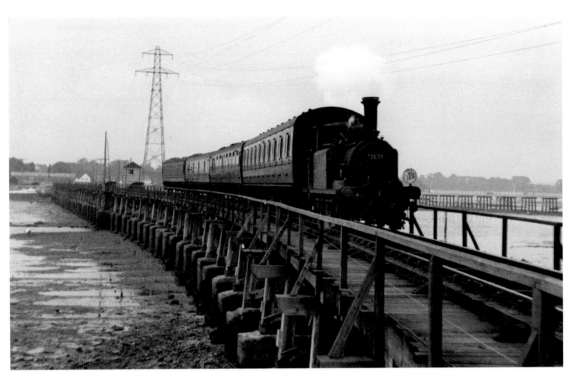

A1X class 0-6-0T No. 32678 (now preserved) *c.* 1955, hauls four coaches towards Hayling Island over the trestle section of Langston Bridge. *David Lawrence*

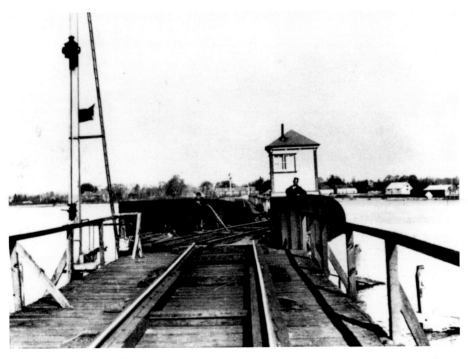

Langston Swing Bridge being swung *c.* 1905. Notice the [red] flag flying. *Author's collection*

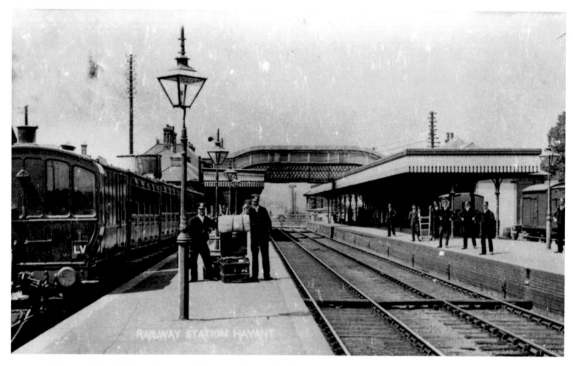

Havant. The 'LV' at the rear of the coach on the left in the Hayling Island bay platform, signifies 'last vehicle' and assures a signalman that nothing has become uncoupled. *Author's collection*

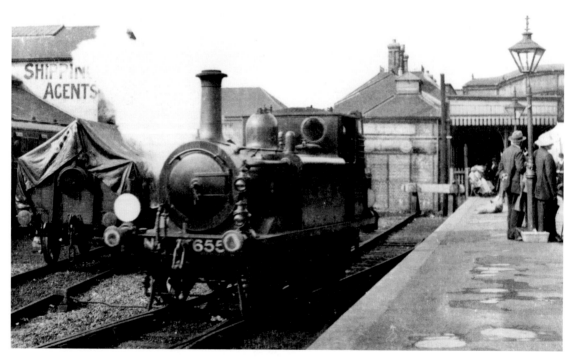

A1X class 0-6-0T No. 655, now preserved, at Havant in LBSCR livery *c.* 1920, running round its train which has just arrived from Hayling Island. Notice the headcode of a disc and two lamps. *Lens of Sutton*

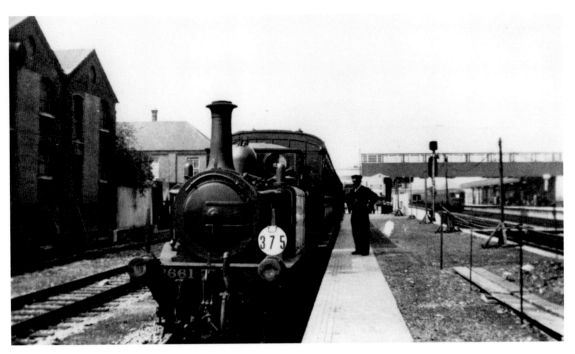

A1X class 0-6-0T No. 2661 at Havant, *c.* 1938, with a train to Hayling Island. An Up main line electric train is on the right. *Lens of Sutton*

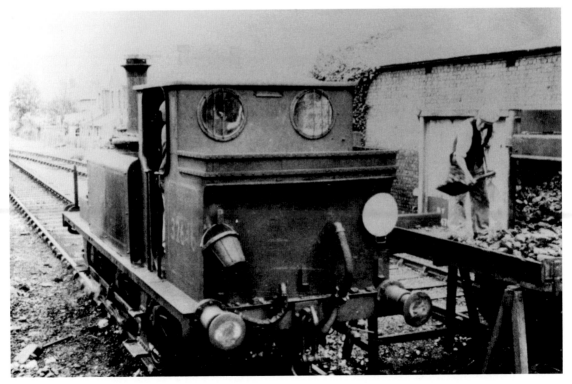

A1X class 0-6-0T No. 32646, now preserved, being coaled at Havant 10 July 1963. *P. Q. Treloar*

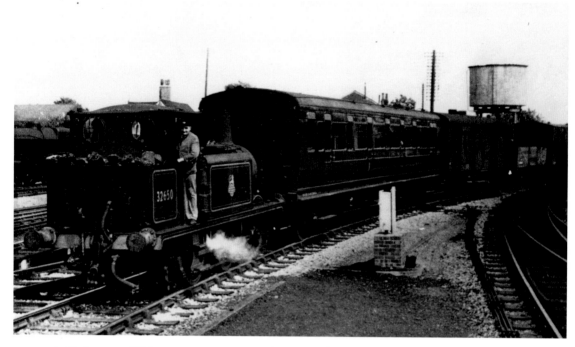

AIX class 0-6-0T No. 32650, now preserved, enters Havant from Hayling Island *c.* 1959 with a mixed train. The coach is branded: 'Hayling Island Branch' on its solebar. The engine carries no lamp or headcode. *Author's collection*

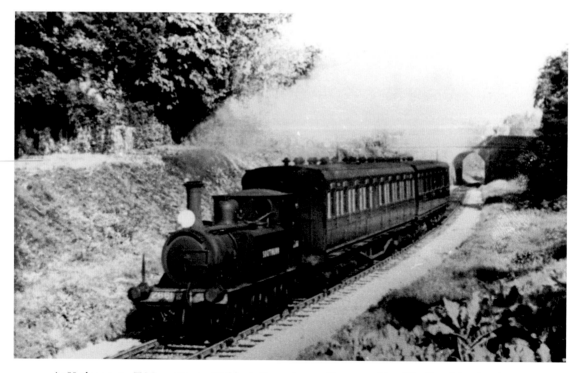

AIX class 0-6-0T No. 2661 in SR black livery, leaves Havant with a Hayling Island train, 25 September 1949. *Pursey Short*

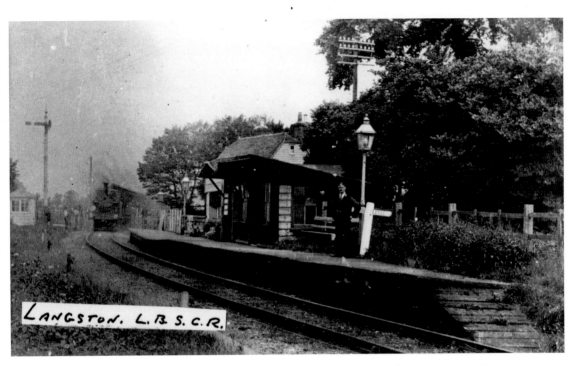

A Down train headed by an A1X class 0-6-0T approaches Langston. One arm on a gradient post on the platform indicates a down gradient of 1 in 230, while the other shows 'Level'. There is a distinct sag towards the far end of the timber platform. *Lens of Sutton*

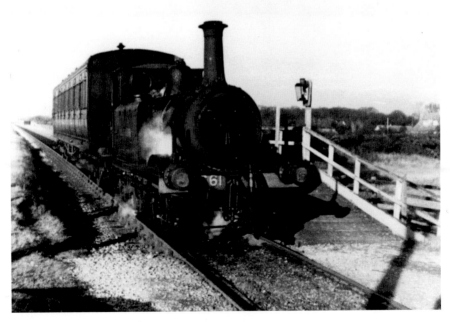

A1X class 0-6-0T No. 2661 leaves North Hayling Halt, 22 January 1949. *Pursey Short*

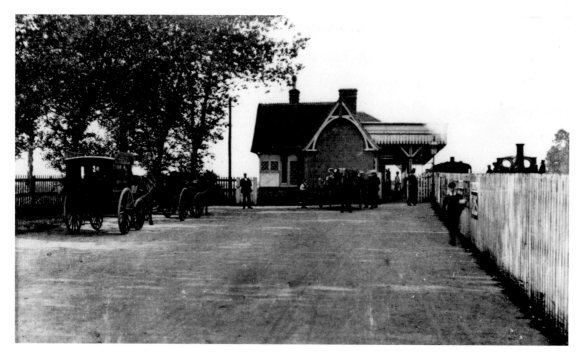

The carriage approach to Hayling Island station, *c.* 1910. Notice a horse bus on the far left. A Terrier tank engine has just arrived, been uncoupled and is running round the coaches. *Author's collection*

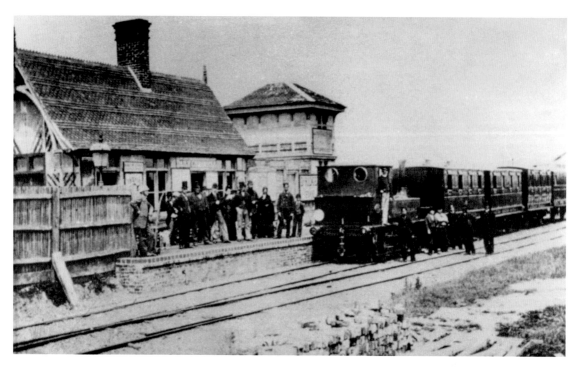

Sharp, Stewart 2-4-0T *Hayling Island* at Hayling Island *c.* 1888. It worked the branch from 1874 to 1889. *Author's collection*

Portrait of the staff at Hayling Island station. The nearest coach is a Billinton 6-wheeler and beyond are Stroudley 4-wheeled coaches. It appears that pigeons have been recently released on a training flight. Their next flight might be from the Channel Islands. *Author's collection*

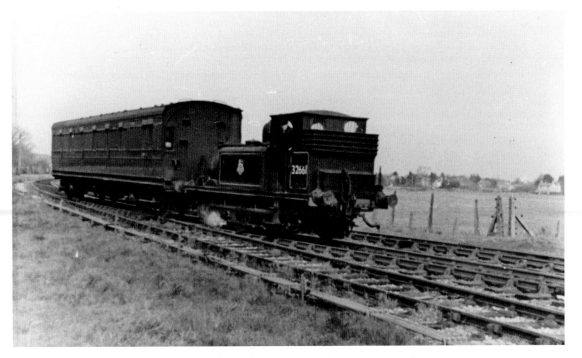

Class A1X 0-6-0T No. 32661 arriving at Hayling Island, 1951. *Pursey Short*

Suggested Further Reading

Antell, R., *Southern Country Stations: The London & South Western Railway*. (Ian Allan 1984).

Bennett, A., *Southern Holiday Lines in Hampshire and Isle of Wight*. (Runpast 1994).

Bradshaw's Railway Guide August 1887; April 1910; July 1922; July 1938 [reprints]. (David & Charles).

Bradshaw's Railway Manual, Shareholders' Guide & Directory 1869 [Reprint]. (David & Charles).

Brown, P. A., *Many & Great Inconveniences: The Level Crossing and Gatekeepers' Cottages of the Southampton & Dorchester Railway*. (South Western Circle 2003).

Clinker, C. R., *Register of Closed Passenger Stations and Goods Depots 1830 -1977*. (Avon Anglia 1988).

Cooke, R. A., *Track Layout Diagrams of the GWR & BR WR Section 23*. (Author 1986).

Course, E., *The Railways of Southern England Secondary and Branch Lines*. (Batsford 1974).

Course, E., *The Railways of Southern England: Independent and Light Railways*. (Batsford 1976).

Cox, J. G., *Castleman's Corkscrew. The Southampton & Dorchester Railway 1844 – 1848*. (City of Southampton 1975).

Ellis, H., *The South Western Railway*. (Allen & Unwin 1956).

Fairman, J. R., *Netley Hospital & Its Railways*. (Kingfisher 1984).

Fairman, J. R., *The Fawley Branch*. (Oakwood Press 2002).

Glenn, D. F., *Roads, Rails & Ferries of the Solent Area*. (Ian Allan 1980).

Glenn, D. F., *Rail Routes in Hampshire & East Dorset*. (Ian Allan 1983).

Griffith, E , *The Basingstoke & Alton Light Railway*. (Kingfisher 1982).

Harding, P. A., *The Longparish Branch Line*. (Author 1992).

Hardingham, R., *The Mid Hants Railway*. (Runpast 1995).

Hateley, R., (ed) *Industrial Locomotives of Southern England*. (Industrial Railway Society 1981).

Hawkins, C. & Reeve, G., *An Historical Survey of Southern Sheds*. (OPC 1979).

Kidner, R. W., *Southern Railway Branch Lines in the Thirties*. (Oakwood 1976).

LSWR Working Timetable of Passenger & Goods Trains 1 June to 30 September 1909 [reprint]. (Ian Allan).

MacDermott, E. T, revised Clinker, C. R., *History of the Great Western Railway*. (Ian Allan 1964).

Marshall, C. F. D., revised Kidner R. W., *A History of the Southern Railway*. (Ian Allan 1963).

Mitchell, V. & Smith, K., *South Coast Railways: Southampton & Bournemouth*. (Middleton Press 1987).

Mitchell, V. & Smith, K., *Fareham to Salisbury*. (Middleton Press 1989).

Mitchell, V. & Smith, K., *Andover to Southampton*. (Middleton Press 1990).

Mitchell, V. & Smith K., *Branch Lines Around Wimborne*. (Middleton Press 1992).

Mitchell, V. & Smith, K., *Reading to Basingstoke*. (Middleton Press 1994).

Paye, P., *The Lymington Branch*. (Oakwood 1979).

Popplewell, L., *A Gazetteer of the Railway Contractors and Engineers of Central Southern England 1840 — 1914*. (Melledgen 1983).

Pryer, G. A. & Paul, A. V., *Track Layout Diagrams of the Southern Railway and BR SR Sections S1; S2; S3*. (R. A. Cooke 1980; 1983; 1981).

Pryor, G. A., *Signal Boxes of the L&SWR*. (Oakwood 2000).

Reeve, G. & Hawkins, C., *Branch Lines of the Southern Railway Vol. 1*. (Wild Swan 1980).

Robertson, K., *Railways of Gosport*. (Kingfisher 1986).

Sands, T. B., The Didcot, *Newbury & Southampton Railway*. (Oakwood 1971).

Simmonds, R. & Robertson, K., *The Bishop's Waltham Branch*. (Wild Swan 1988).

Smith, M. *Britain's Light Railways*. (Ian Allan 1994).

Stone, R. A., *The Meon Valley Railway*. (Kingfisher 1983).

Tavender, L., Southampton, *Ringwood & Dorchester Railway* (A.E.Baker 1995).

Thomas, D. St J. & Whitehouse, P., *A Century and a Half of the Southern Railway*. (David & Charles 1988).

White, H. P., *Regional History of the Railways of Great Britain Vol. 2 Southern England*. (David & Charles 1982).

Williams, R. A., *The London & South Western Railway Vols. 1 & 2*. (David & Charles 1968; 1973).

Young, J. A., *The Ringwood, Christchurch & Bournemouth Railway*. (Bournemouth Local Studies 1985).